The New
Town Square

ABOUT THE SERIES

The American Association for State and Local History Book Series publishes technical and professional information for those who practice and support history and addresses issues critical to the field of state and local history. To submit a proposal or manuscript to the series, please request proposal guidelines from AASLH headquarters: AASLH Book Series, 1717 Church St., Nashville, Tennessee 37203. Telephone: (615) 320-3203. Fax: (615) 327-9013. Website: www.aaslh.org.

ABOUT THE ORGANIZATION

The American Association for State and Local History (AASLH) is a non-profit educational organization dedicated to advancing knowledge, understanding, and appreciation of local history in the United States and Canada. In addition to sponsorship of this book series, the association publishes the periodical *History News*, a newsletter, technical leaflets and reports, and other materials; confers prizes and awards in recognition of outstanding achievement in the field; and supports a broad education program and other activities designed to help members work more effectively. To join the organization, contact: Membership Director, AASLH, 1717 Church St., Nashville, Tennessee 37203.

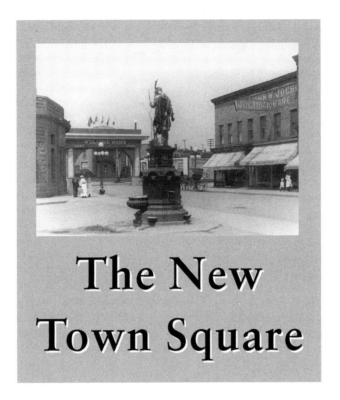

The New Town Square

Museums and Communities in Transition

Robert R. Archibald

AltaMira
PRESS

A Division of
ROWMAN & LITTLEFIELD PUBLISHERS, INC.
Walnut Creek • Lanham • New York • Toronto • Oxford

ALTAMIRA PRESS
A division of Rowman & Littlefield Publishers, Inc.
1630 North Main Street, #367
Walnut Creek, California 94596
www.altamirapress.com

Rowman & Littlefield Publishers, Inc.
A wholly owned subsidary of The Rowman & Littlefield Publishing Group, Inc.
4501 Forbes Boulevard, Suite 200
Lanham, Maryland 20706

PO Box 317
Oxford
OX2 9RU, UK

British Library Cataloguing in Publication Information Available

Library of Congress Cataloging-in-Publication Data
Archibald, Robert, 1948–
 The new town square : museums and communities in transition / Robert R. Archibald.
 p. cm. — (American Association for State and Local History book series)
 Includes bibliographical references and index.
 ISBN 0-7591-0287-2 (hardcover : alk. paper) — ISBN 0-7591-0288-0 (pbk. : alk. paper)
 1. Public history—United States—Philosophy. 2. Historical museums—United States. 3. United States—History, Local—Philosophy. 4. Memory—Social aspects—United States. 5. Community life—United States. 6. Social change—United States. 7. United States—Social conditions—1980– 8. United States—Civilization—1970– 9. National characteristics, American. I. Title. II. Series.

 E175.9.A69 2004
 303.4'0973—dc22
 2003024700

Printed in the United States of America

♾ ™ The paper used in this publication meets the minimum requirements of American National Standard for Information Sciences—Permanence of Paper for Printed Library Materials, ANSI/NISO Z39.48-1992.

Contents

Acknowledgments vii

Introduction: The Past as Context 1

1 Creating a Place 15

2 The Power of Place 37

3 Sharing the Story 61

4 Making Connections 77

5 Contemplating Change 101

6 The Call of Wildness 115

7 Sustaining the Future 137

8 Touring a Culture 157

CONTENTS

9 A Wonderful Place 179

10 Under Construction 201

Index 219

About the Author 223

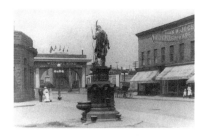

Acknowledgments

WRITING IS SOLITARY WORK, BUT THIS BOOK IS THE PRODUCT of many hands. This book was a challenge because it is based on lecture addresses and even radio vignettes that I wrote and delivered over five years to audiences in communities all over the United States.

Making lectures into a book is a special challenge. Kathy Petersen, my editor and research assistant, cut and pasted, wrote transitions, and added paragraphs so that this book became a nonrepetitious whole. She also selected the photographs. Kathy Petersen was more than an editor on this project. I wish there was an adequate word between editor and author, for only such a word describes her labors. I am grateful to her for her work, her friendship, and her gentle but effective guidance in all my writing efforts.

Sue Archibald, my wife, not only made the sacrifices that this project required but also took many of the photographs in this volume. Wherever we travel, she is there with her fine photographic eye taking images that catch her aesthetic fancy and simultaneously document my thoughts. I thank her and only hope that I can adequately show my appreciation.

Lee Sandweiss, a former colleague at the Missouri Historical Society and a friend of long standing, read the manuscript and offered good suggestions for improvement. Lee is a light-handed but fine editor. I have appreciated

her help, encouragement, and suggestions on many occasions. I have learned to always pay close attention to her ideas.

The entire staff of the Missouri Historical Society has been unfailingly supportive of my writing efforts and the publishing process. Executive Vice President Karen Goering, Vice President for Community Services Nicola Longford, and my executive assistant Vicki Kaffenberger have been especially patient and cooperative in the Executive Offices. Duane Sneddeker, Director of Library, Archives, and Still and Moving Images, and curatorial assistant Ellen Thomasson quickly retrieved images from our collections, often from the scantiest of description; and Tami Lent, our Coordinator of Institutional Design, often and ever cheerfully guided us through the labyrinthine ways of PhotoShop, the TIFF format, and CD burning.

This is the second book that I have had published by AltaMira Press. Mitch Allen is direct, and his guidance has always been sensitive and accurate. Mitch made several important and useful suggestions about how these essays might become a book. Susan Walters was efficient, prompt, and always helpful in handling the manuscript. It is a pleasure to work with AltaMira, whose professionalism is enhanced by the warm friendliness of all the staff.

As I begin to think of the many people across the country who contributed to this book, I realize that I can never name them all. Some I have gotten to know on both a professional and personal basis; they have contributed immensely to this collection. Others I only know as people in an audience, whose attention and insightful observations have renewed my commitment and reinforced my thinking. All of them, all of you are a part of building the "new town square."

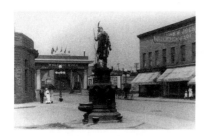

Introduction:
The Past as Context

THE MOST PROFOUND DILEMMA OF THIS NEW CENTURY, inherited from the last, is a deepening crisis of place and the accompanying ennui of placelessness. Lack of attachment to place disembodies memory, sunders relationships, promotes prodigal resource consumption; it threatens democracy itself, which so much depends upon those "mystic chords of memory" and habits that bind us to one another in a shared voluntary pursuit of the common good. Democracy could even be defined exactly that way—as a shared voluntary pursuit of the common good—and it must happen in a place, a piece of physical geography, a particular spot on the planet. Those places, especially the ones that early nurtured us, are deeply impressed upon us. When we lose those places, we lose an essential part of ourselves and our stories.

So we come to the heart of this book: a crisis of place. My hometown of Ishpeming on Michigan's Upper Peninsula is my barometer of change, and what I see now is distressing. There are only skeletal remains of the town I once knew so well. I am cautious in my observation because I know that in the case of Ishpeming, condemnation of change could be self-indulgent, a nostalgic mourning for my own lost youth. But I do not think so in this case. The same changes that I see there afflict cities and towns all over this land, and they worry many people.

Ishpeming as I knew it when I was young does not exist. But I do not mourn the closing of the Butler or Ishpeming Theaters, the demolition of E. A. Johnson's Grocery, and not even the ramshackle condition of our old home. It is not the physical rearrangement of space that most confounds me. What I truly mourn is less tangible but more important: the destruction of a community that is so integrally a part of me. The social interactions that result in community—common past and present, a commitment to the common good, and shared aspirations—are more difficult to generate and sustain in far-flung suburban neighborhoods. Every place's culture is now undermined by the homogenizing pressures of mass culture. Increasingly Ishpeming is becoming like everywhere else, a place that soon will not matter much because it will be indistinguishable from any other place.

The essays in this book examine issues of community, place, and culture from a variety of perspectives. Much of the content is drawn from presentations I made in the past several years in dozens of different big cities and small towns around the country. The groups that invited me to speak were historical societies, historic preservation organizations, professional planning associations, religious groups, cultural tourism conferences, arts organizations, environmental advocacy groups, mass transit advocates, civic improvement groups, and sometimes loosely organized citizens concerned about the future of their own communities. My interactions with all of these people were invaluable, for they repeatedly described for me the importance of their places, their concerns for the future, and their yearning for ways to recover the community sense and spirit imprinted upon most of us with our first views of the world.

I am an archetype of deep imprinting and proof positive that we always see the world through our first lens. I had a stay-put childhood in the Upper Peninsula of Michigan, that disconnected, irregularly shaped land mass that juts out into Lake Superior, east from northern Wisconsin; it does not touch the major mitten-shaped part of Michigan at all. I lived there for twenty-one years. Although I have not lived in the U.P., as natives abbreviate it, for more than thirty years, it represents normalcy to me. If you have not lived there, you cannot know how abnormal the U.P. is for most others. When I tell people that I lived in Montana for a dozen years, they raise one eyebrow and sympathetically ask me how I lived through Montana winters. I was well prepared, I explain. Unless I spent the winters at the top of Beartooth Pass outside of Red Lodge, Montana was temperate compared to the U.P. Those

hardy people endured more than three hundred inches of snow during a recent winter, and it was still snowing in May. But the denizens of this subarctic patch of the northern Midwest bundle up in long johns, high boots, long scarves, hats, and mittens and go about their business. There, you have to keep going during the winter, otherwise half of the year would be written off like a bad debt. Persistence through repeated, predictable adversity creates ties among locals that outsiders cannot penetrate. The snow-laden winds streaming south from the Arctic suck moisture from Lake Superior and dump it in flaky white form on the U.P. in what weather predictors euphemistically call "lake effect snows." When I lived there we just called them "blizzards."

The population of the Upper Peninsula is sparse. But beautiful, dense, dark forests, pristine lakes, abundant wildlife, and the enchanting, mournful nocturnal calls of the black-and-white, orange-eyed loons partially compensate for engulfing winters. Forests are called "the woods" up there, and it is easy to get lost because in some places trees are so densely packed that you cannot see landmarks. My brother got lost during his week at "deer camp," another tradition for U.P. males. He got turned around, as they say, but had the good sense to build a fire and stay put instead of wandering through the woods. My father found him in the morning. Deer camp is an unofficial holiday; many businesses just give up and shut down and schools wink at absences. The ostensible purpose of going to deer camp is to hunt deer. Hunting in Montana was an arduous mountain climb, miles of often acutely pitched hiking, and game tracking. But in the U.P. they do it the lazy man's way. Hunters buy "deer apples" and salt blocks during the summer months and pile them near their camps with the expectation that, come late fall, they can hide in tree blinds and shoot deer arriving for an accustomed meal of apples and a lick of salt. Sometimes it works.

Deer camp is really less about hunting deer than it is about being boys. Deer camp is an escape for men, a place where conventional rules of civility, cleanliness, speech, dress, and behavior are suspended. And for most deer camp denizens there is a lot of drinking, some gambling, and a few dead deer hanging from a wooden beam suspended well off the ground between two trees. Deer camp is a part of the culture of my part of the U.P., a culture based in its origins as an iron mining community. The deep and dangerous underground mines are closed, but their legacy persists in a fatalistic culture and in the thousands of acres of empty ground, including places that

were once whole neighborhoods and huge chunks of towns, now surrounded by chain-link fences and signs that warn would-be trespassers of "caving ground." This ground is not polluted in any conventional sense. It is just wrecked forever and destined to sink in fits and starts into the huge underground tunnels and caverns thousands of feet below.

Historically the risky business of underground mining was reflected in winter sport. Immigrant Finns and Swedes knew about winter, and they brought skis. But in the U.P. snow skiing as a means of winter locomotion mutated into ski jumping. In the dead of winter men strapped on skis, hurtled down scaffolding, and soared several hundred feet to what they hoped would be a smooth, upright landing. Thousands of people stood at the bottom of the hill and watched, drinking hot chocolate and steaming coffee to keep warm. So seriously did our town take the annual competition that we were released from school and fathers were released from work so we could watch the graceful jumpers finish up during the week. The ski jumpers were our local heroes. One of the tournament days was named for Paul Bietila, who died in a crosswind that blew him off a ski jump and into the rocky bluffs and trees on the sidelines. Ski jumping well done is graceful and beautiful, but it is also dangerous. I jumped on small slopes where the distance was calculated in dozens of feet, but I have stood at the top of Suicide Hill, and so I know that pushing off that precipice of no return takes a huge helping of what the local Finns call *sisu*. The word does not quite translate into *courage*.

The first miners in the Ishpeming area where I was raised were Cornish, people with names like Tremethick, Treloar, and Penhale. Cornish wrestling had died out by the time I arrived, but the "pasties" were thriving. Pasties were the miners' lunch, or dinner, as they called the noon meal. Although the ingredients were simple, locals now debate at length the merits of variant recipes. Should it be ground or chopped meat? How finely should the rutabaga, potato, and onion be chopped, or should they be grated? Should the ingredients be mixed or layered before folding the crust over them? Basically a pasty is hamburger, chopped potato, grated onion, rutabaga, seasoning, all mixed together, wrapped into a kidney-shaped crust, and baked. It is a complete meal that stays hot for a long time and does not fall apart. Local lore says that miners carried them in their shirts and heated them on shovels held over candles and lamps underground. If so, it was before my time. By the time I came along, miners I knew carried black barn-shaped

4

lunch buckets. There were fewer pasties in the buckets and more baloney sandwiches. But pasties are still a part of our indigenous culture.

Despite the harshness of the climate, this land is sublime. While Scandinavians brought skis, older French Canadians and Métis were already moving across the deeply piled winter snows on snowshoes, a concept borrowed from American Indians. Whether on skis, which only work on snow with a firm crust, or on snowshoes, people in the Upper Peninsula enjoy an indescribable winter stillness and solitude. Snowshoeing into the woods in midwinter quiet is a transcendent experience that transports humans into an unparalleled reverie that is on the one hand introspective and on the other a form of close communion with the natural world. In the stillness hearing becomes acute and the distant snap of a frigid and brittle branch or the scampering of a rabbit or mouse across hard snow, unheard in a noisier world, seems almost to echo in this cold, clean, white place. Such experiences are ample reward for living here.

Lake Superior is the biggest and deepest of the Great Lakes. It never really warms up, and even in midsummer the azure blue water is too cold except for the most daring and hardy. But imagine a lake so big you cannot see across it, surrounded by fine sand beaches alternating with rocky granite cliffs. These outcroppings of ancient rock are the backbone upon which the entire North American continent hangs. The shoreline is not barren but covered with beautiful stands of birch, spruce, and pine trees. The trees have grown back now, but not so long ago the entire U.P. was denuded of forests—they had been chopped down, sawed into boards, and shipped south and west to provide the raw material for the building booms in the cities to the south and the treeless plains to the southwest. The U.P. always had a colonial economy in which iron and trees were stripped from the land to sustain other parts of the country. The large company owners lived elsewhere—Chicago, Detroit, Cleveland, and Pittsburgh. And the capital to finance mining and logging came from big cities. For this reason, and because of the inherent danger of underground mining and logging, U.P. residents always feel a bit victimized, suspicious of outsiders and of other places, especially cities, and are imbued with a deep sense that the fates, not the people, are in charge.

U.P. residents, "Yoopers" as they call themselves, either own or aspire to own camps. Although outsiders use the word *cottage* or *cabin* to describe their getaway places, *camp* is not quite the same. Camp is not just life as

usual in another place. Camp is a stripped-down version of place and a simplified version of life. Camp is in the woods, near water if possible. The water may be a river or an inland lake. (We say inland lake to distinguish small lakes from the majestic Lake Superior.) Camp is rustic but it is a kind of rustic that goes further into the primitive than most city slickers can tolerate. Camps can be frame or constructed of logs. Frequently they do not have indoor plumbing or electricity, although some have portable generators to run a few lights, and often only a woodstove or fireplace for heat. Outhouses, woodpiles, and frequently a wood-heated sauna surround camps. I think of *camp* as a verb as well as a noun, for people really work at being at camp. Life is reduced to basics, a trip back in time where much effort is expended on the essentials such as chopping wood, feeding the fire, preparing meals, heating the sauna for a bath, and beating off the swarming insects. Camp is a throwback and a counterpoint to modern life, and existence there is simplified and slow. Meals are more "make do" and standards of dress are relaxed. Often camps are intentionally so remote that frequent trips to town are impractical. These places function according to rules of order distinct from those of home and town. Camp is a retreat into nature, and there many of the technological conveniences of home are eschewed in favor of a less complex and less convenient life. But less is expected here. At camp no one minds wood smoke, smelly outhouses, mosquitoes, mice, and a sprinkling of pine needles in food. No one expects gourmet meals at camp. Fine food and fancy dress at camp are a serious infraction of woods etiquette. However, camp is only a summer place and summer in the U.P. is ninety days long in a good year, and half of those are rainy and chilly. Most of these retreats are absolutely inaccessible in the mounds of winter snow.

In retrospect, the Upper Peninsula exuded a powerful sense of place, a particular, peculiar, and robust identity that branded it as distinct from anywhere else. While all places are distinct, mine was overwhelmingly so. The climate, people, culture, terrain, and Lake Superior are thick layers of distinction like the layers of Cornish, Irish, Finnish, Swedish, and Italian accents that washed over the language of the place as each new immigrant group arrived until a novel and unmistakable accent emerged. When I am with fellow "Yoopers," I regress to those sounds in an instant. "Yoopertalk" they call it, and it might almost be a foreign tongue.

The themes of this book are the themes of Yoopers, of Ishpeming, and of almost all cities and towns in America. Ishpeming as a community is dis-

sipated, and its distinct culture is submerging into American monoculture. Many of the downtown buildings of my childhood still stand, but "downtown" doesn't exist anymore. Now downtown is just another street. Nobody shops there for necessities. The movie theaters are demolished or closed. Only a few people walk down Main or Division Streets. Now a version of downtown is fifteen miles of nondescript commercial development along US Highway 41. Most of the highway stores are on a much larger scale than the downtown stores of my youth, and people can only get to these new stores by automobile. If people are too old or too young or too disabled or too poor to drive a car, these stores are not accessible. The old neighborhoods close to the real downtown are no longer desirable places to live because proximity to downtown is meaningless in an automobile culture; besides, older houses in town are generally small, close to each other with spacious front porches that were transitional spaces between the private interior and the public street. Now most seek bigger houses, larger lots, and more privacy. Front porches are superfluous on new houses because the whole point of new developments is maximization of privacy—and there are so few pedestrian passersby anyway.

So the new downtown is a highway strip. Functionally it is very different than the obsolete downtown. The old downtown was a walking social space where everyone mingled. The new downtown is stripped of its social function. Shoppers park in front of stores, shop in the store of choice, and return to their cars. Encounters with familiar faces are less frequent. The new downtown is just commercial space, serving several surrounding communities besides Ishpeming. The schools, government buildings, doctors' and dentists' offices, libraries, churches, clubs, post offices, and cultural organizations are scattered in other places. This downtown neither reinforces nor builds community. The only values that endure are those that elevate and promote consumption. No one who lives there even calls the new places downtown.

Locally owned businesses were bankrupted by the new highway stores. People flock to Wal-Mart and Target to get the best deals and then take a break under the golden arches of McDonald's. The new "downtown" offers lots of selection and rock-bottom prices. But these businesses are not operated by the friends and neighbors that you see casually on the sidewalks or in the pew in front of you on Sunday. These stores are operated by some of the biggest corporations in the world, and they have no stake in

Ishpeming other than high-volume sales. People in Ishpeming have never met the owners of the stores where they spend most of their income. A few friends and neighbors may work in these stores, but with no influence and at a low wage. This is a radical change. These stores are not social places. They are big boxes with lots of goods designed to treat everyone who walks in the door, not as friend or neighbor, but as consumer. What an unflattering comparison with Theresa Andriacchi, a fixture in her family's storefront for ninety-eight years! Until she died recently, she kept her Ishpeming store open with little merchandise to sell, just because it was a place where neighbors visited with each other and with her. Andriacchi's Store and the Andriacchis themselves were intrinsic to the community. The huge new stores are not somebody's stores, not Theresa's, Mr. Jackson's, Jack Richard's, Kemp's, or Ombrello's. They are just stores.

We live in a nation that abhors Luddites—a twenty-first-century version of those seventeenth-century craftsmen and laborers who smashed the newly invented machinery that was threatening to make the workers obsolete—and in our culture change is synonymous with progress. It remains true, however, that not all change is good change and that we are not very sophisticated at discerning the difference. Sometimes change is just change. It is not necessarily progress and frequently it is even bad for us and for those not yet born.

The new downtown has other disturbing attributes. I can walk into any Wal-Mart store anywhere in this country and find the same stuff. Not just at Wal-Mart but in any of the dozens of fast-food, housewares, pet, clothing, or bookstore chains. In this time when we purport to value diversity as never before, we are becoming eerily alike. We watch the same television shows, wear the same clothes, read the same books, buy the same furniture, eat the same food, and talk about the same things. Increasingly we are just defined by our ability to consume instead of the distinctive qualities each of us brings to our world and our place upon it. The distinct qualities of place are obliterated in a consumer-driven mass market. It shows in Ishpeming and everywhere. Places and people are not as identifiable in appearance and habit as they once were. We may make individual fashion or decorating statements, but our choices are all drawn from the same common well.

What has happened to Ishpeming and to so many other places is far-reaching change that crept upon them as the product of a thousand seemingly innocuous small decisions, some local and some national. The

consequence is the destruction of the figurative town square upon which democracy and human happiness depend. And despite the optimistic predictions of some people, the virtual world of Internet chat rooms, e-mail, and instantaneous transmittal of information of all kinds will never adequately substitute for communities of place. We do have real, not virtual, bodies. We will have to put ourselves someplace, and that place will inherently matter more than other places. We can only care for our places in concert with the others with whom we share the space.

Actually the stakes are even higher. Our spreading out of towns and neighborhoods and our obsession with the automobile culture upon which these changes depend are sustained by higher rates of resource consumption, escalating environmental degradation, and a planetary mortgage that will be called in the future when we are moldering in our graves. We will be the planet's first intergenerational deadbeats.

We must find new ways to nurture the civic "we" instead of our current overemphasis on the individualistic and insular "me." Downtown Ishpeming was once the figurative town square. But it was not just the aggregation of stores and sidewalks in the downtown area. The entire arrangement of the town encouraged informal mingling. The sense of community was reinforced in churches, school, social clubs, at the Winter Sports Club where we skied, at the skating rink, and at the library. There was no escape from each other. But I look around my St. Louis, my home now for many years: downtown St. Louis has a decrepit civic plaza encompassing City Hall, a truncated and abandoned civic auditorium, a soldiers' memorial in disrepair. Our City Hall is stately if grimy, but in too many newer suburbs, city hall is just a suite of back offices in a strip mall. For the most part people live only the private parts of their lives in suburbs. They do not go to the same churches, stores, or schools, and there are few community spaces. The juxtaposition of the civic plaza with the strip mall city hall is tangible commentary on our devaluation of the civic enterprise, the idea that together we can aspire to something greater than we can individually and furthermore that we have needs in common that can only be met through collective action. In our new or changing communities where are the symbols that testify to the importance we attach to the civic enterprise? Where can we find the "we"?

The changes I have described have undermined both sense of place and commitment to the common good. Few people argue now that nothing has

been lost in the transformations of our communities. They worry about the loosening of ties that bind, the world their children will inherit, loss of spirituality, family disintegration, environmental degradation; they express deep concern over loss of identity and are very troubled about what is happening to their places. I have been involved in historical work for more than thirty years, and my own definitions of history and its uses have evolved over time. Today I believe that history is about culture very broadly defined. If we are to preserve any sense of identity and value for ourselves and for our places, we will have to look to the past, for it is in the past that we will find affirmation of individuality and difference. And it is there that we will also find the context within which to consider the choices we have made that have affected our places and ourselves. Those discoveries will inevitably facilitate thought and discussion about how we might do better. Most importantly, such examination will place us in the context of time, freeing us from our sense of isolation in the present, disconnected from both past and future. But we also need to learn to think of history differently.

We have used history as a barometer of progress, too often as a story of progressive change. If change does not lead us somewhere, if there is not some story of progress implicit in history, then why bother studying the past at all? So history itself is a part of the problem. Now I think that there is something else we can find in the past. We discover that it was inhabited by people more like us than different from us. If people in the past were unlike us, then the past is not knowable and does not matter. So I want to focus on the past as a place to discover what does not change and less on history as a story of progress. Only if we do this, can we discern what humans will need in the future and confidently make decisions that will affect the people who will live there, people we will never know. If the past was so unlike the present that it is irrelevant, then we must assume that the future is unknowable. If past and future are inscrutable, then we are marooned in the present and free to behave as if there is no tomorrow.

We who work in public history must discover the full potential power of the tools at our disposal. Let us acknowledge our ability to connect past, present, and future, thus actually creating the future; while we may never live in it, nevertheless it is a place that we will make. Let us suggest those enduring needs and aspirations of humanity for places that sustain, comfort, and become crucibles for memory, relationships, and happiness. Let us identify and strive to preserve those qualities that distinguish places and en-

courage people who live in them to be distinct and special. Let us oppose all those forces that homogenize places and make them matter less. Let us facilitate discussion of those qualities of place that encourage and sustain concern for civic well-being and the common good. Understanding that exclusive dialogue serves only special interests, let us commit ourselves to a process of inclusion and become facilitators of public conversation about burdens and legacies, where we resolve to overcome burdens and build upon legacies. The past is no panacea for the present or the future, but it is a place to discover what we have done well, what we have done poorly, and how we might do better. Perhaps public history can offer a source of identity for people and their places, a wellspring of community and an incubator of democracy, a consciousness of connection and responsibility to those who came before and those who will follow.

I have heard repeatedly from citizens that they see us and our organizations as appropriate convenors of public dialogue about these important things. Resistance to new and expanded roles for our work is not external; instead, as in many instances, resistance to change when it occurs is internal, embedded within the "best practices" of historians, anthropologists, museums, history organizations of all stripes. Best practices require the objectivity of the practitioner and the necessity of distance from the subject. But history has never been that kind of a science; rather, its focus is upon the memories and emotions of people. Making meaning of the past has always been a matter of perspective. Objectivity erects too high a barrier between professional and public. All professional best practices discount the authority of the amateur and seek to define and protect the exclusive authority of the expert. While some standards and best practices are vital, we must learn to recognize those that are perceived by the public as signals of control, exclusivity, and power.

Several years ago my sister Anne, who still lives in the Upper Peninsula, told me that the local historical society was exhibiting my grandmother's wedding dress. My grandmother was the family matriarch and held her eight children, their spouses, and the more than thirty cousins together in a tightly knit family. Everything changed when she died in 1966. The secure world I grew up in crumbled. Some of the change in my life was due to my own graduation from high school, but grandmother's death was a tangible marker of profound change. Every time I go to the U.P., I visit her grave next to my grandfather's and not far from that of my great-grandparents'. On

one trip north I visited the local historical society and looked for my grandmother's dress. It was no longer on exhibit. I spoke with someone at the museum and asked if it would be possible to see the dress. "No," she replied, "you need to call and make an appointment." "But," I explained, "I live in St. Louis and have to drive back tomorrow." The woman, although polite, made no further offers. I left disappointed.

I know that people get similar answers from museums everywhere. Sometimes we even view such requests as nuisances, interruptions of low priority. We museum professionals are likely to respond much more quickly and enthusiastically to what we call a "scholarly inquiry." Yet, implicit in the refusal to let me see my grandmother's dress was the presumption that the museum owned the dress. And further, I know that museums are offered far more wedding dresses than they need and that they can sell them or otherwise dispose of them if they so choose. People save wedding dresses because they symbolize very important events; hence they survive when everyday articles disappear. My reaction was emotional. How could that museum claim ownership of that wedding dress? To the museum it was just one more wedding dress. For me, it was laden with meaning. I conjured images of grandmother as a young woman, radiant and beautiful. And I know that if she had not put on that dress and married my grandfather, I would not be here now. The museum can own the dress but not my memory. Without the memory it is just an old dress. Can we find a better accommodation in which my need for the dress as a confirmation of my memory of my grandmother and the museum's need for the story that gives meaning to the dress are both equally acknowledged?

I know why museums have rules and practices that apply to collections, research, ethics, interpretation, governance, and virtually all areas of activity. Every time a new legal or ethical issue surfaces, we adopt a best practice and a new standard. And every time we make more rules, we become less accessible to the public we serve. Rules separate the professional from the public the profession serves. Every profession has gone through the same process. Surely doctors and lawyers have worked for decades to exert exclusive authority over the practice of medicine and law. Yet especially in medicine there is growing pressure to relax professional boundaries and to view the patient as a partner in health care decisions. The pressure for change in medicine has come from us as patients, insisting upon our right to make informed decisions about the welfare of our own bodies. And in re-

cent decades people have insisted upon their own rights to make sense and story of the past. People will construct their own story of the past no matter how we struggle to erect professional barriers around our exclusive right to interpret history. Like physical health, memory and identity are too important to people to be entrusted to the experts.

I received my doctorate in history from the University of New Mexico, an experience and an opportunity I value beyond measure. But doctoral training in history is only in part a process of learning more about the past. The other, indeed the major, part is an inculcation of standards, practices, procedure, and processes, which is to say "becoming professional." Getting a PhD is not easy. It is arduous and stressful work capped off by the granddaddy of all exams and a book-length research paper. Finally, I was a newly minted "professional" and proud of it. So proud, in fact, that when I went into the real world beyond the university womb I resented and resisted the fact that everyone seemed to have particular notions about the past and that there were popularly acknowledged historians in every community who had no professional training at all. My first reaction was to insist upon the exclusive right of those who had "taken the vows," as my major professor put it, to define historical significance and interpret the past. But slowly I accepted the reality that this was not a point I could make stick. Even more gradually I acknowledged that people must make some sense of the past, that they must weave usable stories around it as they make meaning of their own lives. The past, I finally realized, would never be the exclusive purview of professionals because it was too important, too vital to the very character of humanity. People with no memory, no story, no sense of the past for themselves are profoundly dysfunctional.

So now I conclude that the role of the public historian is not as authority, but rather as a facilitator of useful storymaking based on fact, acknowledging that vastly different meanings can be assigned depending upon the perspective of individuals. All communities and societies, especially democratic ones, must have some story elements in common. Without shared stories there is no basis for civic life and no basis for shared ambition and aspiration. We must see some things similarly or community building and democracy are imperiled.

Public history can become the basis for inclusive dialogue and shared stories. This is not the imposed "master narrative of old" that defined insiders and outsiders, but instead a process of storymaking that creates room

13

for the diverse and multiple perspectives that exist in consequence of our individuality. This is the most important thing that we can do together. From this may come a common agenda for the future, agreement upon the character of the good life, and the community and neighborhood arrangements that will nurture it. It is just possible that the past may become the context within which together we can create the new town square.

Seems a bit optimistic) but I'm intrigued

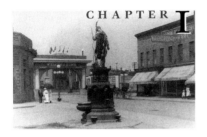

Creating a Place

T HE ST. JOHN'S CATHOLIC CHURCH OF FORTY YEARS AGO—
a rather plain brick edifice in Ishpeming—often occupies
my thoughts. It's part of my history, my heritage, a sense
of my place. And it was the rituals of St. John's—droplets of holy water, de-
licious incense aroma, paschal and votive candles, palm branches, and Latin
chants—that symbolized the closeness of angels and of heaven and offered
proof of the deity and eternity.

Childhood was a time of infinite magical possibility. This was my age of
faith, before the grown-up world obsessed with objectivity confronted my
mystical beliefs with that inexorable logic that confounds all mysteries. Yet
some words persist in my mind from that time, resonating more than forty
years later, expressing perhaps a truth that I have once more embraced. I
have taken the long way around, but I have come to understand what T. S.
Eliot meant in *Four Quartets*:

> *And the end of all our exploring*
> *Will be to arrive where we started*
> *And to know the place for the first time.*[1]

Every mass at St. John's—and at every other Roman Catholic church be-
fore the 1960s—concluded with the reading of "The Last Gospel," the

opening paragraphs from the Gospel of St. John. "In the beginning was the Word, and the Word was with God; and the word was God. . . . And the Word was made flesh and dwelt among us." These lines with their poetic mysticism and perplexing analogy gave me goose bumps. How could the gospel writer have used "word" to define the deity? I began my pondering on this before I was ten. Now I know more, but still I do not pretend to understand.

What I do know is that we humans use words to define ourselves and our places. The planet is layered with names applied by successive generations of humanity: Ishpeming and Lake Angeline; Albuquerque and Truchas; St. Louis, the Jefferson Memorial Building in a manicured green space we named Forest Park, streets we call Lindell Boulevard and Grand Avenue and Prather, where the house I call home is. My children were baptized Robyn and Adam. The first order of business as we brought our new cat in was to name her. We name everything. When we name something, we can think about it and we can talk to each other about it. Truly, when we name our babies, or when we name our places, or when we learn the names for new places or unfamiliar objects, they come into existence for us. They are created in our minds. Think of this: we really do create reality in our minds with words. We all wonder how we could think without words or how we could communicate with each other or between generations without words. While it appears that thought at some level is possible without language, what we define as human thought is both a cause and a consequence of words. For the ancients, words were the creative act. For St. John, God was the "word," the creative force.

St. John was not alone in his fascination with the word. The origins and transformative power of words attract the attentions of writers, linguists, neurobiologists, psychologists, and anthropologists. But I like the explorations of poets best. In a poem titled "The Makers," Howard Nemerov wrote this of poets:

They were the ones that in whatever tongue
Worded the world, that were the first to say
Star, water, stone, that said the visible
And made it bring invisibles to view
In wind and time and change, and in the mind
Itself that minded the hitherto idiot world
And spoke the speechless world and sang the towers
Of the City into the astonished sky.[2]

Buried deeply in the evolution of our brains and senses is the need to make sense of the world. The need to explain the world with words, with stories, is a reflection not of the existence of narratives in the world around us but rather of how our minds go about making sense of the world. Chronology—the arrangement of events in time, the idea of sequences that can be put in order according to place in time—is at the very core of narrative, stories that have beginnings, middles, and ends. We begin these narratives in infancy, gradually weaving stories around events and assigning meaning to them and remembering and re-remembering those to which we attach significance in our lives. Memory depends on story, and our identities depend upon memory attached firmly to chronology—not a fixing of precise dates, but rather sequences of events. Our narratives identify both who we are and our place in the world, explaining our own lives, forming relationships and attachments to objects, buildings, places, landscapes. We change, our narratives change. They are not fixed but fluid, works in progress as distinct as every individual, an evolving compilation of self, a diary that we open each day and then examine, rethink, rewrite, and change as we confront new experience and find new meanings.

From where I sit in my study at home in St. Louis, I can look up at the small clay figurine given to me by Hartman Lomawaima, a friend who is a traditional Hopi. It is the storyteller figure, ubiquitous in southwestern shops in Santa Fe, Tucson, and Albuquerque. A seated female figure in generic American Indian dress has a child on each knee; in some versions a dozen children are swarming over her. Her mouth is open wide. She is telling stories, but not just fairy tales or amusing yarns. She is telling Hopi stories. Her stories do not come from books but rather from the mouths of one generation into the ears and hearts of the next. Her mother told the stories, and her children will do the same. Her stories are about Hopi places, about people and their land, about kinship, about values, about how to behave, about the spirit world, about the natural world. She is transmitting culture; she is wording the world. Her stories and her actions in telling them are timeless. What she tells is history, not of an academic sort that meets our criteria of objectivity, for little of what she says can be verified in the usual sense. Rather, what she tells is a universal truth that imparts unchanging lessons with a legitimacy sanctioned by tradition. Some might call her storytelling myth, not history, but labels are inappropriate, even impossible here. In traditional societies, origin stories and stories that inculcate values are far too important to be left to historians or anthropologists or other experts. The

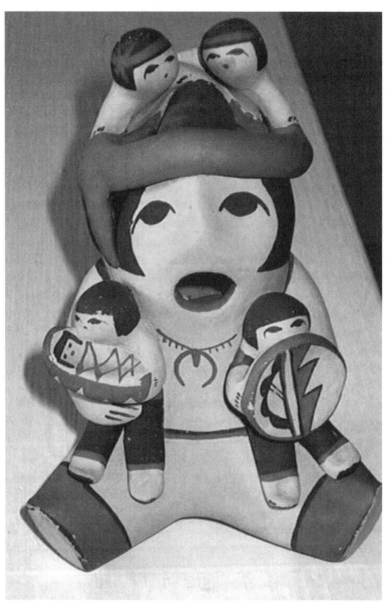

The storyteller figure from the author's collection. Photograph by Sue Archibald, 2003.

storyteller-mother fulfills an obligation that has always existed and always will. In Hartman's culture you cannot be a Hopi if you do not know and live the stories. Every mother, every Hopi, is a historian.

I went to Montana as the director of the Western Heritage Center in Billings in 1977 with my recently minted PhD and two years' experience as a curator at the Albuquerque Museum. I was not yet thirty years old, full of the hubris and self-importance characteristic of many people at that age. The Center was closed to the public when I arrived, but Franklin Longan, a local attorney and Center board member, had agreed to loan his fur trade collection as the basis for a renovated and reopened museum. Longan evidently found the new director agreeable, for he often invited me to dinner, where his friend J. K. Ralston, a hardy old man who had known Billings for many decades, regaled me with stories of open range days, stories I could never have found in the more traditional sources in the history profession. I realized when confronted with Ralston's stories that my PhD didn't cut it. Ralston's history had a legitimacy and authority that my book learning did not. Ralston taught me that no graduate course or dissertation can usurp people's history. History is not an academic tome, or a movie documentary, and history is certainly not a museum nor a rosy, romantic look in a rearview mirror. History is ultimately, I realized, the stories that give meanings to people's lives, those heartfelt stories woven around individual lives and places that establish mile markers, guideposts, and road maps. Ralston's stories drew for me some of those maps of Montana.

In 1975 when I began my first job at the Albuquerque Museum, I began to listen to the people who lived in that place to supplement books from the university's Zimmerman Library. I was infatuated with their stories, especially those of the people whose families and countrymen had arrived in this place before the English had sailed into what became Jamestown. I was amazed by the idea of people living in this isolated place, clinging tenuously but tenaciously, with what little water dribbled down the Río Grande, to the thin strip of green farms and ancient cottonwoods that followed the river's meander south. The rest was arid land, connected then by a scarcely discernible thousand-mile "Camino Real," or royal road, into Mexico, then through the treacherous Gulf of Mexico and from there thousands of miles by a perilous sea route to Spain and the harbor at Sevilla. I calculated how many years it would take to receive a letter or a length of cloth from Spain. The scope of this place was tremendous.

On Good Friday in 1976 I accepted an invitation to attend a Penitente Tenieblas ceremony in Truchas, a small town in the Sangre de Cristo Mountains on the high road to Taos, north of Santa Fe. This little village is famous for its restaurant The Rancho de Chimayo, but I know it for the small church with an anteroom that contains a small well of healing earth. The walls are covered with crutches, braces, and other devices that assist the disabled—Lourdes in the New Mexico mountains. But this was Good Friday, not just any day, and straddling the road up the hill a whole line of pilgrims, some on their knees, struggled toward the Sanctuario de Chimayo. I had never seen people behaving as if a place was truly sacred. I have seen it since, but never before. What kind of faith, what belief in the healing power of this place and the clay of the Sanctuario motivated them? What makes a place sacred? I concluded that we do; we make a place sacred by what we believe and how we act and the stories we weave around and into it. But I also thought of Lincoln's words at the dedication of the burial ground at the Gettysburg Battlefield. "But in a larger sense," he said, "We cannot dedicate/We cannot consecrate/We cannot hallow this ground." That place was sacred ground by virtue of the blood shed and freedom's victory won at extraordinary price—by what had happened to people there.

Places become sacred to humans when the humans imbue the places with stories—stories that attach the grand cycles of life, the continuity of time through sequences of generations, and life's transforming events to particular places on this earth. I know how deeply my own being and identity is planted in Michigan's Upper Peninsula, and I can sense how very deeply the roots of my friend Veryl Riddle are plunged into the soil, the stories, and the people of Riddle Hill, a place in southeast Missouri, what we call the Bootheel of our state. Veryl gave me a copy of *The House on Riddle Hill*, a memoir by fellow native Glenn Tompkins. This book is eloquent testimony to the ways each of us constructs stories that explain who we are and evidence of the importance of memory to our species. Neither a recorder nor a computer, memory is a dynamic process of using the past to define and redefine who we are, what we believe, what we like and dislike, and the values we hold dear. Glenn Tompkins's book is also a love song to his place and its people.

He describes the scene when Mrs. Mays died in the middle of winter. The ground was frozen and the weather was bitter:

Mom, Dad and Randy and Lorine went to help as soon as they received the word that she had passed on. Dad made the pine box and coffin. Mom and some other ladies took cotton and a silk-like material and lined the coffin and helped dress her. . . .

A lot of people were at the wake that night, even though it was very cold. The funeral was held the next day at their house and Lorine sang the hymns. Few people went to the cemetery because of the cold weather. . . . [Randy] stayed to help close the grave. . . . back in those days neighbors were closer to each other. I don't know if it was because they were poor, they knew each other better, or they just stuck together more when a crisis happened. They all pitched in and did whatever had to be done. . . . Now you are lucky to get to know your neighbors, sometimes you don't get to see and talk to them for weeks.[3]

While I share Tompkins's view of what we have lost, I have learned to be very cautious about idealizing the past. I also know that as we age and as more of our lives are transformed into memory, there is a natural tendency to glaze those memories with the romantic tints of nostalgia. *The House on Riddle Hill* is admittedly a love story, but Tompkins's book manifests that sense of place that haunts us all.

A minister and his wife now live on the home place. . . . he told me that any time I was in the area to feel free to stop by. When my wife and I walked into the house I experienced strange feelings. . . .

I walked across the yard to the peach shed and the tile garage where dad kept his Model T Ford. . . . My mind wandered back to yesterday. I used to play there with my sisters. One day I got brave and climbed the ladder to the loft of the shed and there found an old oxen yoke. Dad said it was in the shed when we moved to Riddle Hill and probably at one time or another it was used there on the farm. He told me how many years ago people plowed their land with oxen, but I couldn't imagine anyone plowing the old hill farm with oxen. . . .

As I wandered through I saw things like my initials in the corner of the cement on the sidewalk and a few sayings I had painted on the garage walls. There was the shelf in the shed where Dad used to figure the price for a truck or trailer load of peaches. Oh, the memories.[4]

CHAPTER I

I once lived in a one-hundred-year-old house in St. Louis's Central West End. Thomas McKittrick built that house in 1897 on Berlin Street. (The street name was changed to Pershing in the anti-German hysteria that gripped St. Louis during World War II.) As a boy Thomas Wolfe stayed near Berlin Street during the 1904 World's Fair and listened to the screech of the streetcars on Kingshighway and could smell the odors left by urban horses, whereas I used to hear airplanes and smell auto exhaust on smoggy days.

Thomas McKittrick was president of a very successful dry goods firm and one of the promoters of the construction of the Railway Exchange Building that still exists in downtown St. Louis. He served on the Board of Directors of the Louisiana Purchase Exposition (the 1904 World's Fair) and on bank boards. I know the guest list for his wedding, the clubs he belonged to, his grave in Bellefontaine Cemetery. But the point is that Thomas McKittrick has become part of my story and, although he cannot know it, I became part of his. I no longer live in the house that Thomas McKittrick built but I am still there.

Although I was raised in an old house, as a child I didn't comprehend the notion of a house outliving me. Now I think of myself as having been a temporary trustee of Thomas McKittrick's house, rather than its owner, a curator in effect of the memories that house embodied. While I was refinishing the floor of the sunporch or sweeping up the alley, I was caring for a gift, a message of value, a reminder of continuity from those who lived before my lifetime to those who will come after me to that address, that memory place on Pershing.

Cemeteries too are memory places. I find nothing morbid or forlorn or spectral in the burial grounds of our forebears, nor do I focus on the memento mori that our Victorian ancestors emphasized. Rather, I see cemeteries as storied places, places of remembrance, continuity, and affirmation that we are not the first to inhabit this place and will not be the last.

My attraction to cemeteries began in childhood. There is a cemetery not far from the small iron mining town of Negaunee on the U.P. In it is a family burial plot containing the graves of my father's people, the Quinns, the Archibalds, now even Archibalds of several generations. I went to the cemetery often, first with my grandmother and then after her death with my Aunt Barbara. I viewed these trips with delighted anticipation, not morbid fascination or fear. What occurred between the marble stones was a running dialogue, full of marvelous anecdotes, like Glenn Tompkins's book, about

the people whose bodies were interred there. It was in that place that I learned who my people were and learned about myself. Here I first discovered the ties that extended from me back in time, and here I could imagine that they would also extend beyond my own lifetime into a future inhabited by others. I also learned that from these people I inherited obligations. I realized that I was not alone in the present but that I was connected to the past and to the future.

I barely remember my great-grandfather Michael Quinn, but I do remember snatches of the conversations in the early 1950s about his driver's license. Family members feared that, in his nineties, Michael Quinn was too old to drive. Michael insisted on driving just so that he could continue his weekly visits to the graves of the three wives that he outlived. I think I now understand his insistence. I think Michael was not mourning his losses nor grieving over the dead, but rather he was strengthening the links he had forged and continuing the story he had inherited.

I found the Old Lorimier Cemetery on the hill overlooking the Mississippi River at Cape Girardeau, about one hundred miles south of St. Louis. I have walked many old graveyards, but none more carefully tended than this. The paths between the headstones are neatly trimmed, and disintegrating gravestones have been replaced with new ones but with the old inscriptions. What kind of town and what sort of people care so deeply about their legacy and their stories that they tend an ancient graveyard so carefully? At least in this instance, the people of Cape Girardeau have preserved their sense of the past, a storied place of their past. I found a contradiction between this sacred place and the unstoried no-place of a strip mall/office complex along the interstate. Is there a message in this, a possible course correction required? I tried to look at every grave in the cemetery—Irish, Germans, a few French, and others. Many came here from southern states, many from Virginia. I saw Louis and Charlotte Lorimier's plot. Much affectionate attention had been lavished upon these early settlers' graves. The inscription was old and weathered but legible:

To the memory of Charlotte P. B. Lorimier,
consort of Maj. L. Lorimier, who
departed this life on the 23d day of March, 1808,
aged fifty years and two
months, leaving four sons and two daughters.

She lived the noblest matron of the Shawanoe race,
And native dignity covered her as does this slab.
She chose nature as her guide to virtue,
And with nature as her leader spontaneously
followed good,
As the olive, the pride of the grove,
without the planter's care,
Yearly brings its fruit to perfection.

This is a trail, a story of this place that leads to France, to Canada, to the Revolutionary War when Louis Lorimier picked the losing side and paid an enormous price. This trail leads to Spain, whose government this remarkable man represented in this outpost of Cape Girardeau. His relationship with Charlotte, a Shawnee Indian, reaches deeply into the past of the first humans to inhabit these new continents. It also speaks most eloquently and deeply of Louis Lorimier's respect for native peoples, his appreciation that there is more than one "right" way, more than one way to explain the world around us.

I have left Indian friends behind in New Mexico and in Montana, places where I once lived. I now have new Indian friends from many different tribes in the St. Louis region. Charlotte's epitaph, which I presume Louis Lorimier either wrote or approved, made me think of them. The vision-quest sites, the mountains, the kivas, the animals, and the very landscape are sacred places, places that give birth, that renew life, that connect us one to the other. How would we build communities, and how would we treat our legacies if indeed we believed that they were as sacred as this ancient cemetery that holds the remains of the people who first storied this place and called it Cape Girardeau? I think that we would have healthier, happier communities and people who evidenced more concern for each other and for their places. Something has happened to change us, and I think that it is, in part at least, what we have done to our places.

But there is something else in the Old Lorimier Cemetery. It is a caution from the past not to idealize that world, a message to be careful before waxing nostalgic about the "good old days." There are many children and young people buried on that hill. One epitaph indicated that a woman of seventeen years of age was buried there and so were her infant children. When the five infant children died, Xs were added to the count on the grave-marker. Can you imagine the tragedy, the despair, and the heartrending agony of this family? And this was not an isolated instance; death was ever

present, in the ships that came up the river transporting strangers to the levee, in the swampy, humid waters of summer, in the often contaminated water, and in the mere shaking of hands. This kind of fear we have mostly, and gratefully, left behind.

There is still another lesson here for me. While it is easy to romanticize the past, it is equally tempting to look back upon those times with smug superiority. I am not willing to be arrogant enough to believe that I am smarter, with a larger and better brain, a being refined and updated from those who rest at my feet. I must discard such notions along with the propensity to desire the "good old days." I differ from these people only because of the intervening history and accumulation of technology. It is time to ask the dirty, difficult question—Just what is progress?

Let us leave them in their graves—Confederate, Yankee, slave, German, Irish, Indian, French, husbands, wives, babies, tragedies, and triumphs. But we must remember, for if we forget we have lost not them, but ourselves. Go to this place often, this storied place and others, for our own stories are there.

In 1998, when I went to Ishpeming to work on a book on history and memory, I found Theresa Andriacchi still opening the doors to her family's general store. I knew this store intimately in my childhood. It had changed little in appearance, but the bustling activity had almost disappeared, and the place was a dusty time capsule. Theresa lived in a storied place: firmly set in what had been an Italian immigrant neighborhood, buttressed by her community's profound Catholic faith, and supported by her native language, her family, and neighbors. As I sat with Theresa in her window on what had been the busiest street in town, I mused on this storied place. Later I wrote,

> This store, built by her father, is at once a means to a living and a familial obligation. Through this store Theresa entered into those bonds that united her with family, neighbors, and community in a dense thicket of intricate relationships encompassing the store, the church, and the neighborhood, and the entire community of Ishpeming. The store was more than a marketplace; it was also a place where relationships were initiated, reinforced, and buttressed by life on Division Street, the values of church, the parish school, and a shared ethnicity.[5]

In his book on Riddle Hill, Glenn Tompkins describes one of those places, like Theresa's store and the Old Lorimier Cemetery, teeming with the dynamic interaction of memory, past, present, and future. These are places where we confront ourselves, where we contemplate who we once were, who we are now, and what we might become. These delicious but bewildering and usually bittersweet feelings are always attached to places, to people, and to stories. To experience these things is to be human. Yet I fear that in our overly rational age, when the unexplainable is dismissed as insignificant, we are in danger of losing ourselves and the places we hold dear and even sacred; and in losing our places, our roots, we will lose ourselves. Will anyone care about the strip development on the fringes of the interstate, the way people of Cape Girardeau care about the old cemetery or Mr. Tompkins cares about his house on Riddle Hill? What will become of us when we live, work, and play in unstoried places, places that do not matter? Trying to attach stories, memories, and ourselves to places that are temporary, places that have no opportunity for sacredness or even appreciation, is a forlorn and pathetic pursuit.

Peder Gustav Tjernagel, a Norwegian immigrant to central Iowa, wrote a wonderful memoir called *The Follinglo Dog Book*. His grandson Peter Harstad wrote the prologue:

> I never met Grandfather because he died three years before I was born. But I am named after him and have been curious about him as long as I can remember. I have walked the fields he tilled, milked cows from bloodlines that he developed, visited buildings and rooms that he built, handled items that he made out of wood, viewed pictures of him, read his writings, and spent time with his next of kin. Even as a child I asked relatives to share Tjernagel lore.[6]

I was especially struck by this passage in the prologue: "*Follinglo Dog Book* is not exempt from the usual limitations of reminiscent accounts. In places, grandfather employed literary license, including exaggeration, in the telling of his tales. These instances are readily apparent to discerning readers." This is the crux of the conflict between our definition of history and tradition. The purpose of tradition, whether that of Hartman Lomawaima, Theresa Andriacchi, or of Peder Tjernagel, is not the elucidation of historical fact but instead the revelation of larger truth, truth about values like hard work,

honesty, pride, and conservation of the earth. When we reduce history to recitation of fact, we lose sight of truth. Facts and explanations of the past are not necessarily useful truth. When history is pursued in this way, it becomes a story of change and progress, however we define it, but not the revelation of enduring truths about human life on this planet. That kind of history cannot reveal guideposts for our behavior; its story of change and progress is merely a celebration of ourselves. While we may insist upon scholarly objectivity and standards of accuracy, we also demonstrate our faith in the fallacy that ultimately the past is self-explanatory—that if we dig into the facts long enough, hard enough, and deep enough we will discover unassailable truth. This belief leads us to suspect other kinds of truth. This is why Peter Harstad accuses his grandfather of exaggeration and so casts suspicion upon the reliability of his grandfather's narrative.

But if we think about it, history is narrative construction, storytelling. We really do not know a lot about the past. The evidence that has survived is only accidental and, compared to the thoughts and actions of every human who ever lived, it is just a few shreds. To appeal to these scant vestiges and insist that we can find out what really happened is folly. Maybe the best we can find is a story that makes sense to us in the present.

Although it may appear contradictory, it is possible to remember the future as well as the past. Hartman Lomawaima and Theresa Andriacchi can remember the future. They know that the most important things don't change, so they can define the future by remembering the past and examining the present. For them the scholarly definition of history as change through time is nonsense. Nothing important changes. Both past and future are contained in the present. The past was like the present and the future will be as well.

We cannot always find the past. On a business trip to Indiana, I knew I was in the town of Fishers, for the map and even the signs said so. I stayed at the Frederick-Talbott Inn, a bed-and-breakfast, in what I presumed to be an old farmstead now surrounded by booming suburban development, exploding out from Indianapolis. I looked for Fishers's downtown. The best I could do was a series of nearly contiguous strip malls, one anchored by a chain supermarket called Marsh's. I went into Marsh's, looking for something that would identify this place. I did find "Amish Country Chicken," but it was concocted by marketeers to create a hometown identity and is probably available at Schnuck's supermarket in St. Louis. Not bad, though, compared to the nearby signs for Hardee's, Domino's, Sears, and dozens of others.

All the development in Fishers focuses on Allisonville Road. I noticed that the new subdivisions are considerably set back from the road, a farsightedness that will permit the eventual widening of the road to accommodate the escalating automobile traffic. This is what passes for community planning: build it and the automobiles and the highways will come, no matter the destruction of land, the resource consumption, the environmental degradation.

Sometimes I worry that I resist the notion of these new towns because I grew up in a small town in the 1950s and this town persists as my benchmark. But a discernible downtown is an important element in a town's identity. In Fishers I could not find identifiable public buildings—city hall, town square, library, courthouse, post office. I knew that they were around somewhere, but they, like so many others, must have been inconspicuous, perhaps even camouflaged in a strip mall down the road.

What does this say about the importance that we accord to the public or civic spheres of our lives? What does it say about the regard in which we hold our obligations to each other and to our community and our environment? This is a form of impoverishment in which our sense of "us" is severely diminished. These are places with impoverished narratives and only a shrunken symbolism around which to shape new stories.

I searched my room looking for background on the Frederick-Talbott Inn. There wasn't any. I also explored around the grounds for any remnants of original buildings. Besides the brick exterior on the front side, facing Allisonville Road, nothing remains. The interior had been worked into rooms that meet all current building codes. I really do appreciate the convenience, the comfort. The whole inn is lovingly decorated with antiques, lace curtains, old negligees hanging as though ready to put on, doors rescued from building graveyards and restored and reinstalled to create a quaintness about the place.

Yet there I was in the midst of subdivision construction, Stevenson's Mill with homes beginning in the $155,000 range. I knew what these places were like; I used to live in one very much like Stevenson's Mill. Certainly they offer a fine standard of living free of the complexities, conflicts, and worries of actual urban living. Should we wonder, given our agrarian past, that Americans of all kinds, given the option, choose these places that offer a version of a rural dream? But they offer none of the real features of rural life and none of the community life of a real city. I sense that this place like so many others is completely segregated by class. How else is one to interpret

the zoning that protects these residential developments or the sign that says "homes from the $155s"? I inferred that Fishers is just a geographic place name, no longer the name of a community.

I wonder what will become of Frederick-Talbott Inn. It seems an intrusion into a space meant for other things, a relic, a blemish, a snag in an otherwise uniform and placid development of high-priced, segregated-by-zoning, suburban residential housing.

As I checked out of the inn, I tried again to find out about the origins of the place. To my chagrin I heard that what I took to be the oldest part of the inn is a transplant, a peripatetic brick structure that had no more roots in this place than the expensive home that I could see under construction from my second-floor window at the inn. In fact, I was told, my bedroom was located in an addition that was built on after the move to this site. My section of Frederick-Talbott Inn was a great hoax, less honest than the subdivision next door. Frederick-Talbott Inn is a chimera, a place that is not what it seems, an attempt to capitalize on the yearning for places that are real places, places with stories, places with a past, places that are not transient but rooted, echoing continuity and making us feel less alone and more connected to each other, to the past, and to the future. Perhaps we all know exactly what it is that we want and need but we simply are bewildered about where to find it. What a forlorn quest it was at Frederick-Talbott Inn. But it does appeal to a deep-seated American concern that something critically important is dying and that perhaps a sense of it can be recaptured, reexperienced, and rescued at places like Frederick-Talbott Inn, rediscovered among the antique-y furniture, the hats from the used clothing store, the piles of variegated bed pillows, enormous breakfasts, and personal attention. It is fascinating—pampering in the form of a fantasy trip to a fictional past—a carefully constructed artificial narrative, a miniature theme park, a poor substitute for the real thing, in spite of its comfortable accommodations and the delicious breakfast I enjoyed on my way to a meeting in Indiana.

Fifty miles north of Fishers, I encountered Nead School, a slick brick construction next to the highway—a nondescript building, not really much different from a strip mall or a factory or any other utilitarian structure.

What distinguished this place was an arched doorway that stood in the grass between the school and the highway. The doorway, made of rough brown brick, was a peaked arch with a window above it. The double doors themselves are gone, as are the side windows, leaving gaping cavities. Over

these cavities, on cream colored tile, are words in chiseled lettering: NEAD SCHOOL. Here in the fields by the highway I visualized generations of students passing in and out of this doorway when it was attached to a school building. I wondered if at reunions alumni walk through this arch "just for old times' sake." Perhaps the disembodied doorway is also meant to contrast with the new school as a symbol of conquest, a paean to progress, a song of celebration of the future, a reminder of the primitive, the good old days and the bad old days all at once, coming together in the length of field that separates the remembrance of the past from the symbol of the future.

I could hardly pick out the entrance to the new school—much less its nameplate if there is one—in the low line of brick and glass windows. There was no statement in the exterior about the significance to the community of this school building, of the hopes and dreams of parents, children, friends, and neighbors. The only door that stands up and says that this is an important place is the old one that no longer belongs to a building.

I am puzzled by our attitudes toward the past. It is a weird form of loving destruction, tinged with the romance and nostalgia that leads us to create reminders of what it is that we have destroyed. Sometimes I think that we are very confused about what is real and what matters. In our overly rational, scientific, and technological age we confuse progress with accumulation of wealth and technology, and we ignore what we cannot measure: the value of community, love, affection, neighborliness, stories and storied places, honor, commitment, steadfastness. But we all know that we need to do some things differently. We are concerned about what is happening to our towns and to our neighborhoods. We worry about crime. Our schools often don't work as well as we think they ought to. We feel that we are losing control over our lives in the midst of mergers, free trade agreements, multinational corporations; and we have become so cynical about democracy that many of us do not vote. Some say we need to find new national myths, new stories in order to heal ourselves. I say that we don't need to invent new stories and new myths. I say that they are right here around us if we will but listen and look.

On Saturdays my wife Sue and I often go to Soulard Market, an open-air market bequeathed to us from 1838 when landowner Julia Cerre Soulard donated a piece of property to the City of St. Louis. The land, she stipulated, was to be used in perpetuity as a public market. Hence we have this marvelous anachronism, a place that, at least in basic form and func-

tion, hurls us into a past where going to market meant more than purchasing edibles at a mammoth food store. The city had numerous other public markets through the years since its founding as a fur trading post. Pierre Laclede in his original 1764 village plan set aside a prominent block for a market, and both the city and private concerns established other public markets throughout the 1800s. The original Soulard structures were erected beginning in the 1840s; they were replaced more than eighty years later with a two-story central building, designed in the mode of Renaissance architect Brunelleschi's fifteenth-century Florentine foundling hospital, with four open-air wings to accommodate outdoor stalls. Under the roofs hundreds of vendors back their trucks up to their stalls and unload a marvelous array of produce, flowers, fish, meat, even live squawking chickens and ducks. These are the buildings Sue and I prowl, with our baskets and canvas totes brought from home to fill at bargain prices.

Here in St. Louis only Soulard remains of those public markets that were places of exchange for buyers and sellers but also places for strangers

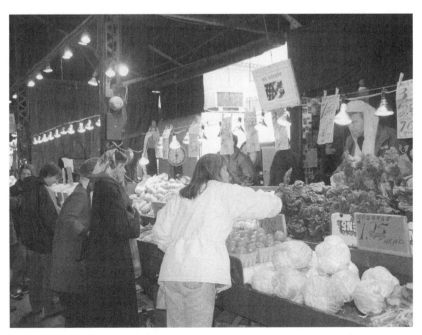

Soulard Market—an unvarnished experience in reality, eclectic, out-of-doors, teeming with fellow citizens. Photograph by Sue Archibald, 2003.

31

to become associates, neighbors, and even friends. Friendly conversations that establish relationships will still get you a deal with most vendors. (And by late afternoon every vendor has a deal to proclaim through a cacophony of competing voices. We bought a dozen roses for five dollars.) But I do not think that people really come here just for deals. The supermarket is closer and faster, and Soulard Market is disorganized and unsanitary by comparison. It is, I think, the layers and layers of complex intergenerational stories and variously intertwined relationships that bring people here. Longtime St. Louisans will tell you stories of their reluctant forays to the market with Mama, Grandma, and an assortment of aunts and neighbors much too early on a Saturday morning in their childhood. An old woman still talks about a little dog she found and brought home with the vegetables and oranges, and "boys" of every age stroll up to the second floor to see if the gym's hardwood floor still has that dead spot on the south end under the basketball net (it does). Soulard Market is a catalyst for stories, for communication between generations, and between strangers, who find common ground in this place.

The twenty-first-century crowd at Soulard Market is, as it has always been, a microcosm of our city: black, white, immigrants—Asian, Russian, Bosnian, Hispanic—young, old, healthy, and infirm. We can actually see each other at close range, sometimes closer than would be acceptable in more formal places like the modern supermarket. People really come here for an unvarnished experience in reality, eclectic, out-of-doors, teeming with fellow citizens, with real odors and authentic human sounds. No electronic voice tells us to step back because a fine water spray is about to refresh the produce. There are no scanners, not even a cash register in sight. Psychologists have not advised on the design to aid impulse buying and advertising. This is a real place where people have to talk to do business. It is a community building block because it is authentic, unstructured, and unmediated by technology. People have to mingle here. People have to see those they share their city with here. People will learn each other's stories and begin to understand. Familiarity does not breed contempt; it breeds tolerance and acceptance. It inspires a natural cultural exchange and incubates those informal relationships upon which democracy and community both depend. Soulard Market is a message from the past of how relationships are built, of how stories are shared, of how communities are sustained. It is a perfect place to remember the future and to think about how we want it to

be. Open-air markets are not our only option for building community, but we will have to discover equivalents where community can find sustenance.

There are whispers of hope to be heard now from Soulard Market: that some things are not commodities. And there are other murmurs spreading out from scores of other places: some things must be sacred, irreplaceable; not everything is relative. Perhaps a new story will emerge, one that nurtures and sustains, one that says "slow down," remember the past and pay attention to its accumulated wisdom, a narrative that will urge us to leave this a better place, a place with an abundance of stories that future generations will tell, retell, and augment.

We cannot resolve the concerns of our time or overcome the isolation of our age without coherent narratives. Without these narratives we will not likely conquer our tendency to emphasize individual rights instead of mutual obligations, or change our cavalier treatment of environment and resources, or mend our class and racial divisions. We need to construct new and modified narratives, stories that bind us to one another and to the places we inhabit. Narratives that heal divisions and value community will encourage us to construct neighborhoods that invite us to mingle and preserve places that inculcate a sense of continuity with the past. Narratives that confer particular identities on us and our places will stimulate the development of civic spaces and those "third places," those places beyond home and work, so essential to fostering community. Such narratives are crucial not only for our own happiness but for the survival of democracy and perhaps of the planet. Heedless neglect of the past will contribute to a disregard for the future and thus further imperil our communities present and to come. We have a sacred obligation to those generations not yet born, an obligation to bequeath to them healthy and sustainable communities and a planet capable of supporting life of an acceptable quality.

Our vital task is to preserve the connections that remain and to work to rebuild those that are broken or lost. In the process we will conserve, construct, or recreate stories that create a sense of belonging and attachment to a place on this earth, stories that vibrate with a reverence for life and a recognition of the limits imposed by our finite planet, stories that link the living, the dead, and those yet to be born.

As the buildings collapse and the people leave, many a storied city has become a forgetting place, a city in which stories are unmade and where we are diminished by the loss of narratives about who we are and who we used

to be. Brick by brick and block by block we forget, and while change is necessary and expected and even welcome, here we have no replacement for what we discard. The suburbs and the exurbs offer no replacement in those unstoried places where neighbors do not have time or congenial space to develop ties to each other, where there are few civic spaces and no street life, where no one can walk anywhere, where houses have back decks instead of front porches, where people move up and out.

In the late nineteenth century, St. Louisans taxed themselves to construct a grand City Hall, now besmirched with age and less grand than it once was. Yet the hopes and aspirations of its builders are still evident in its massive rotunda, the grand staircase, elegant marble, impressive legislative chambers, and the stately Office of the Mayor. It is an undeniable statement of the importance of the public's business and of civic optimism despite the foibles of its citizens, a symbol of the idea that we have an obligation to the common good and that together we are capable of great things, an emblem of the significance once attached to community. Memorial plaques on its walls commemorate war veterans, civic events, and mayors of the city and impart a sense that this city is a work in progress and that, while optimism for the future is apparent in the building's grand lines and public spaces, the past was appropriately remembered in the recognition of those who had contributed to the undertaking.

Look at this City Hall, and know that we are not the first people to have lived here. Stand on the surrounding streets and know that beneath are tunnels where trains once ran, wires, gigantic sewers, gas lines, and water mains. See the trolley tracks perforating the layers of asphalt, reasserting themselves through the cobblestone laid a century ago. Know that this place, where you perhaps grudgingly pay your taxes and pressure your alderman, has a story that belongs to us here now, brought to us from the people who made this place in the past, to take into the future for those who will stand here some other time.

We can find places that were built for permanence. We can mend, rather than desert, places that were important in the time before we came. They are statements of the aspirations of those now gone, messages from the past about what is important. These storied places are legacies from the past, a gift that is ours to use but not to destroy, an inheritance we are obliged to augment. For those places already lost, we can recall the stories that permeated them and seek new places, in which to remember and restore them.

City Hall, St. Louis in the 1930s. Missouri Historical Society, St. Louis.

The past and its stories are a priority. They remind us of the continuity of time and provide an antidote to the isolation of the present. These are stories not to be forgotten but to be preserved and sustained and most importantly to be shared. Together we can make stories that matter and endure. Together we can build a new town square.

Notes

1. T. S. Eliot, *Four Quartets* (New York: Harcourt Brace, 1943), p. 39.
2. Howard Nemerov, *Sentences* (Chicago: University of Chicago Press, 1980), p. 65.
3. Glenn Tompkins, *The House on Riddle Hill* (Cape Girardeau, Mo.: Southeast Missouri State University, 1997), pp. 247–48.
4. Tompkins, pp. 271–72.
5. Robert R. Archibald, *A Place to Remember: Using History to Build Community* (Walnut Creek, Calif.: AltaMira Press, 1999), p. 12.
6. Peder Gustav Tjernagel, *The Follingo Dog Book: A Norwegian Pioneer Story from Iowa* (Iowa City: University of Iowa Press, 1999), p. xv.

The Power of Place

Places I love come back to me like music,
Hush me and heal me when I am very tired.
—SARA TEASDALE, *Flame and Shadow*, 1920[1]

I SHARE WITH SARA TEASDALE, A ST. LOUIS NATIVE, AN APPRECIATION of the power of places, and not only the places past and present that I cherish as an intimate part of my own story, but also the places I have visited and researched during my years as a historian, museum professional, and advocate of community and of the role of history and of museums of all kinds in community building.

I am indebted to the many people who have invited me to share their places, their stories, and themselves, as I am invigorated and intrigued by the many people, in my profession and outside it, who share my intense commitment to the significance of place and its importance to a strong and vital community.

I am obsessed with the word *place*—no place, any place, some place, my place. Once it seemed to me an innocuous sort of word, uninspired, passive, devoid of passion. But now *place* is a word with subtleties of meaning, nuances

of intent and emotion. Perhaps I thought *place* was a dull, undistinguished word because I understood places as disembodied, existing outside of the people who live in them, just there, like unseen and unheard trees falling in uninhabited forests. I thought that places existed even without witnesses. But now I understand that humans create places, and that until we live in them, bury our dead beneath them, empty our tears upon them, name and remember them, and weave our stories in and through them, places do not exist. To name a place defines a relationship as surely as falling in love. We are the name givers, story weavers—the place makers.

Places are made of earth and earth reshaped, transformed by hands into human homes. Nothing is foreign here. Human hands and feet are not alien to the earth, but rather they are as intrinsic to the earth and the universe as grains of sand and black holes. Human beings and the earth are all made of atoms, molecules, arranged into distinct places: towns and cities, neighborhoods, farms and factories, houses, parks, fields, streets and highways, resorts, malls, airports—and the corner of Prather and Nottingham in front of my brick house with its garden of golden zinnias, flashy azaleas, and brilliant roses.

Humans are inseparable from place. As long as we have three-dimensional bodies we must be someplace on this earth. Place is our life-support system and our respirator. Charlesetta Coleman describes her attachment to her home in one of St. Louis's historically African American neighborhoods like this:

> We had moved so much when I was little. . . . when we moved here the house was brand new, practically . . . And I just put too much of my life in the place, too much money. To me it's just that I just could not stand to go any place else now, at my age, and I just don't intend to move. . . . my sweat and blood has been out there in that yard. I've laid bricks, circular bricks when my mother was living. We just worked ourselves, you know; this was our home. . . . I've invested too much into my house; it's just a white elephant but it's mine.[2]

For me there is one historic site that looms sweetly, but sorrowfully. Our house on the hill in Ishpeming was cream-colored when my memories of it begin. My parents moved to the house two years before I was born. My older brothers and sister remember other houses before the house at 551

South Pine Street, but I don't. I spent my whole childhood and adolescence in the house. Later we painted it barn red, beginning with a sample slash of paint under the kitchen window. Part of me is always there in that barn red paint, in the first whiff from the backyard of moldy autumn leaves, in the boyhood shack on the hillside built of scrap lumber and tar paper, and in the garden where I pulled green onions, stripped off the earthy outer layers, and then ate them or plucked purplish red raspberries from their thorny bushes and stuffed them in my mouth. For the fortunate young, home is a haven from which one ventures inside and out to find the world for the first time. There is nonetheless a primeval attraction for all of us to those places where we first tasted the world. Home is where we first worded our world, where our memory began. When I was a small boy I accidentally moved too close to the wall grate of the heater in the second-floor bathroom. The red-hot grate was at the same height as my stomach. I walked into it, and it seared a hatched pattern into my abdomen. I can still see its faint outlines, a symbolic reminder for me of how indelible my first place is upon my mind and how comprehensively it is my point of reference for every new place I go and every thought I have.

One of Ishpeming's mines was called the Lake Angeline, and it was down the hill from my home. A few weeks ago a friend brought me a piece of puddled iron from this mine, rusty, spindly, in the elongated shape it assumed when it poured out as molten metal. It is a memento of my historic site and reminds me each day of where home is and where I come from. I return home with that piece of iron, if only in my memory, to remember who I am and even sometimes to try to find out. My attraction to this place is not rational, but it is real and it is urgent.

I am not romantic fool enough to believe I can, or even want to, go home again. It is not because of change; rather it is because of time passages. I am older, so are people I knew, and some are dead: my mom, my grandparents, a legion of others. The home of childhood is gone forever, even though its referents are still there. I have memories and when I visit Ishpeming, enough remains to give my memories confirmation and in turn to work magic by enhancing the memories at those places. And whether or not I think that the world and places of childhood were better than the time and place I now inhabit is irrelevant. That place is absolutely irretrievable.

Home is where people and place are embedded in each other, where people know they are sustained by a place that is the crucible of all that is

The house on Pine Street, Ishpeming, Michigan. From the author's collection, ca. 1950s

important to them and where the very soil encloses, embraces, and reinforces memory and identity. It is a familiar street, familiar faces, a sidewalk, the church, the school, stores, inhabited and maintained by neighbors who are committed to the place and who understand that their individual welfares are linked and that a common good impels them to sacrifice for each other. Home requires permanence. It cannot exist in transient groups, for it needs investments of time, effort, emotion. Home envelopes joy, tragedy, death, birth, lovemaking, squabbling, holiday celebration, and everyday life. Home is where people, place, and memory are mixed in a thoroughly mixed-up delicious soup. Home requires familiarity. Like my hometown, and now St. Louis where I have lived longest since childhood, there must be places that confirm my memory. Change cannot overwhelm continuity because then real community will die and humans will be deprived of something with no market value but crucial to an opportunity for happiness surrounded by familiarity—in other words, home, that traditional incubator of security.

Do not try to understand home. The longing to return is as deeply imbedded in us as the salmon swimming upstream or buffalo seeking the prairie, as Teresa Jordan describes in "Playing God on the Lawns of the Lord."

A few days before the official release, the bison had been trucked to a holding pen on the Tallgrass Prairie Preserve so they could acclimate before being set free. Minutes after being unloaded, several of

them found old wallows, depressions in the ground hollowed out by their ancestors when they had rolled to rub off flies or shed their winter coats. No creatures had used the wallows for at least a hundred and fifty years, but the newcomers, fresh off the truck, instinctively made for the depressions and started rolling. It was as if both the animals and the land remembered.[3]

Human memory is transferable both in oral and in documentary form and hence the piecemeal experience and memories of countless generations are projected into the present. Memory is contained in the shape of buildings, streets, landscapes, manuscripts, photographs, objects, in the entire shape of things reworked by human hands, and in habits of the heart passed on in families and communities—in traditions, quilts, recipes, lilts of the tongue and in the values we hold dear. We are surrounded by messages from the past and we use these whisperings and shouts of those gone before to understand our present. Our world is full of mnemonic devices, and they can extend memories back in time.

To the left of my office desk is a framed bird's-eye view of Negaunee, another small iron mining town near my hometown, where my grandparents lived and where my father was raised. The view is long before my time, or even my father's, but in it I recognize bluffs, the lake, the crisscross of streets, and names that confirm it as the same place I knew. My memory reaches into the past and the bird's-eye view projects forward those features that intersect with my memory of Negaunee that now extends back to 1871, the date of the old picture. But the picture only extends my memory, because the memory of my own experience of the place supplies the context, the hitching post, the point of intersection. Without my own memory the view would have no personal significance. People connect with the past when their own memories contain the contexts that provide points of intersection.

Wendell Berry expresses the depth of attachment of humans for place as a consequence of memory and history in his book, *The Long-Legged House*:

In this awakening there has been a good deal of pain. When I lived in other places I looked on their evils with the curious eye of a traveler; I was not responsible for them; it cost me nothing to be a critic for I had not been there long, and I did not feel that I would stay. But here, now that I am both native and citizen, there is no immunity to what

is wrong. It is impossible to escape the sense that I am involved in history. What I am has been to a considerable extent determined by what my forebears were, by how they chose to treat this place while they lived in it; the lives of most of them diminished it, and limited its possibilities, and narrowed its future. And every day I am confronted by the question of what inheritance I will leave.[4]

I am entranced with these relationships between people and place. I sense that the intertwining of the two is so intimate as to be inseparable. Our relationship with a place is so profound a piece of our fabric and so ingrained into how we function that it is difficult to analyze it with any perspective. Yet in some real respects recognition of the relationship may be crucial to our very survival, for survival of humanity depends on places capable of sustaining us. Only when we animate our understanding of our dependence upon place can we, like Wendell Berry, assume responsibility for the welfare of the place and all the life that it sustains. It is not just our relationship to landscape and built environment that is incubated in places of memory; it is also our relationships with each other.

Yet the landscape, the environment, the place will go on without us. Continuity and change are not polarities but rather a kind of balance, the double-faced Janus at the core of all existence. I found this reality in the eloquent but unvarnished words of Elroy Bode, a child of the 1930s born in Kerrville, Texas. His grandmother and grandfather left for church one Sunday morning. And he found profound truth in this simple thing:

I was standing on the ranch-house porch, seeing the old green Buick get smaller and smaller as it made the familiar curve around the big oat field and then finally disappeared into the line of shin oaks that marked the eastern horizon of the ranch. Long after the dust had drifted slowly southward over the front pasture, I stared down that curve of road, telling myself: You had better get ready. Someday there will be no grey heads framed in a Buick window. . . . Someday this corner of the earth will heave in an invisible little spasm, surrendering its old folks and its claim to glory.

I knew then, as I know now, the facts: that the windmills would find no reason to stop their turning just because one set of owners had gone; that the pecan and post-oak trees would keep on towering above the yards. Even the back gate would go on slamming with the old collapsing sound, no matter whose hand grasped it and let it go.[5]

Bode is struck that his grandparents' imminent deaths will make little difference on their ranch. He realizes that life will go on without them—that their place will endure despite their lives' ending. In this is fundamental truth. The present is not all there is. People lived in the past. People will live in the future. Every generation occupies this planet as temporary trustee. And every generation enjoys a right to be here identical to that right accorded to every other generation, past, present, and future. There is no priority assigned to the living generations of any age; we do not have a right to behave as if we are the only generation to occupy the planet or our place upon its surface. In our thinking, our decisions, and our actions, we must accommodate the needs of the future. History and those remnants that are its symbols are irrefutable evidence that there are times beyond our own, that the future is as real as today and as real as the past.

While Bode presumes a continuity of place despite the passage of human lives, another Texas writer observes the obliteration of place and the homogenization of space. The juxtaposition of Bode's message of continuity with Larry King's tortured commentary in *Of Outlaws, Con Men, Whores, Politicians, and Other Artists* is chilling:

> Too much, now, the Texas landscape sings no native notes. The impersonal, standardized superhighways—bending around or by most small towns and then blasting straightaway toward the urban sprawls—offer homogenized service stations, fast-food chain outlets, and cluttered shopping centers one might find duplicated in Ohio, Maryland, Illinois, or Anywhere, U.S.A. Yes, there is much to make me protest, as did Mr. Faulkner's Quentin Compson, of the South—"I *don't* hate it. I don't hate it. I *don't*. . ."[6]

"No native notes": these three words express not only a loss of place, but even more excruciating for him and for us, a loss of identity.

We often assume far too cavalierly that, while places may be important for us, they are not crucial to our well-being. Yet we do know how profoundly space and place influence us even if the effect is subliminal. I know, for instance, how light in the places where I live influences my own moods. I need windows, and I do not mean a window over a treeless expanse of asphalt parking lot. There are no windows in the discount chain stores—no windows, no external ornamentation, no interior finishing, but huge parking lots—structures built cheap to maximize gross sales per square foot. Such

places are not built with any idea of aesthetics, any attention to customer comfort. Here, shoppers are strangers, just consumers, not friends and neighbors; these are not social spaces. Courtesy and friendliness are not natural here but inculcated, if at all, in training programs, as a way to boost sales and repeat business. And in most communities these behemoths have sucked the lifeblood out of both the comfortable neighborhood shops and the elegant downtown department stores. The companion piece of the new places where we shop are the suburbs where we live—home as commodity, segregation by real estate values. In a definite sense these places are no-places, without a past, without any embracing narrative, without any attempt at permanence.

So far you might accuse me of being a nostalgic curmudgeon stuck in the past and unable to face the reality of the present. I know that Wal-Mart succeeds because of good merchandise, lots of it, sold at the best price. And I know wherever I spy those golden arches I can count on predictable food of uniform quality at a modest price. Suburbs spell modern comfort, stable housing values, green lawns and trees (but sustained by a hazardous brew of fertilizers, pesticides, and millions of cubic feet of precious water). But in the midst of the homogeneity, the inexorable sameness of our modern world, I may lose my identity, my community, myself, and Elroy Bode and Larry King may lose Texas.

I do not claim to "know" Texas. Really knowing Texas is a claim that I surmise few can make. The state is geographically vast, its different regions nurturing divergent cultures and an ethnic diversity underscored by rich and distinct traditions. My own sense of not knowing Texas was reinforced by a search for Texas literature in St. Louis area libraries when the Texas Historical Commission invited me to address its annual meeting. I found plenty of titles (over eight hundred just in fiction) but as I perused the books, Texas proved to be elusive. Perhaps it is that Texas like all of our states, like our nation itself, is an artificial creation. We in the United States are not unified by geography, culture, ethnicity, religion; and our political boundaries are just lines on maps. In most ways this is a blessing. Too strong a distinction between "us" and "them," which is to say an overpowering sense of identity, produces the international equivalent of gang violence, where people slaughter one another over ethnic, religious, or cultural differences. But without some sense of shared identity, some common purpose and common destiny, communities cannot not work, and democracy that depends upon common ground and shared aspiration is at risk.

But people live and have lived in Texas, each with a particular story woven from that marvelous interaction of place and personal experience. In individual and communal narratives we can glimpse Texas, in the stories people tell and the significance people attach to their places. This is what really makes Texas. Don Graham writes in his introduction to *Texas: A Literary Portrait* that

> The problem of knowing Texas is made more difficult by the swift changes that the state is undergoing. Not even the landscape seems permanent anymore. In much of Texas in the 1980's, the landscape is being transformed by the all-consuming needs of economic growth, "development," and urban sprawl. The roads in the hills west of Austin, where I live, are being straightened and widened, and with every billboard, video store, country-club church, and executive plaza, the landscape retreats, loses its natural contours, becomes tamed, safe, manicured, lost.[7]

So Texas is a place of landscape, a land of great diversity and natural beauty, and a land of change. For all practical purposes, places do not exist unless we perceive them through our senses and assign meanings to them through narratives that explain our relationships to them. We are place-bound creatures who use narratives not just to define place, whether natural or man-made, but also to create our own identities and construct our relationships with others. Neighborhoods, communities, democracy itself depend upon a shared past, an agreement upon enough components of a common identity to permit a consensus upon issues of civic life. Narratives are our means of understanding the relationships between past, present, and future expectations.

The relationships necessary to facilitate this affinity can only occur in "good" places. A crowded freeway, an impersonal mega-mall, or a pop-up neighborhood are bad places measured on this scale. So is the Internet, much touted at the moment as a new community form. But cyberspace is no-place. Such places do not build relationships; they breed isolation. Because such places have no pasts and are not built for permanence, they remove individuals from that sense of continuity with the past and the future. Is it any wonder that long-term thinking is virtually impossible for people in such places? Places are good if they connect people to each other and

to the preceding generations that have walked that place and left their mark to be absorbed by those who inherit their place.

I once stood on the top deck of the *Casino Queen,* a gambling palace boat that thrusts its glittering four stories out of the swirling Mississippi on the Illinois side at St. Louis. By the time the Mississippi gets here it is a giant of a river, not so spread out as it is in the delta country below Memphis but still huge compared to itself in Minnesota. I was not on the *Casino Queen* for the gambling but rather for the filming of the latest episode of a local public television series on the history of twentieth-century St. Louis. We are here because the river and skyline provide an unmistakable backdrop. If you could identify St. Louis in a single camera shot, this would be it.

If I could abridge this St. Louis fingerprint to the essential elements, it would be only two items: the Mississippi River rolls in the foreground of my abstraction, and the graceful gleaming catenary curve of Eero Saarinen's Gateway Arch stands on its bank. Transfixed by the view, I imagined that I could obliterate separations of time and stand on this deck with representatives of those who lived in St. Louis a hundred years or more before my arrival in 1988. If I asked them to tell me by looking at my abridged St. Louis fingerprint where we are, they would not know. If any of them guessed correctly, it would be on account of the river. Even if I expand my St. Louis view to include everything that I saw before me now from the deck of the *Casino Queen,* my friends from St. Louis's past still could not tell me where we are. There is no evidence in this current scene that my fellow citizens of 1870 were ever here. Most of the city that they could have recognized was obliterated for the national park that enfolds the Gateway Arch, that symbolic monument commemorating St. Louis's past and its role in westward expansion.

But if I gathered on the deck with me a group of St. Louis citizens who lived in my city only thirty years later, they would know with certainty where they were. When they turned to face north, they would see the bridge. Its stone stained with soot, its iron looking rusted, the worn but still grand Eads Bridge stands firm, anchoring memories of every generation since its construction in the 1870s when it first connected the rails and roads that previously had to halt at the river's edge. The bridge was not only an engineering marvel of great beauty; it was the means by which locomotives could haul long trains of raw materials, manufactured goods, and passengers in place of the laborious passage across the river by ferryboats.

The Eads Bridge today does not carry steam locomotives, just two tracks of St. Louis's light rail system, MetroLink. The bridge's value now is hardly commercial; light rail is important but hardly approaches this bridge's original significance as the first bridge connecting St. Louis to Illinois and beyond. Now the bridge is preeminently a memory place, proof positive that the nineteenth century happened on this very spot. The bridge is visible, even tangible, ghostwriting on a blackboard from before our time, helping us to keep ourselves in perspective, reminding us that we are not the only humans to come this way and that others will come when we have passed on. Its very presence is an effective antidote to the hubris of the living and a reminder that others will take our places and that we, like the builders of this bridge, will certainly be remembered for what we have done and also what we have left undone. The bridge illuminates the tacit trust that binds the dead, the living, and the unborn in a bond of continuing obligations. In the bridge we confront the fact that we didn't build this place but rather we built upon the foundations of others. Likewise what we do here will be left to others to do with what they wish. Will we build well? Will we have made this a better place? The bridge asks with insistent eloquence that we consider the consequences of our actions for generations we can never know.

But the bridge is the only memory place we have along this stretch of riverfront. For most of my fellow St. Louisans there are no messages of other times and other humans, no sources of perspective on ourselves, no reminders that our places are always intergenerational works in progress. A place without such reminders is not a good place. Life in such places forces us to search in artificial reconstructions and flimsy recreations. We seek reassurances of continuity in other places to compensate for what has been obliterated at home.

Think about your town, wherever it may be. What memory places have you kept? What storied places illuminate the direction you are taking? Humans cannot live without such places. Without them we do not know who we are or what to do. Without them we behave in crazy ways, acting as if there is no past and no future. At the end of the twentieth century, for the first time, history became contingent: we now have the awesome power to put an end to history. History and its continuation is contingent upon us—upon our ability to use technology with enough foresight and self-control to avoid unleashing some unknown monster in a genetic laboratory

47

or incinerating ourselves in an atomic furnace—and contingent upon our behavior toward our planet and its resources, for if we act as though no generation will need this earth after us, then we surely will be the last generation to live here.

New Mexico was once on the far northern frontier of New Spain, later Mexico. For hundreds of years Spanish-speaking people lived in those mountains north of Santa Fe in complete isolation, developing what seemed to outsiders strange cultural traditions. When David Ortega invited me to attend the Penitente Tenieblas ceremony in Truchas, I headed north from Albuquerque, up La Bajada hill to Santa Fe, and then on the twisted high road to Taos. I joined David in Chimayo, and at dark we drove farther up the winding road to Truchas. Those mountains have a special brooding quality and for me the trip north on the high road was always a journey back in time to a mysterious place. It seemed a landscape animated by the beliefs and history of the people who lived in it, imbued with a spiritual presence and blended with the smells of brisk mountain air and burning piñón.

The Penitentes are a lay brotherhood driven underground in the nineteenth century by the more orthodox Catholicism brought by the American bishops and the Anglo gawkers who sensationalized the sometimes bloody rituals of the brothers. The Penitentes also formed a community mutual aid organization and ministered to the needs of their neighbors, caring for the sick, the hungry, and those down on their luck. As an Anglo and an outsider I was honored at the invitation to participate in a centuries-old ritual preserved here in this small mountain village. It is not appropriate for me to describe the evening's rituals but I do want to explain the sense I made of what I witnessed. The ritual, the ancient chants and music played on wooden flutes, rattles, and little wooden "clackers" called matracas in the chilled spring darkness with moonlit mountains as backdrop seemed to rise organically from the place. What happened that evening had antecedents in other places: medieval Spain from which the ancestors of these people came with admixtures of cultures encountered by these same ancestors in seventeenth-century Mexico before their migration north.

But the rituals now belonged to Truchas, to this place, nowhere else. The place merged into a singularity; the people and the land were mirror images of each other. These people built the homes, chapels, and outbuildings of adobe, the earth of the place. Buildings grew here in the same way that gar-

dens grew, through cultivation by human hands. To the extent that rituals from the past are reenacted in the present, time is made irrelevant. In Truchas, history was present. As I recall that evening in Truchas I am struck now by the lack of any sense of individual people, mental images of particular buildings, of individual mountain peaks or even of the music or the sweet pungent smell of piñon smoke. All elements of the experience have blended into a delicious and inseparable whole. After more than three hundred years the land, the people, and the Good Friday rituals coexisted in a state of symbiosis in which all the pieces of the people and the place supported one another in a precisely balanced angle of repose. No element could be removed or altered without upsetting the balance of the remaining pieces. No one building in Truchas can be preserved as a historic site because taken out of the context any one element distorts the meaning of the place.

Of course Truchas is a historic site, but actually every place on the earth is just as historic as every other place. All places on the same planet are made of materials that were already present when the planet's surface first solidified. The contours of the earth have changed, and humans have modified the planet in diverse ways to meet their needs. Civilizations, cities, and people have come and gone. In some instances evidences remain obvious. And in other cases we purposefully seek out and preserve pieces of the past, a process that has brought about the preservation of homes, farms, factories, streetscapes, monuments, and sometimes whole neighborhoods. When the originals do not exist we assemble whatever evidence we can find and recreate them. In still other instances we ignore accuracy and rearrange historic structures in places where they never stood and in relationships to each other that never existed. We decorate our restaurants with memorabilia and erect theme parks loosely, often very loosely, based on the history of our nation. There is not a sharp line dividing what is accurately and inaccurately preserved and presented, just gradations and scale.

Why our fascination with representations of the past? Some might argue that we preserve pieces of the past as testimony to our progress, illustrations of how far we have come and how superior we are to those who went before. Those who seek that kind of affirmation in the past miss the point. I recall an elderly friend surveying the twentieth century from the perspective of ninety-eight years. I asked her what she thought of all the progress she had witnessed. "It's not progress," she said, "it's just change."

CHAPTER 2

I think that our fascination as a nation with preservation of the past runs deeper. People who live in Truchas thought little about change and preservation. Why worry about preservation of abandoned adobes when so little changes and when the cycle of replacement is in itself an element of continuity? Why worry about preservation when the past persists in the present? Why worry when what is important never changes?

Conventional cliché has always maintained that people who "forget the past are condemned to repeat it." Nonsense. Although human nature is a constant and consequently our behavior follows similar patterns, the past does not repeat itself. The truth is worse. Those who forget the past, or who choose to ignore or obliterate it, will behave as if there is no future. And those who behave as if there is no future mortgage the planet and trample on the rights of the unborn. To think with a consciousness of the past is to be able to think on a long-term basis both about the past and the future. The past, after all, is our only guarantee that the future beyond the limits of our own lives is real; for the past, we are the future, and from the perspective of the future, we are the past.

We can provide antidotes to a dangerous preoccupation with the present with preservation of symbols of the past. Historic preservation is not just a matter of aesthetics or a nostalgic hobby; rather, it is crucial to the future, for without tangible reminders of the way we have come, we are isolated in the present, unable to make sense of our predicament, and rendered incapable of rational decisions for the future.

Symbols of the past are not just those pickled and embalmed places that we go to see on vacation: the Alamo, Colonial Williamsburg, Fort Mackinac, San Simeon. Such places are valuable, but they are not the informal everyday places where people create their narratives, construct identities, share aspirations. We must have reminders of the past in all our places: in the neighborhoods where we live, the places where we shop, along the routes we travel. Historical consciousness must become our way of thinking.

When I survey my hometown or my adopted home, St. Louis, I see whole neighborhoods and downtowns radically rearranged, abandoned, demolished, and neglected, while new stores and subdivisions pop up on the margins. And in the midst of such wrenching change, I find preservation of reminders, which seems to me a form of protest against the destruction of places that once enfolded the memories of those who lived and worked in

them. As if to underscore the futility and profound loss, there are "ghost re-unions" in St. Louis, gatherings of people who once were neighbors but are now dispersed in suburban developments. These people gather, if only for an evening or weekend in a highway hotel or public park. It's a poignant, forlorn form of preservation.

Abandonment has always been an identifying characteristic of the American landscape—the oil was pumped up, the mine played out, the people moved on, the neighborhood was shabby, the downtown was decrepit, the whole place was abandoned. You have seen it in your town or city. I have seen it in St. Louis, my city that lost more than half of its population in a decade, and in the worn-out mining towns of my Michigan's Upper Peninsula. We are a prodigal people in an increasingly finite world. We will be on a fatal collision course unless we change directions now.

At the pinnacle of historic preservation in our nation are sites preserved to commemorate influential events and great people. But there are relatively few such sites, and they are not the core of the most fundamental value of preservation. I think that the preservation battle cry in our communities is this: change that is too rapid disorients humans. Escalating rates of change deprive people of the referents and confirmations of their own memories. People's identities are corroded, bonds of community are severed, environments are damaged, and suspicion replaces the mutual trust upon which democracy depends. Historic places and contemporary good places encourage humans to flourish and to develop those connections to each other that are the bedrocks of community and crucibles of democracy. Conversely, the denigration of space is connected to the rise in social distrust and the increase in cynicism about public life. Research in London conducted over forty years ago by Michael Young and Peter Willmot tracked the migration of immigrants from a close-knit, working-class neighborhood in East London to a new housing subdivision. In the neighborhood, Young and Willmot discovered that social solidarity was the product of common ties to a shared place, a common sense of turf and familiarity among neighbors formed by frequent contact on sidewalks, in local stores and pubs, and outside schools. But when the same residents moved to the new, lower-density housing estate, a place with one-fifth as many people per acre, the culture of friendliness and familiarity was replaced by distrust, social privacy, and materialism.[8]

We blame the isolation of the individual, our sense of loss of control, as well as hate crimes and mass murder, on other factors: parental failure, poor

schools, racism, cynicism, amorality, drugs, television, video games. These diagnoses grasp at symptomatic straws but miss the central failure.

We must become advocates for rates of change that do not cause wholesale obliteration of places of memory. How can we care about places that are interchangeable, homogenous, transient, and disposable? Places that conserve memory are good places for people and incubators of community, but they are also inherently oriented toward preservation because they emphasize reuse of what is old and eschew new development that too rapidly consumes increasingly scarce resources.

Not only is our social fabric frayed because of detachment from place and from each other and consequently from community; this world we have made is actually not sustainable on a finite planet. If we persist in destroying the old and building only the new as if there is no tomorrow, there won't be.

St. Louis has three spectacular water towers from the nineteenth century, now obsolete, but still soaring community landmarks. I was invited to speak at the rededication of the Compton Hill Tower on the occasion of its hundredth anniversary. The water tower is now completely refurbished, thanks to many thousands of dollars raised by the community, countless volunteer hours, thousands of hours of labor—to save a useless, obsolete pile of stone, but a place that neighbors see every day. This tower was not saved and restored because of its attraction to tourists or its importance to the water system. It was saved because it is a symbol of continuity, of connections between living and dead generations, a statement of aesthetics, a declaration of the rejuvenation of an endangered neighborhood and its hope for the future. And finally, in the act of cooperating in its restoration, this community built bonds of mutual accomplishment and common concern expressed in loving attention to a common symbol. This act was not nostalgic obeisance to the past. It was an act of faith in the future, a pledge of commitment to friends and community, and a statement of values. The tower is a living antidote to the prevailing notion that what does not have value in the marketplace is of no importance. What a bold and wonderful statement. What a harbinger of hope.

Bonds with the past do endure. Until I was invited to speak at the Schwenkfelder Library in southeastern Pennsylvania, I had never heard of Schwenkfelders, although I know of other groups that came to this country to escape religious persecution. But after acquainting myself with the

Compton Hill Water Tower, a community landmark. Photograph by Robert J. Byrne, 1999.

Schwenkfelders, I concluded that I had never known of a people who are more respectful of their own past and who work so diligently to nurture it as a living legacy.

We gathered in Pennsburg in September, the month of the Schwenkfelder "Day of Remembrance," which some equate with "Thanksgiving." But to call it a day of remembrance has a very distinct nuance. The roots of Thanksgiving in the Pilgrim experience on the rocky coast of Massachusetts are withered, and the holiday has become commercialized overeating when thanks is given, if given at all, for good fortune in general. Day of Remembrance cannot be disassociated from its heritage in the same way, for it is irrevocably connected to the past. Schwenkfelders on this day remember how they came to be in this place in the 1730s, the religious persecution in Europe and the flight of just two hundred people, followers of Meister Schwenkfeld, to this new land where they would not be punished for their spiritual beliefs. And I think that Schwenkfelders remember the ideas for which ancestors willingly took such drastic measures. So this day of remembrance is not about food, not about material things, but instead about the life of the mind and a distinct identity, and about the ties that bind this community together, to the past, and hopefully to the future.

Remembrance is not about a nostalgic look back, but rather an affirmation of who we are. Remembrance is not only about remembering ancestors, but also about reinforcing ties in the present through recollection of a shared past that contains common tragedies, triumphs, and perseverance made possible by mutual assistance and support. Through remembrance the past is affirmed, the present confirmed, values reinforced and transmitted, and the future defined. Remembering is profoundly conservative in the best ways because it buttresses the notion that the past envelopes wisdom and values that are relevant to the present. It presumes that inherent in generations of human life over tens of thousand of years are values and accumulated wisdom that are not relative but instead absolutes that govern all human life in every age. Remembering further insists that those values that provided valid guideposts for human life in the past and the present will be equally valid in the future.

Husbandry is an old word. It usually applies to farming these days, but it really means management, to take care of things, to conserve them, and not consume them in a way that permanently diminishes them. So how do we husband our places these days?—which is to say, how do we husband

humankind, since the health of humans depends upon the health of our places? The idea of husbandry encompasses our roles as trustees of our places rather than as consumers. Remembrance defines a set of principles based on eons of human experience that define good places for people. I know when I stand in the middle of acres of asphalt surrounding a shopping mall that I am not in a place that is good for people. I know that when I am stuck in congested traffic, feeling frustration and even anger stirring, that I am not in a good place. I know that when I am in a subdivision without sidewalks or common ground that I am not in a place conducive to community creation. For many people it no longer matters where they live because the people who live next door or in the apartment above them are not really their neighbors. Relationships are detached from place. If the places where we live and work are not the crucibles for the familial and neighborly relationships that sustain us, then places do not matter and we will not nurture and sustain them. But the price is isolation, loneliness, and disconnectedness. We cease to define ourselves as a node in a web of sustaining relationships, and we are left defined as consumers by television and advertising, marketeers and media. In the end we allow ourselves to be valued only as consumers because the market has no way to value any other human dimension. Neighborliness and sustainable communities have no discernible dollar value.

The market cannot value what is not bought and sold: ideals, religion, aesthetics, morals, community, relationships, love, or legacies. So if we persist in letting markets determine values on our behalf, we will get what we deserve. The relationships that sustain community will be undermined. Our distinct identities will be diluted. All standards will be relative and all beliefs subject to question, and in the end we will destroy the earth's ability to sustain us and our own ability to sustain ourselves. I cannot watch an evening of prime-time television without a certain squeamishness, or look at billboards, or magazine ads, or even the local or national news. I grieve over the extent to which the intimate becomes public whether it is personal grief or joy or overwhelming tragedy. I don't want to see the private grief of a mother on display as she is queried about the death of her child or the embarrassment of a son whose father's unsavory sexual affairs have been revealed. A few weeks ago I picked up a copy of a popular magazine and was assaulted by sexually explicit advertising and images that were often hermaphroditic and ambiguous. I am not a prude; I just resist making what is

most sacred and most intimate about human experience into a public spectacle for our entertainment and vicarious enjoyment. There is a serious issue of propriety in the public display of what is intimate and personal. What gives us the right to peek in on such things? We have lost our compasses, and we deny the existence of limits in the name of individual freedom. Excessive personal freedom without responsibility is not what the founders meant by "pursuit of happiness." This is not freedom, for freedom always brings with it the obligation to behave responsibly, to act as good stewards, practice husbandry, to leave our places better for our children, our children's children, and our neighbors' children as well.

There is a list of dos and don'ts contained in the Ten Commandments and in the tenets of nearly all religions. The logic is impeccable. If we are to live together in a community of humans we cannot lie, cheat, steal, murder, commit adultery; and we need to acknowledge some higher power than ourselves lest we drive all absolutes out of this world. If humans are the ultimate authority in the universe, and all rules are made by us, then we are free to break those, our own rules. But there are other rules that we need to embrace besides those espoused in most theologies. For example, we have an obligation to leave our places in better shape than we found them. We must build neighborhoods that facilitate development of close-knit intergenerational relationships. We must create schools that really teach children what they need to know, not just to find a good job, but also to fully participate in the human race. We must leave places that are clean, that do not consume or pollute resources at unsustainable rates. We must become communities of people who treasure intimacy, sexuality, and human emotion so much that we refuse to permit such sacred qualities of life to become degraded, commercialized, and objects of voyeuristic prying.

These rules cannot be relative. That is, we humans must acknowledge them as absolutes not up for debate. It is not my task to create these values for the future. We must do that together. But I do know that the future is in the balance. As a historian I know that certain attitudes and actions have unalterable consequences. We are behaving in ways that are not sustainable and violate our most sacred obligation to unborn generations, the obligation that offers them a chance to inherit the earth and human communities upon it in a condition that allows them to live a decent life.

It is not enough to object to the despoliation of communities, lewd advertising and programming, environmental destruction, or the undermining

of values that support community and human pursuit of true happiness. If we do not like zoning practices that encourage community dissipation, we must take action. If we object to burgeoning expenditure of tax dollars on highways that encourages more sprawl and destruction of farmlands and wildlife habitat, then we must build a coalition to change tax policy. If we worry that there won't be enough left of this planet to sustain healthy grand-children and great-grandchildren, we must work to change an ethic that ap-parently values humans mainly for their ability to consume. If we distrust government, then we ought to work to reform it and make it responsive to us. And we must not be afraid to exercise judgment and say when some-thing is wrong, crude, destructive, or ugly. Bad things do not just happen. They happen because we acquiesce too often and do not object effectively enough when we know that we should.

We are the living generation, and now is our turn to make our own im-print here, just as generations before us did and just as subsequent genera-tions surely will. The impressive legacy of the Schwenkfelders, the stock they place in ideas, in education, in history, can provide others in their community with the best of foundations. This possibility was evident in the work ex-pended in the Schwenkfelder Library and Heritage Center. Yet, the question remains, what will they make of this place? What kind of world will they give to unborn generations? How will they respond to issues that confront them? Will this place look like every other place in America in twenty-five years, or will they see to it that it retains at least some of its distinctiveness? Can they be good stewards of this place and of each other?

But these are not questions only for those descendants of a small eighteenth-century sect and their present-day supporters. These are ques-tions that must be answered by every human being on our planet. Stewardship is a sacred obligation, and for most of us in the museum field, a profession, a career. But each of us, whatever we do, has that sa-cred obligation to be stewards of a place.

Can the concept of stewardship operate in no-place? Several years ago I accepted an invitation to talk about community with a group of graduate stu-dents at Washington University's School of Architecture in St. Louis. I was thoroughly familiar with the topic; I didn't have to prepare much. I began by defining community as a place, stressing the interaction between people and place. When I finished speaking, I invited discussion. One bright young man challenged me. "Your definition of community," he said, "does not describe

my community, and it does not describe how I think of community. My community is not a place," he insisted. "My community is those people with whom I choose to associate. I have a community based on cell phones, e-mail, and fax machines, sustained by visits back and forth in automobiles and airplanes. It does not matter where I live," he continued, "because the people who live near me are not my community." A community that is no-place, I thought. I was horrified at the implications of what this young man, this future architect who will make an imprint on the land and thus on community, said, for we are not as likely to take care of a place and sacrifice self-interest for strangers as we are for friends, neighbors, or even acquaintances.

I also knew that for most of us he was right. Like many people I make a living spending a portion of each day ensconced in front of my office computer screen reading and responding to an escalating volume of e-mail, downloading and reviewing voluminous attachments, checking a series of websites and listservs germane to my work. I tote a cell phone to be in touch with my office at all times. I travel a lot, maintaining occasional long-distance relationships with colleagues and acquaintances all over this land. I have fax machines in my home and my office. I maintain more contacts with business associates in Washington, D.C., than I do with neighbors around my St. Louis home. My story is not unusual but instead is increasingly the profile of modern America. It is a radically different lifestyle than any of those possible just a few decades ago. My life has spanned change from the first affordable televisions to the ubiquitous high tech of the information age. While all of these technological innovations have made my work more efficient, and give me the choice between several hundred television programs in my own living room, I pay an extreme price for them. My life is more cluttered with information that is often useless, and I have less time for the things that I now think really matter, actions and interactions that are of inestimable value: my wife, Sue; children and grandchildren; our house and neighborhood and friends; pursuits such as cooking and poetry; and a casual evening stroll to our public park just a block away.

I know that we will increasingly live in virtual worlds and intangible communities made possible by electronics and by transportation. But I have a physical body and must put it in a physical space on the planet, a place that has been entrusted to me and for which I must be responsible. I fear not only for the stewardship of place; I fear for democracy and human happiness if we do not relearn how to build and live in communities of place.

Let us slow down. Let us really live in our places and become advocates for their conservation to preserve our own sanity, protect a sense of context and continuity for our own lives, and be good stewards of those resources that are really the property of those who will follow us. We cannot blindly oppose, nor can we blindly accept, what is new; but we can look for a pace and quality of change that respects the fundamental human need to remember. All of us need places of remembrance, and we need to stay in place long enough to embed memories, for only then can we truly be at home. Our most sacred obligation is to care for our places and exercise good stewardship and take advantage of their power to remind us of where we came from and sometimes even to discover who we are.

Notes

1. Sara Teasdale, *Flame and Shadow* (New York: Macmillan, 1920), p. 15.
2. Interview with Charlesetta Coleman, Missouri Historical Society Archives, June 1999.
3. Teresa Jordan, "Playing God on the Lawns of the Lord," in *Heart of the Land: Essays on Last Great Places*, Joseph Barbato and L. Weinerman, eds. (New York: Pantheon, 1994), p. 112.
4. Wendell Berry, *The Long-Legged House* (New York: Harcourt Brace, 1969), p. 178.
5. Elroy Bode, *Home Country* (El Paso: Texas Western Press, 1997), p. 71.
6. Larry King, *Of Outlaws, Con Men, Whores, Politicians, and Other Artists* (New York: Viking, 1980), p. 56.
7. Don Graham, *Texas: A Literary Portrait* (San Antonio, Tex.: Corona Publishing Co., 1985), pp. 21–22.
8. Peter Willmot and Michael Young, *Family & Kinship in East London* (London: Routledge & Kegan Paul, 1957), passim.

CHAPTER *3*

Sharing the Story

W HO ARE WE? THE MULTIFACETED ANSWER TO THIS ongoing inquiry is the essence of community, a community that can only be built and supported by the acceptance of our full story. In examining the story of our places, we examine not only ourselves but each other, the sum total of our history and culture.

Thomas Jefferson broods over the busy St. Louis intersection at Lindell and DeBaliviere from the loggia of the museum named for him—the first memorial to this U.S. president who more than doubled the size of his country with a daring purchase of land that includes St. Louis's present metropolitan region. Jefferson never set foot in—or for that matter, laid eyes on—this land beyond the Mississippi, but his importance to our place can hardly be denied. Distant though he is in time and place from us, Jefferson's legacy is a part of our shared story. Thomas Jefferson, gentleman farmer of Virginia, also was a slaveholder and, in a twenty-first-century interpretation, a racist. Admirable genius that he was, he still has certain qualities that we need not esteem but must admit.

An exact replica of Charles Lindbergh's *Spirit of St. Louis* hangs over the Grand Hall that connects the Jefferson Memorial with the Emerson Center, opened as the Missouri History Museum's expansion in 2000. That airplane, or rather its original, became world famous, while its pilot gained international acclaim and adulation with his boyish charm and exemplary

manners. St. Louis, where he found the funds and support for his daring venture, certainly laid claim to him as a local hero. But in later years his proclaimed admiration for Nazi Germany's power, his isolationist stance before World War II, the taint of anti-Semitism injured, perhaps justly, that beloved image. But it is the whole Lindbergh, not just the pioneer aviator, inventor, and environmentalist, who is part of our story.

Every working day I walk through the museum past these icons of heroism and civic pride, known at least in part by all our visitors, local or from far away. And I also pass by another image, equally an icon of civic pride and heroism but too long unacknowledged as an integral piece of the narrative that makes up the story of St. Louis.

The large glass etching of Homer G. Phillips Hospital in the 1930s is a symbol of both trial and triumph, an achievement over adversity that the African American community sensed even when "Homer G." sustained broken windows and sagging stairs awaiting its rehabilitation with the optimism and determination that attended its beginnings some eighty years ago.

I recall a visit to the remains of this nationally known hospital in the company of a colleague, the alderman of the ward where the hospital is, and a married couple deeply involved in revitalizing The Ville, this historic African American neighborhood in north St. Louis. For my four friends this was an emotional homecoming, for they were born here. Now the lobby is dark and musty, the halls strewn with sodden insulation, peeled paint, and broken glass. We bump into abandoned gurneys, wheelchairs, crutches, IV stands. A pack of wild dogs growls at us from a dingy corridor. On that day it seemed an abandoned hall of hope, a promise broken, a place defiled, a legacy lost.

Opened in 1937, "Homer G." was a center of extraordinary excellence in a meanly segregated city and a point of great pride for African Americans. Within five years Homer G. Phillips ranked in the top third of the ten largest general hospitals in the nation. By 1948 this hospital had trained over one-third of the graduates of the two black medical schools in the country and had a national reputation for treatment of the acutely injured and for techniques for intravenous protein feeding. Treatments for burns and for bleeding ulcers were pioneered here. The hospital also ran schools for nurses, X-ray technicians, and laboratory technicians, and a medical records library service. This place casts long, enduring, and nurturing shadows. It is indeed a symbol of heroism and civic pride but one that is not shared by the whole

community, for so many St. Louisans are unaware of the extraordinary con-
tributions of this facility, at a time when most hospitals refused admittance
to African Americans, either as patients or as doctors and nurses, and most
medical schools limited their student bodies to whites. The story of the years
of labor and lobbying and setbacks to even begin the hospital is one that all
of us should know and celebrate.

It is a story of extraordinary achievement in a racist place, a story that
embodies what a community of well-intentioned people with a common
agenda can achieve. Its closing in the 1980s, after intense and often acrimo-
nious debate, sent shock waves through St. Louis's African American com-
munity and within a few years generated the movement to restore the
hospital to some kind of community service. The fate of the building became
more than hopeful with the start of its renovation in February 2002. It took
nearly twenty years, but on April 6, 2003, the Homer G. Phillips Senior
Living Community and its residents offered an open house to show off the
hospital building that had become magnificently rehabilitated as a complex

Homer G. Phillips Hospital, 1938. W. C. Persons Photograph, Missouri Historical
Society, St. Louis.

of 225 luxury apartments and the handsome common areas that indicated a strong sense of forming and reinforcing the "community" in its appellation.

But, whatever the state of its blond bricks and distinctive architecture has been, its story has continued in unabated vitality, not only as St. Louis African American history but as one of the glittering threads in the narrative that we all weave as we live in this place and pass it on to the next generation.

Jefferson and the Louisiana Purchase, Lindbergh and his *Spirit of St. Louis* have made the history books and earned a prominent place in the Missouri History Museum. Homer G. Phillips Hospital shares the importance and the prominence of place, but insuring its story's survival is up to us.

Our work at the Missouri Historical Society is to facilitate the creation of a new story for our region, one that overcomes burdens, a story that includes and does not exclude, a story that acknowledges the contributions of all who have called this place home, a story that heals and calls us to look out for one another, a story that condemns what is ugly and celebrates what is beautiful. It must be a story that summons all of us to action, action that promises a better, more just, more humane, and more sustainable world for our children and our children's children. Finally, the new story must belong to all of us and so all of us must write it. If we do not write the new story together, it will be like the old stories in which some people count and others do not, separate histories that divide us.

Divided histories force us to look at the world with a different set of understandings and hence assign different meanings. To be black in St. Louis is to have your reality, your history, and your identity denied, your place in the story diminished, even suppressed.

Whites remember and commemorate St. Louis's 1904 World's Fair as a grand and glorious celebration when the whole world came to St. Louis, while for African Americans it is a racially divided event, where an African, Ota Benga, was displayed as a specimen of a racially inferior people—later Ota Benga died in a zoo. Primitive Filipino tribes were "invited" to set up villages in the anthropological exhibit, where they were displayed, in a zoo-like setting, as a lower rung of the ladder of civilization while their more civilized (that is, more Westernized) countrymen were assigned a higher step in the imaginative progression. Pianist and composer Scott Joplin, the King of Ragtime, was allowed to play on The Pike with other entertainments but certainly not inside the fairgrounds where more acceptable but not necessarily more talented Caucasians performed. Whites have forgotten this story of the World's Fair; blacks have not.

The Race Riots of 1917 are another egregious example of parallel but separate histories that are the basis for persistent racism and, for many

African Americans, the basis for the conclusion that St. Louis, and America, does not recognize their history. Many white St. Louisans do not know the story, or they want it submerged; but blacks remember and have incorporated these gruesome days into their story of themselves.

Here are newspaper headlines from the July 3, 1917 edition of the *St. Louis Republic*:

100 SLAIN, 500 HURT IN RACE RIOT

6 EAST ST. LOUIS BLOCKS BURNED BY MOB TO WIPE OUT BLACKS

East St. Louis, Illinois, is part of the St. Louis metropolitan area, although the Mississippi River divides the Illinois side of our community from the Missouri side. A blue-collar town with a generally tolerated but severely segregated black population, East St. Louis in the spring of 1917 was the scene of rising racial tension, due in part to the increasing black population and white workers' resentment of the new cheap labor source. In April workers at one of the city's largest factories went on strike. The corporation found striking-breaking substitutes, many of whom were African American, and squashed the strike. Already strained relations between the races simmered and boiled over on the horrible nights of early July.

More from the local newspapers:

BLACKS ARE SHOT DOWN LIKE RABBITS

MEN, GIRLS, LAUGH AS THEY TORTURE

BULLETS PICK MOB'S PREY OUT AS THEY TRY TO SNEAK OFF SHIELDED BY WOMEN

"PORE WHITES" WARNED TO FLEE BEFORE HOMES ARE BURNED

FURNITURE MOVED INTO STREET, ALL ELSE DESTROYED

65

And:

The mobs, 10,000 strong, blood-crazed white men, women, girls and boys, then turned to the "Black Valley" near City Hall and fired it while soldiers of the Third and Fifth Illinois regiments stood by powerless. . . . The search for the blood of another race began at 6 o'clock when the mobs started fires in the negro district, about a block from the heart of the city. . . . A few negroes, caught on the street, were kicked and shot to death. As flies settled on their terrible wounds the gaping mouthed mobsmen forbade the dying blacks to brush them off. Girls with blood on their stockings helped to kick in what had been black faces of the corpses on the streets.

A county official is quoted as saying, "These negroes long have considered themselves as good in every way as white people. . . . White people were simply desperate. That is the reason underlying this outbreak." A survey taken two weeks after the worst of the rioting did show a droplet of sympathy: "Being the most disinherited of men, Negroes at times work for lower wages. Some won't join unions and wouldn't be admitted if they tried."

I quote these stories not to shock or offend but to indicate how deep is the historical racial abyss that separates black and white in our community. It is far deeper than the Mississippi River that separates St. Louis from East St. Louis. We must all remember this history and look with some kind of knowledge and empathy on the stories of countless lynchings, beatings, humiliations suffered at the back of the theater, at the water fountain, and on the lunch counter seats. Otherwise we will never comprehend the anger and the suspicions that often fuel the attitudes and behaviors of African Americans. Otherwise we will find reconciliation difficult, our identity as a community will stay fractured, our story will remain unshared.

While whites have long forgotten what happened in the summer of 1917, African Americans have not. Miles Davis, born almost ten years later, grew up in East St. Louis where the events of that summer were imprinted on black memories. The legendary jazz trumpeter in his autobiography, written with Quincy Troupe, Jr., tasted the bitter irony of the race riots that had seared his town before he was born. "That same year black men were fighting in World War I to help the United States save the world for democracy. They sent us to war to fight and die for them over there; killed us like nothing over here."[1]

Memories of such brutal slaughter persist, feeding anger and breeding suspicion and mistrust, especially when they are remembered by nearly no one but the victims and their children. As I write or study, I often listen to music; my favorite is 'Round Midnight by Miles Davis. The race riots are part of us but so is this music. Miles Davis learned to feel and play like this from the best of the world's blues and jazzmen here in St. Louis. These beautiful, soul-searing sounds are of this place. They come from our soul. This is our soul, rich, intimate, haunting, urgently identifiable.

Before he died in 1991, Miles Davis was acknowledged in his own country and abroad as a giant musical genius of the twentieth century. His death was a front-page story in the New York Times, and the world mourned his passing, while the local St. Louis newspaper ran a small obituary on an inside page. We, in his own hometown, did not see his story as part of our place, only one instance of how we ignore some of our most sublime achievements as a species and as a community.

How we understand the past determines how we behave now. Can we understand that African American slavery is the most profound exception to the American ideal that "all men are created equal"? Can we acknowledge that racism and its tragic burdens are in part historical problems and that historical amnesia will perpetuate racism and subvert our future? At the end of our Civil War, 618,000 Americans were in their graves and four million slaves were unshackled. The Union was saved, but equality of the newly free hung in the balance. Frederick Douglass, ex-slave, abolitionist, orator, intellectual, and patriot, knew that the future of the nation and of his people depended on how Americans remembered the Civil War. "America," Douglass thundered, "paid this horrendous blood price to ensure equality for all citizens." No other memory of the war could justify the awful price paid out on fields of battle, and no other memory could ensure that former slaves would be truly free.

Stand at the tomb of the Unknown Soldier in Arlington Cemetery in 1871. Look at Frederick Douglass, the man with the white hair flowing in all directions. Listen as he stands and speaks.

We are sometimes asked in the name of patriotism to forget the merits of this fearful struggle, and to admire with equal admiration those who struck at the nation's life and those who fought to save it—those who fought for slavery and those who fought for liberty and justice. I am no minister of malice. . . . I would not repel the repentant but, may my tongue cleave to the roof of my mouth if I for-

67

get the difference between the parties to that bloody conflict. . . . I may say that if this War is to be forgotten, I ask in the name of all things sacred what shall men remember?[2]

In 1883 Frederick Douglass, now an old man, was still opposing an understanding of the Civil War as a completion of the hopeful words of the Declaration of Independence. He told the crowd:

You will already have perceived that I am not of that school of thinkers that teaches us to let bygones be bygones, to let the dead past bury its dead. In my view there are no bygones in the world and the past is not dead and cannot die. The evil as well as the good men do lives after them. The duty of keeping in memory the great deeds of the past, and of transmitting the same from generation to generation is implied in the mental and moral condition of men.[3]

America remains, as it always has been, an unfinished project. The concepts of justice, equality, and the other self-evident truths upon which this democracy was founded have always been ideals. America's success and salvation remain, as Frederick Douglass defined them more than one hundred years ago, dependent upon our ability to redefine our past and hence our present, to create an American identity that encompasses the struggle of African Americans to expand our national ideals. Since the abolition of slavery African American insistence on an end to segregation and granting of full citizenship has yielded expanded legal rights to all. Every citizen of this nation must learn to acknowledge the debt we owe to African Americans for the rights we enjoy. In the nineteenth century the cause of abolition was the stimulus for reform of prisons, for greater educational opportunities, for expanded rights for women, disabled people, and those labeled as insane. A sampling of United States Supreme Court rulings in the twentieth century continues this litany of rights won at the instigation of African Americans: in *Powell v. Alabama* (1932) the court ruled that a limited right to counsel was essential in due process in capital cases; *Brown v. Mississippi* (1936) reversed as a violation of due process a state conviction based on a confession resulting from physical brutality; *Shelley v. Kraemer* (1948) forbade state enforcement of privately made, racially restricted land covenants; *Gomillion v. Lightfoot* (1960) declared it appropriate to apply constitutional standards to apportionment of electoral districts; *Dixon*

v. Alabama State Board of Education (1961) established a right of due process for students facing summary disciplinary action at state colleges.

We are a fairer, more just, more democratic nation, with the most extensive guarantees of legal equality in the world, because of the determination of African Americans. To live in this nation, no matter your skin color, country of origin, or length of residence, and no matter what side your ancestors fought for in the Civil War, is to enjoy the fruits of the efforts of African Americans, made at great cost, with tremendous suffering and much bloodshed.

Yet, despite the pleas of Frederick Douglass and hundreds more orators and activists, we remain not only a work in progress but, sadly and dangerously, a divided nation with separate histories. Our histories, and consequently our identity as a nation, has never embraced the centrality of African American experience. We have never admitted the truth that would finally acknowledge the contributions of all Americans and set us free from our burden of racism. America needs one story, a story that respects the diversity of a people whose ancestral origins include every corner of the planet but that at the same time acknowledges our country's dependence on the progress of African Americans from enforced, inhuman bondage toward equality for its own progress toward the fulfillment of our democratic ideals. A new American story will proclaim that this nation has benefited throughout its history from the consistent pressure applied by African Americans to create "a more perfect union."

In our quest for this more perfect union we have cast aside the old idea of the melting pot, that smooth, uniformly blended soup that denies individual characteristics. Rather, we favor an American stew, bubbling with a variety of ingredients but all together in the same pot. Diversity and its twin multiculturalism have become pop jargon, but the concept is valid and alive as we refine our American identity. Our differences abound. We are different based on individual genetic composition, gender, race, ethnicity, religion, sexual orientation, political convictions. We are different because of our family histories, our heritage and traditions, the intertwining cultures of our ancestors, our life experiences and personal memories. These are differences that we cannot, must not deny. Indeed we nurture and celebrate each distinctive ingredient in our American stew.

Simultaneously, we recognize that in the midst of our focus on diversity we share some things that inextricably bind us together. Each of us is born

and each of us will die. We all crave love, recognition, intimacy, and that elusive but inalienable happiness. We grieve over loss, we laugh and shed tears, we grow weary and sleep, we need food, shelter, friendship. We all seek the transcendental, something beyond ourselves and our little time upon this planet. Further we share life upon this earth, and the decisions we make now will affect the world where our children and unknown generations beyond will live. We are all in this together. Surely we want to create a world with greater peace and understanding, more safety and benevolence, less suffering, violence, and hatred.

We cannot change what is in people's hearts with talk, and we cannot obliterate racism with logic. We must act. We must celebrate new days like Emancipation Day, a day of deliverance from the evil of slavery that made the grand promises of freedom and equality more real. And we must acknowledge our debts to those who we once enslaved. For as much as we claim Irish, English, Italian, Scottish, Scandinavian, and other traditions as our own, we must claim Africa, for to her sons and daughters we owe an incalculable debt for the blessings of our great democracy. We must create a new story, a single story that acknowledges the contributions of all. We must learn to celebrate each other.

But it is not enough to change our hearts and celebrate a new story. We must change what we do. We must reawaken our sense of civic obligation. We must end the segregation of poverty that creates cycles of poverty, limited opportunity, pits of hopelessness, and devastation of lives. Does your community permit the construction of housing for low-income people? Will we, who have our personal automobiles always available, support mass transit so that those without automobiles can get to jobs and decent stores? Can we all acknowledge that the problems of the city, and increasingly of inner suburbs, are the problems of the region, that they are our problems? Can we stop the profligate waste of tax dollars on suburban and exurban developments that diverts money from the needs of an older neighborhood? A change of heart must lead to changed behavior, otherwise all we are doing is engaging in idle talk.

I am increasingly impatient with talk of racism. The idea that we can talk it out of existence is nonsense. We have had too many forums on racism, too many studies, too many feel-good sessions with nothing long-term to show for it. I once read a psychology text concerning "beliefs, attitudes, and human affairs." The point of the book was that you cannot talk people out of deeply held beliefs and attitudes. You cannot confront or elim-

inate racism with facts and rational argument, because the basis of racism is not rational nor is it based upon fact. It is an emotional belief. But people's actions tend to be consistent with their beliefs, and therefore the book's conclusion was that forcing people to behave in ways that contradict their beliefs will gradually change those beliefs. Certainly civil rights legislation in this country proves the point. But what this further suggests is that we need to stop worrying so much about rhetoric and pay attention to actions, to confront behavior. To challenge and undermine racism, something must be done, not discussed. We have choices: we can do the right thing, we can do the wrong thing, or we can do nothing. No one can escape responsibility by doing nothing. No matter which choice we make we are accountable.

But it is taking us a long time in St. Louis. One afternoon a few years ago Charlie Hoessle, then director of the St. Louis Zoo, called me. "We're putting a new engine on the Zooline," he told me, "and it's about time we named one for an African American." He didn't want Dred Scott or Martin Luther King, but rather someone strictly local whose name on a little engine would spark interest in St. Louis's African American heritage. I was delighted to hear it, and immediately a long line of African American St. Louisans paraded before me: Reverend John Berry Meachum, who, according to reliable legend, circumvented the law that forbade educating slaves by holding classes on a boat in the middle of the Mississippi; William Wells Brown, who escaped slavery in St. Louis to become a well-known writer and antislavery activist; Elizabeth Keckley, who learned sewing as a St. Louis slave and became seamstress and confidant to Mrs. Abraham Lincoln; James Milton Turner, who led the movement for schools for blacks after the Civil War and, as ambassador to Liberia, was America's first African American diplomat; Annie Malone, whose cosmetic products for African Americans made her a millionaire and a community hero; Julia Davis, the extraordinary public school teacher who made black history a part of St. Louis; Homer G. Phillips, black attorney and social and political activist; Captain Wendell Pruitt, the much decorated World War II pilot. And this was only my short list.

These are people who are honored in the African American community but people whose names too often merit a blank stare on white faces. The stories of their deeds, their lives, their accomplishments and determinations are not only sturdy and colorful ribbons in the tapestry of black St. Louis: they should be woven into the fabric of a story that belongs to all of us.

The name Charlie chose was probably the most fitting: Charlton Tandy was an activist in the fight for equal access to public transportation. In the 1880s Tandy, a Civil War veteran who had been captain of the black volunteers' state militia, took action to enforce a much ignored court order that allowed black people to ride inside public transportation vehicles, instead of hanging on the outside rails. One memorable afternoon Tandy grabbed the reins of a streetcar's horses and held them back until all passengers, black and white, had boarded the car. He was arrested, probably for disturbing the peace or interfering with lawful commerce, but Erastus Wells, owner of the horsecar line, obviously admired Tandy's tenacity, for he paid his fine.

Tandy also traveled frequently, to the east coast where he raised money to assist migrating former slaves on their trek toward a better life as homesteaders in the West. When he was past fifty, he passed the Missouri Bar exam and practiced law in St. Louis. A community center and its nearby park in The Ville, the part of St. Louis where he lived, are named for him. To African American St. Louisans, the name Charlton Tandy is well known and honored. I told Charlie that his new engine would spread that story to the larger community, who should know Tandy's story, and Captain Pruitt's and Annie Malone's and so many more.

The Zooline Railroad has been in operation since the summer of 1963. Its mile-and-a-half of track loops around the whole perimeter of our zoo, with stops at several stations and views of the animals in their natural-like settings. The Zooline has six engines, all named for local historic figures: the Auguste Chouteau and the Pierre Laclede, the fur traders who established St. Louis; the Daniel Boone; the Lewis & Clark (they share an engine); the Ulysses S. Grant; and at last, more than thirty-five years after the Auguste Chouteau made its first trip around the zoo, the Charlton Tandy. It is taking us a long time to mend the fissures that separate white from black in St. Louis, to recognize the contributions of all the people who have made this place and formed this community, to restructure the lines of communication so that we might all share the story of our accomplishments, our values, our treasures, and, yes, our burdens, too. One engine on the Zooline Railroad is not enough, but it is one station on our journey to heal our divided history and share our story.

Over the years I have discerned a logical progression that results from a shared story. First, history is power; whoever is telling the story of the past has power in the present. Therefore, useful history for a multicultural soci-

[handwritten annotations in top margin: "and what is danger when you think you've been inclusive but really you've failed? but how to do it?"]

ety must be told leaving no one out. A shared story will define the common ground and mutual aspirations that are the basis for civic action and healthy democracy. Common ground will allow us to think and act as a community or region so that we can fix what ails us, we can figure out what to do about our schools and our health care and our environment, we can be economically competitive, we will accept responsibility for poverty. We cannot construct an inclusive conversation, or business or neighborhood or community or new town square, unless we jettison the practice and the baggage of exclusivity. Finally, there are no acceptable excuses: it does not matter what kind of organization we represent. We will not succeed if we do not embed inclusivity in our mission and establish internal processes and procedures that guarantee implementation.

The Missouri Historical Society has a long-standing good track record of presenting exhibits and other programs for African American audiences. For us, programming is comparable to products in a business. Products are what attract customers. However, product is only the beginning. We cannot expect people to come or customers to buy if we contradict our product messages with messages of exclusivity by our hiring and business practices and, in our case, board composition. How we spend money is a more powerful message about who we believe really matters than the finest programming with African American themes. People know who it is that we hire, where we spend money, and who makes decisions. St. Louis, and maybe everywhere else, is a small town in this respect.

Shortly after I arrived at the Missouri Historical Society in 1988, we renovated and expanded a former Hebrew temple into our library and research facility. We established goals for minority participation in this eleven-million-dollar construction project. Just over 10 percent of contracts were awarded to minority firms. Although this represented an improvement over previous projects, I judged it an abysmal record, given that the minority population of the St. Louis metropolitan area was nearly double that and in the city itself almost half the residents were nonwhite. "Goals" and "quotas" just didn't work. Quota systems for purchases, minority goals for contracts, affirmative action for hiring have continually frustrated me, especially when such actions are seen as a self-sacrifice of some sort for business.

We have changed our strategy and our tactics. We have developed community contacts and working relationships with African American resources to insure that our job openings, purchasing needs, and planned projects are

widely disseminated. Now every hiring at the Missouri Historical Society requires a final applicant pool of three individuals. One must be African American. We then hire the best qualified applicant. For every purchase over five hundred dollars we require three bids. One must be from a minority-owned firm. We take the low bid. When we issue construction contracts, we assume that the problems of minority-owned businesses are the same as those of small business. Using methods that make work accessible to small firms also makes it accessible to minority firms. Plainly, many are undercapitalized. Mechanisms are available to compensate: break big jobs down into smaller components with more bid packages. Ease cash crunch by paying every two weeks so firms can meet payroll. Pay for materials when they are delivered to the job site. Take some risk and lower bonding requirements. Finally, be serious about doing business with African American-owned firms. Search out these companies, encourage them to bid, and respond to their needs. It will prove to be good business, achieving good work at a lower cost. In our case, the people we do business with do business with us; they become members, they attend events, they volunteer their time, they visit our exhibits, they spread the word. We cannot buy this kind of publicity. We had to earn it. Bottom line: we cannot create an inclusive dialogue about the burdens and legacies of the past unless we behave in an inclusive manner. Our goals require that we pay attention to justice, equity, and inclusion in business and in all that we do.

An equitable process brings in equitable results. An inadequate process assures failure and then results in excuses like this: there were no African Americans in the pool of job applicants, no qualified minority firms submitted bids, we tried and it is not our fault. There are no excuses. If we fail, it is because we were not committed in the first place. We must monitor our process. As Missouri Historical Society's CEO, I constantly look at not only minority hiring practices but also salaries to insure that we are not hiring African Americans for only the lower-paid positions. I want to know the average salary for nonwhites compared to whites. I get regular reports on purchases from minority firms and contracts signed with minority firms. Put the process in place, monitor it, and accept no excuses.

More than 30 percent of our staff is African American; more than 30 percent of our purchases of goods and services as well as construction contracts are from minority-owned firms. This means firms owned by African Americans, because minority in St. Louis means African American.

Numerically, a significant number of metropolitan citizens are African American, and it is African Americans who have endured a legacy of circumscribed opportunities here for two hundred years. I often hear efforts to obfuscate the issue. I have been asked, "Do you track Asian employees the same way?" No, we do not, because that is not the issue. The issue is that African Americans have been the focus of racist behaviors that have limited economic opportunities throughout this community's history despite being a majority population in the City of St. Louis and a sizable minority regionally. The numbers and the ethnicity are different in, for instance, Texas or Florida but the issues and the processes, and the results, are analogous.

This is not about being nice. It's about being just. It's also about being successful whatever your line of business, and it is about making your place a better place to live. It's about not wasting the human resources that are our most precious asset. It's about making money, providing economic opportunity, combating poverty, increasing our tax base, stimulating small business growth, expanding our middle class, revitalizing the city and inner suburbs, and subverting our legacy of racism. It's about building a shared story and a shared future, a new town square where everyone is welcome and all voices are heard.

Note

1. Miles Davis with Quincy Troupe, *Miles: The Autobiography* (New York: Simon & Schuster, 1989), p. 15.
2. Frederick Douglass, "The Unknown Loyal Dead," May 30, 1871, in *Frederick Douglass: Selected Speeches and Writings*, ed. Philip S. Foner (Chicago: Lawrence Hill, 1999), p. 536.
3. David W. Blight, "'For Something beyond the Battlefield': Frederick Douglass and the Struggle for the Memory of the Civil War," *Journal of American History* 75, no. 4 (1989): 1175.

Making Connections

MY PIECE OF PUDDLED IRON FROM ISHPEMING'S LAKE Angeline mine sits on my office bookshelf. It is one of my favorite and most evocative objects. Friends who know me well smile gently when it catches their eye, while people less well acquainted wonder if they should ask about it. It's not especially beautiful but its intriguing elongated shape is impossible to categorize, and its mottled, indeterminate color varies curiously according to the room lighting. It's dense, heavy for its size, and that is not its only resemblance to an anchor, for it is an anchor, one of the moorings that grounds me in the past and reminds me where I came from, who I was, and consequently where I am going and who I am becoming.

Fragments of melted and hammered pig iron litter the landscape of the now-abandoned mines in the region where I was born. That iron mining culture, on the hard, harsh, and beautiful shores of Lake Superior, formed me as surely as it formed the iron fragment that adorns my bookshelf. Fingering my piece of puddled iron, I feel something more than its rough, irregular surface; I experience an emotion akin to what I feel when I stand at Lake Superior's edge, bracing myself against the high breeze whistling down from Canada, reveling in the sounds and the scents of the world that encompassed my younger self. It all comes back to me, a visceral, indescribable reality that assures me that I am who I was, that my stories of myself have endured. This misshapen bar of iron is a personal mini-exhibit, and a powerful one.

Puddled iron from Lake Angeline mine. Photograph by Sue Archibald, 2003.

The most powerful exhibit at the Missouri Historical Society is not in the exhibit halls at all, but instead is in the collection storage areas in an entirely separate building. Katherine Dunham, the famed dancer and choreographer, once remarked to me as I pushed her in her wheelchair through the storage areas, that "she felt the presence of ghosts from the past." Storage level two is large-object storage: furniture, relics from factory and industry, products of Missouri and St. Louis area craftsmanship. As I tour people through the area, their initial reaction is one of amazement at this gigantic antique collection, often, I suspect, surreptitiously wishing they could raid the collection to furnish their own homes. But I always emphasize that we do not collect antiques, we collect stories, stories of people who made this place, people who struggled with the same issues that perplex us even now. "This," I say, "is a place to discuss what we have done well, where we have fallen short, and how we can do better. It is a place for coming together and appreciating how we differ and examining how very much we share. Objects, photographs, works of art, documents, folktales and buildings are symbols—symbols for the thoughts, actions, and aesthetics of people who made our place. They are our mirrors into ourselves and windows into each other, but they are mute unless we use them properly."

There, I point out, is Tony Gagliarducci's knife-sharpening cart, which he wheeled through St. Louis's south side neighborhoods for nearly sixty years, sharpening any dull blade presented to him. And there, I say, pointing in another direction, is famed jazzman Singleton Palmer's tuba, which entertained hundreds of thousands over many, many years. "Sing," as he was affectionately known, presented this tuba to me at his last concert when he was old and ill and only days from death.

"That," I explain as my guests stare at an enormous copper kettle, "is a nineteenth-century vat from the Lemp Brewery, once the largest in St. Louis, owned by an ill-starred family prone to suspicious suicide, a casualty of Prohibition." And there is the actual elk skin–bound journal kept by Meriwether Lewis, as the Corps of Discovery struggled to traverse the spine of the continent somewhere on the Montana–Idaho border. These things I tell them as I steadily transform antiques into stories and meanings. Without the stories these artifacts would be quaint and even valuable, but useless to a museum. Artifacts stimulate memory, make the stories tangible, make the past palpable, but without the stories they are devoid of meaning.

Emily Stine's story is emblematic of this premise. I have told Emily's story in many places, to many different people. The inevitable response to the only trace she left behind reinforces my contention that the past speaks to us, that an object from the past and the story that goes with it can bring us together in a story that we can all share.

Emily Frances Stine was born in 1841, and she died that same year, so we cannot invoke her as a significant figure in history. Her existence was not even recorded in an official census. Yet Emily has had a profound effect, not only on the family who lost her so soon, but also on me, and on the many people who have experienced what she left behind in her short time on earth.

In our collections is a plaster cast of the peaceful face of the infant Emily, given to us by Stine family descendants. Even they know almost nothing about this child. The facts of Emily's brief life are far less important than the effect of this delicate plaster mask, for it is a tie across all kinds of boundaries, a link with many generations.

"Emily's mother made this mask," I told guests in a behind-the-scenes tour of our collections. An awestruck silence followed. Then a woman said quietly, "I know why Emily's mother made this mask." We all know why, if we think about it.

This was an act of love, remembrance, and a desire never to forget. It was not the sadness of death that Emily's mother wanted to remember, but rather a beautiful, too-brief life, a bittersweet act of love and tragedy and loss that calls us all together in shared humanity. We really don't need to know anything more about Emily.

We do know about the Stine family, from other objects and documents. Emily was named for her mother, Emily Miller, who married fellow Pennsylvanian Jacob Stine in 1821 and traveled by barge down the Ohio River, along with her father and possibly others of the Miller family. Eventually the Stines and most of the Millers settled in what was then the village of Carondelet adjacent to the city of St. Louis on the south. Jacob is variously identified as an editor and educator, a grocer and tavern operator, a businessman who owned a shot tower on the bluffs of the Mississippi. He purchased a rather impressive residence called Pleasant Prospect; although the house was razed more than a hundred years ago, we know its exact location on Virginia Avenue, then called the Stringtown Road. When Carondelet was incorporated as a town in 1832, Jacob was register of the first Board of Trustees. His brother-in-law was a mayor of Carondelet and married the sister of a Missouri governor. Another Miller owned the *St. Louis Times* newspaper and evidently joined abolitionist Elijah Lovejoy in his antislavery efforts.

Jacob and Emily Stine had at least six children besides the daughter who was named after her mother. Several of the girls attended school at Lindenwood, in St. Charles west of St. Louis across the Missouri River, and wrote home dutiful and sometimes lively letters. One of the Stine boys, Henry, joined a wagon train west in 1850, and his letters to his mother as well as the diary of his journey give us a personal view of the gold rush era. Henry's granddaughters once took a summer trip to all the landmarks he had mentioned in his journal. We could with standard tools of historical research, and sufficient time, relate more about the Stine family and their place in our local history, but none of it would bring us as close to them, and to the past, as the plaster cast of Emily's tiny face.

Immediately after her infant daughter died, her mother made this plaster cast—a death mask. Infant deaths were sadly quite common in 1841, and parents were well aware that they could lose a child, especially a baby, to sudden and deadly illness. Was Mrs. Stine excessively morbid and macabre? Sentimental and pathetic? Or did she, and many other parents in 1841, love and cherish her children in a way we can apply instantly to ourselves?

Emily, in this plaster face, is a profound reminder of common concern, a timeless symbol of what we all share, past, present, and future. Hers is a story to cherish and to retell, a place to find common ground that diminishes our differences and divisions, a story for us all, for every race and nation and belief. The most profound effect of an artifact is emotional, its ability to make us call to mind another time, another place, a story, and perhaps a memory.

The death mask of Emily Stine. Missouri Historical Society, St. Louis.

A memory, a story resides in a little sugar spoon. An antique spoon is of interest to all kinds of collectors, but as a collector of story and memory, I value Sharon's silver spoon above many a costlier one. Sharon, whom I've never even met, was serving refreshments after a meeting, and a friend of mine who was present commented on a tiny ornate spoon in the sugar bowl. On it was engraved 1883 and the letters AK.

"When I was a child," Sharon related,

Miss Alma Kreckel, who was born in 1883, occasionally babysat for my sister and me. She lived alone, a retired schoolteacher, a maiden lady who had spent all her life in Washington, Missouri. She was very proper, as you might expect, but I think we must have enjoyed her company because I always remembered her fondly. As far as we knew she had no family. When she died, almost forty years ago, there was an estate sale of her belongings. My sister and I went just out of curiosity, but also as a kind of memorial to Miss Alma and to our own past. I bought this little spoon, and I use it often, so I can talk about Miss Alma. It's a way of keeping her memory alive and of recalling my own past.

My friend asked permission to share this story, and Sharon responded, "Of course! It's one more way to continue Miss Alma's story." Sharon treasures that little spoon, and I don't expect to be accessioning it for our collections in the foreseeable future. But we do have the story, and that may be its most meaningful value. Silver spoons, and all the other artifacts we collect at the Missouri Historical Society, are symbols of stories and memories. It is our business to collect not just the spoons but their intimate stories as well.

The Missouri Historical Society has a superb collection of daguerreotypes. They have a special quality of intimacy: the silver-coated copper plate I look into today is the very plate that Thomas Easterly slipped into his bulky camera in 1847. It is the one and the only one of its kind; there was no negative, no print, only this mirrored image from the plate, an artifact that was present at the scene depicted in exquisite detail on its surface.

Keokuk stares into my eyes through the silvery emulsions of the image Thomas Easterly made and penetrates into the present from more than a hundred and fifty years ago. This plate preserves the very light that long ago

touched the stern, commanding face of the Sac/Fox leader Keokuk. It is an eerie, otherworldly experience.

Keokuk was an old man when Easterly caught his image in the daguerrean gallery at Fourth and Olive in St. Louis, perhaps not old in years, but beaten down by hardship, intertribal conflict, and the wreckage of his culture. The entire story of what had happened to Keokuk and his people in the 1830s and 1840s is a repetitive episode of treachery and inexorable loss. In 1837 Keokuk's people capitulated to the onrush of white settlers and signed a treaty agreeing to vacate the lands where they lived, in what we call Iowa. Their departure, or more correctly their removal, took many years and was just completed when Keokuk and a small band arrived in St. Louis, probably with a traveling circus, and stopped at Easterly's studio to have their portraits taken. They were a defeated and degraded people, remnant of a proud and stalwart tribe, and Keokuk would die the following year.

But when I look into his image in that nearly magical daguerreotype, I do not see defeat. Defiance, perhaps, or anger, or a cold, hard resignation. I see dignity in that lined face, pride in a heritage that long preceded the white interlopers who took the land his people cherished, strength mingled with sorrow, age, and fatigue, but not defeat.

When Keokuk died, he was buried in Kansas, the land where his people had been taken. Decades later his body was disinterred and reburied in Iowa, near a white man's town named for him. The *AAA Guidebook* even points out his gravesite: Rand Park, east of US 61 on Lake Keokuk. Would Keokuk find this an honor, or a final degradation?

From what Oliver Wendell Holmes called "the mirror with the memory," Keokuk the Watchful Fox stares into me and my world with a chilling intensity, and I find it increasingly perilous to interpret his expression. I do not know this man, his people, their suffering. I do not know his times or his places, though I have been to that white man's town named for him, and very likely I have traveled along many of the routes where the Sac and the Fox were driven time after time from a homeland. How can I question this noble and defeated man about his life and his passion, when he searches my "white" face with a force that I find so challenging, even inhibiting? Dare I put to him the questions I find urgently beating in my mind?

Watchful Fox, how did you explain to your people the mangling of their world? How did you endure the loss of a world storied by your ancestors, nurtured for your children? How did you create a new place, map

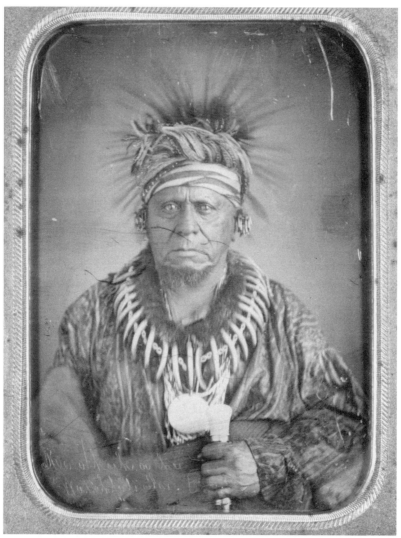

Daguerreotype of Keokuk the Watchful Fox. Missouri Historical Society, St. Louis.

for yourselves an alien land, bring your old stories and reclaim your past in a new and foreign place? Or did you merely slip away into oblivion, as no doubt your pursuers would have desired?

The silvery image of this stalwart Indian does not answer. We cannot reclaim the past but only use our own human experience and our historical imagination to collect both the burdens and the legacies left for us and to

cultivate both empathy and sympathy for points of view that initially seem foreign and unapproachable. And even then we cannot know all of the past, not Keokuk's, not even our own. But perhaps it is enough that we still ask the questions.

These questions, even without obtainable answers, are powerful ties of shared humanity, past, present, and future. The daguerreotype of Keokuk is a message of strength and purpose, of emotions that transcend time. This silvery image is a timeless and powerful symbol of what we have all known in some way: pride in a heritage, weariness beyond our years, hope deferred, sorrow, and dignity. This is a story common to all human experience despite the vast differences in time and detail. The story in that face diminishes to pettiness the things that divide us from him, and from each other.

I can look at the faces of Emily Stine and Keokuk the Watchful Fox and know a part of their stories. But Nettie Weber's image was nowhere, so far as we know, preserved. What we know about Nettie Weber comes from basically two sources: her farm diaries that she kept from 1891 through 1909, which her great-granddaughter inherited, and research conducted from standard sources like plat maps and census materials. We could learn more from available documents and additional research, but Nettie Weber's journals alone are sufficient to bring to life an individual and a way of living, both long gone but still palpable in the strong hand, writing swiftly over those now-faded pages of cheap but sturdy notebooks.

Nettie Weber, at the age of fifty-one, was determined to have her own farm. So she packed up her four youngest children and moved from St. Louis, where her husband remained to continue his carpentry trade, to Jefferson County, Missouri, where she had purchased property near some of her relatives.

"I must work every day, rain or shine," Nettie wrote on June 24, 1904. Her day began at dawn, or earlier, when she made up the fire in the kitchen. Farmwork calls for hearty meals, and there was breakfast, a noon dinner, and supper to prepare, as well as "lunch" at midmorning and midafternoon. She had cows to milk and other animals to tend, eggs to gather, butter to churn and bread to make and her own soap, too. "I washed," she recorded one summer day, "began at 9 a.m. and washed til dark and then did not get the socks done."

Nettie's determination to become a farmer made what was likely an unusual type of marriage at the turn of the last century. While Steve Weber had no interest in farming, he did travel the sixty miles between his home in

St. Louis and his wife's farm for visits. He sometimes sent money—always a scarce commodity on the farm—and once he bought her a gasoline oven that, at least initially gave her some trouble: "The fire went out twice while I was baking the cake." Steve built her a shed over the cistern to keep the meat cool, mended a gate, helped with the scrubbing, lent a hand with the planting. According to Nettie, he was definitely not meant for farming: "in looking at the almanac, I see he has planted the peas at the worst possible time." But in his seventies, "very feeble" as Nettie reports, he came down to the farm to stay.

The Weber boys did the heavy work with the wheat and oats, but most of Mrs. Weber's land was for truck produce ("Mr. Becker of Maxville was here to see about engaging our strawberries" and "Sold Matthias at his general store a half bushel of tomatoes"). Nettie herself planted and harvested lettuce, asparagus, cucumbers, turnips, several kinds of potatoes, all kinds of beans and berries, and more. A few fruit trees came with the place, but Nettie wanted real orchards. "I wrote to Mr. Kellogg of Three Rivers, Michigan, for his book entitled *Great Crops of Small Fruit and How to Grow Them.*" She experimented with apples, peaches, cherries, quince, plums, grapes. Her summer days were busy with cutting and picking, bundling and crating her fruits and vegetables, each day's crop sent off to Pevely, Antonio, Kimmswick, Festus, Herculaneum—place names we can still find along the Mississippi River, towns that remain but in forms and functions that would be mostly unrecognizable to Nettie Weber and her sons.

After Nettie died around 1911, the remaining family decided that the farm, never a profitable investment, was not worth keeping. Rather than merely abandon the house and the outbuildings to the hazard of an uncontrolled fire, they themselves burned them down, after saving household goods and such family items as Nettie's diaries. Somewhere north of Pevely, Missouri, we might be able to find random traces of Nettie's clapboard house or the descendants of her carefully planned orchards. But we have more vivid evidence of the life and work of this otherwise obscure and hardy woman of a century ago. We can find it in her words.

But we can't know everything about her, only what she chose to tell. We don't know why she determined on a farm life. Did she loath the crowded, dirty urban life of 1890s St. Louis? Did she long for the clear skies and green hills of her kin's homeplace? Or was she bored, stagnating with a carpen-

ter's small house to look after and her six offspring mostly grown? And where did she get the money—and the courage—to start out on her own?

I know only a little of farm life, but I do know that running a farm is hard work, and I can imagine, with Nettie's help, how even more difficult it must have been a hundred years ago. But I can catch only a glimpse of Nettie Weber herself in those diaries. Through that little I can experience a bit of the past, a foreign country in some respects but one where people very much like you and me labored and laughed and loved, one that was full of human joys and worries and ambitions, a place and its inhabitants that I can connect with through what has been brought into the present, a story I can share with the rest of the community as we develop our own shared story for future generations to employ.

The past is inscrutable in many ways. There is so much we can never know, and so much more we can only surmise. All we can know of the past is what has been hauled into the present, what has survived through purposeful preservation in objects, documents, and stories or through merest happenstance. Often we don't know which, or why.

Reeve Lindbergh, youngest child of the famous aviator, visited the History Museum just after the Missouri Historical Society opened our latest Lindbergh exhibition in 2002. She brought with her a small commemorative medal she had found among her mother's belongings after Anne Morrow Lindbergh's death the year before.

"My mother had kept it neatly wrapped in a drawer with some scarves and handkerchiefs," Reeve told me. The rather plain gold medallion, with a faded ribbon and lettering that indicated it was from a 1927 reception in New York, bore no indication of historic value or personal significance. "I don't know why she kept it," Reeve remarked with some puzzlement, "and I can't recall her ever mentioning it."

Overwhelmed with the flood of presents, proclamations, and trophies thrust upon him after his flight to hero status, Charles Lindbergh deposited most of these gifts with the Missouri Historical Society for both safekeeping and occasional public display. Our Lindbergh Collection has an abundance of medals and commemorative coins, struck especially for Charles on his return from his history-making flight. New York was his second stop, after Washington, D.C., on his way back to St. Louis. The city's mayor James J. Walker presented him with an elaborate medal, with red enameled banners and engraved with an image of the *Spirit of St. Louis*, from the city

and New York's American Scenic and Historic Preservation Society. The medal Reeve gave us was no such distinctive artifact. Most probably it was the badge of the reception committee that honored Lindbergh on his return to New York on June 13th. Was it given to Charles, or perhaps to his mother, who was honored along with him in the prodigious welcoming ceremonies held everywhere he went? Did Charles himself have a sentimental attachment to this token? Or was it merely overlooked when he presented nearly all his medals, gifts, and trophies to the Missouri Historical Society?

And why did Anne hold on to this piece, evidently with some care? What did it mean to her? She and Charles hadn't even met in June of 1927. Did it remind her of the life Charles had had before his life with her? Or of a trip to New York she later shared with Charles, or a person on that committee who later became a closer associate? Did he ask her to keep it as a memento? Or was its presence in her drawer in her last home in Vermont a mere accident of history? We can only speculate.

"Someone else's silence is a vast field of temptation, an open invitation to project one's own conscious or unconscious thoughts." Reeve wrote these words in her memoir of her mother's last years, when Anne Morrow Lindbergh had, through age and illness, all but lost her ability to communicate.[1]

But the silence of the past is not merely a void for us to randomly fill on our own. It is a gateway that gives us access to ourselves, a mirror that shows us both beauty and evil and how choices are made between them.

This anonymous medal evoked a conversation not only about Reeve's parents, her questions about their past before she came into their world, grief at the loss of a parent. We also spoke of what we value and why, about the power of an artifact, whatever its provenance, to bring us into some kind of communication with the people who have gone before us. By looking at this medal from June 13, 1927, we can make a connection with a man whose place in history is assured, who is beyond most of us in time and talent and accomplishment, and with the woman who married him but shaped her own identity and her own achievements. But Charles and Anne Lindbergh were also parents whose first child was the infant victim of kidnap and murder, and they themselves were children who grieved at the loss of their own parents; they suffered criticism and condemnation for views and statements considered pro-Nazi, anti-Semite, even traitorous; and they thrilled to the beauty of the skies, the earth, the sea. They were people of an-

other time and extraordinary lives but who shared with us emotions and experiences common to all humankind.

Our curators and historians with their meticulous research and abundant resources will no doubt discover more facts about this New York reception committee badge. But it may, despite their efforts and their expertise, retain much of its silence. We cannot know everything of the past. We can only know what's left behind, and often that is of sufficient value for the continuing conversation that links past, present, and future.

Among the artifacts that two Chinese brothers left behind is a small shrine packed with objects and symbols but devoid of explicit explanation. Nonetheless the bizarre (to Western eyes, that is) little shrine is an abundant source of memory and history for the St. Louis community. It tells a story of the values our immediate past has embodied, an archetypal example of appreciation of the diversity and of community solidarity around an issue of mutual concern.

Gee "Sam Wah" and his brother Hong emigrated from Hong Kong in 1910 and learned the laundry business in San Francisco. After a short stop in Chicago, they came to St. Louis where they established a shop in 1922. For more than fifty-five years they operated the Sam Wah Laundry in the city's Central West End, living in a tiny room in the back furnished with a gas stove and two sleeping mats, a conglomeration of photos, calendars, and newspaper clippings adorning the walls. They worked their trade from before dawn until well into the night, faithfully communicating with their family members who remained in Hong Kong and earning a position as a neighborhood institution. Most of their equipment was ancient and out-of-date, but their reputation for superior work and dedication to their craft was newly promulgated with every order.

In the late 1970s, urban renewal endangered their well-respected livelihood. The Gee brothers, then in their eighties, were devastated by the "progress" that would remove them from their business-cum-home, which was, it is true, in a state of dilapidation that was well below city code and a potential danger to both the Gee brothers and their customers. With only a halting command of the American language and scant knowledge of the bureaucratic maze intrinsic to the urban renewal of the period, Sam Wah and Hong were helpless. Happily they soon discovered that the loyalty of their clientele and the esteem of their neighbors were a source of support that could salvage the life they had made in St. Louis. Through a long process of

negotiation and compromise, the informal but effective "Save Sam Wah" movement did save the laundry and allow the brothers a reprieve. They continued in the time-honored "Chinese laundry" operation, in their cramped but now rehabilitated home and headquarters until 1986, when Gee Hong died of heart disease, his brother having passed on shortly before at the age of ninety-four.

Several years passed before the extraordinary little shrine entered the collections of the Missouri Historical Society. But one summer morning ten years ago I found a carefully packed box, and some papers of documentation, in my office. Perusing the letters and news clippings I discovered the story of the Gee brothers and the community who rallied around "St. Louis's last Chinese laundry." It was a story that crossed racial, cultural, economic, and even political boundaries, an account that an often divided city can use as we seek additional ways to connect and relate.

But the shrine puzzled me. It consists of a smiling Buddha of patterned, brightly colored ceramic, a pair of heavy marble candlesticks, and two green plaster figures in elegant Chinese costume, a male and a female. Strung between the two faux jade statues are a pair of rosaries; pinned to the rosaries are two lapel buttons, a red-and-white "Save Sam Wah" button and the other featuring flags of the United States and of China. The whole tableau was mounted in a three-sided cardboard box, probably from a Chinese import shop, considering the Chinese characters along the side, and protected by a length of wire that I assessed was fashioned from a coat hanger. What did this arrangement signify? A historical metaphor for the sixteenth-century incursion of the Jesuit missionaries into the Classical Kingdom? An attempt to maintain traditional beliefs in the midst of a dominant but welcoming culture? An amalgamation of the past and the present? The Gee brothers, who kept the shrine in a prominent place in their laundry along with an enormous old rubber plant that wound around the rafters, never explained. The artifact maintains its silence, and we interpret as best we can.

A framed sketch of a Union soldier in Civil War uniform, a recent gift to the Missouri Historical Society, is another example of this phenomenon. The sketch, according to our curators' preliminary studies of the picture, was probably done long after the Civil War, perhaps even in the early years of the twentieth century, and most likely copied from a tintype, the kind of photograph a young soldier would have had done on his way to a Civil War assignment. Analysis of the paper and the style will no doubt reveal more, but not all, never all.

The shrine of "Sam Wah." Missouri Historical Society, St. Louis.

The soldier in the sketch is an African American named Elijah Madison, born into slavery in 1841, probably on the plantation of a man named Coleman who came from Virginia to establish hemp production on land near what is now Babler State Park in St. Louis County. This much, and more, we know from his descendants who donated the sketch and Madison's certificates of promotion and discharge from the U.S. Colored Infantry. But we, and they, don't know his whole story.

CHAPTER 4

How and when did Madison enlist in the Union Army? Federal re-
cruiters had announced that the army would accept any able-bodied man of
African descent, no matter where his owner's allegiance lay; and some forty-
two thousand African Americans in border states, including Missouri, re-
sponded to this call to fight for their own freedom. Only men of military age
were eligible, so many slaves had to leave families behind as they escaped
and sought an army recruiter's office. Sometime in the late fall of 1863,
Elijah Madison was likely among them, fleeing from the Coleman planta-
tion to St. Louis, where he was mustered into the Union Army's
Sixty-Eighth Regiment of the United States Colored Troops at Jefferson
Barracks. We have no record of his emotions or his motives; these were left
behind in the past, but a past inhabited by humans much like ourselves with
those same, or very similar, needs and yearnings and spirit.

Elijah Madison served the Union well, as indicated by his promotion to
corporal in October of 1865 and his discharge certificate of a few months
later. Madison's complete service record is yet to be discovered, but the cam-
paign actions in which his regiment, and other U.S. Colored Troops, par-
ticipated prompted a commanding officer to comment that "the behavior
of the men . . . was a convincing proof that the former slaves of the South
cannot be excelled as soldiers."

We don't know why Elijah Madison returned to the vicinity of the
Coleman plantation he had furtively left on a fall or winter night a few years
earlier, but something about that land and the people he had left there must
have been in his bone and blood, for he did return, to farm on land not far
from where he had been held in bondage for over twenty years. He married
another former slave named Elizabeth West, with whom he had fifteen chil-
dren, and he became a Baptist minister. Among his descendants, a grand-
daughter recorded, have been doctors, lawyers, teachers, seamstresses,
realtors, singers, military men, engineers, coal miners, Pullman porters, mail
carriers, musicians, and entrepreneurs. And through all of them, this simple
sketch now in our collections looks out at a world he helped to make.

During the Civil War Frederick Douglass encouraged the efforts to al-
low African Americans to serve the Union. A former slave and a powerful
man of words, Douglass wrote, "Once let the black man get upon his per-
son the brass letters, U.S., let him get an eagle on his button, and a musket
on his shoulder and bullets in his pocket, there is no power on earth that can
deny that he has earned the right to citizenship."[2] Elijah Madison may never

have heard those words, but whoever made the sketch highlighted Madison's belt buckle, bearing the brass letters U.S., with a patch of yellow.

Slave, then soldier, then finally citizen, Elijah Madison is far from us in time and experience. But we can walk the streets and the land he walked, perhaps even come across his grave in the African Baptist cemetery near the old Coleman plantation. We can share his story, what we know of it and what our historical imagination can tell us, through the sketch of a young soldier, through carefully researched records and extant documents, and through the long-told stories of his descendants. In Elijah Madison and his story we can develop connections with the past that are crucial for ensuring a future for our descendants and his. We can explore the humanity we share with the generations that have gone before us and sustain it for the generations to come after us. Thus Elijah Madison's story becomes our story too.

From Elijah Madison to Robert Campbell is a great leap, not in time for they did share the planet for some years, and not in geography, for Campbell's St. Louis home was only about thirty miles east of the site of Madison's bondage and later farm life. But fur trader and millionaire businessman Robert Campbell had little else in common with the former slave/soldier/minister, and Campbell himself lived in two very different worlds. Even today the vast disparity between Campbell's worlds is startlingly apparent. The country of the Upper Missouri and Yellowstone River, the parabola of the Great Plains, and the abrupt eruption of the Rockies makes a stark contrast to the growing commercial city of frontier St. Louis in the 1820s and 1830s.

In 1988 I reversed Robert Campbell's trek from St. Louis to the west when I moved from the Montana mountains and plains to this city on the Mississippi River. For me this was a wrenching transition from an out-of-doors life and open spaces with vistas to the vanishing point, to the confinement and foreshortened perspectives of urban space and environments—rearrangements and camouflage of that natural environment that was for a long time so necessary to my own sense of self. And thus I can discern a connection to Robert Campbell.

Reading Campbell's journal of a trip he made to the Rockies in 1833 resurrected my own old yearnings for the plains and mountains and made me wonder at the disparities between his life as a fur trader and his other life in the increasingly urban environment of St. Louis, his subsequent life as a denizen of Lucas Place, a wealthy enclave just west of what was then the city

boundary. It is easy to forget in the elegance of his house, still remarkably extant, that this was a man of the untamed and unsettled West, a man who possibly longed for the freedom and challenges of his former life while comfortably installed in his mansion. I imagined his recounting of this other life in the wilderness, the enthralling stories of high adventure he told in his genteel home as the hardships of the frontier dimmed, and time and distance magnified the romance of the West and the uplifting intimacy with nature.

From his journal I know that he was not immune to the enchantment of the rugged, isolated, nature-saturated life of the West. I understand this. My late twentieth-century experiences with both the West and with St. Louis also impart a dramatic contrast, although less spectacular than in Campbell's lifetime. The juxtaposition of his life in the wilderness with his existence in the citified environment of St. Louis is an incongruity that I can faintly glimpse. Campbell was a prominent figure in society. While he dealt with asocial trappers and warriors of the plains, he was an owner of St. Louis's first-rate Southern Hotel, an elder of the Presbyterian church, a founding member of my own institution, the Missouri Historical Society. By the time he died in 1879, St. Louis had changed from a raucous frontier capital to a burgeoning industrial and mercantile city with muscular branches of trade extending beyond the commercial shoots Campbell and his mountain man contemporaries had planted.

Members of the living generation always assume that they live in times of unparalleled change. But doesn't the transition from quill pen to typewriter seem more consequential than the replacement of typewriters by word processors and the Internet? The locomotives and railroad tracks that replaced canoes and keelboats wrought changes at least as momentous as the airplanes that in their turn replaced trains. Change was as much a benchmark in Campbell's life as it is in our own.

Even from his windows on the city on the east side of his home he must have seen the approaching decline of Lucas Place. By the end of the nineteenth century Lucas Place—now Locust Street—was seedy, its homes poorly maintained and even turned into rooming houses. Finally the stately homes, except for Campbell's, were razed and houses of commerce and industry erected in their stead. In the second half of the century just passed, the business and factories that once thrived where Lucas Place had reigned were abandoned as occupants moved or disappeared in economic dislocations.

Campbell's mansion is a testament to his wealth and taste, and also a solitary vantage point, bereft of its original surroundings, from which to

consider the profound changes in our city, our infrastructure, our community, our civic virtues, and the consequences of decisions made by those who preceded us in this place. For just as we have received the legacy of those who came before, so too do we shape a legacy in our own day that burdens or blesses those who succeed us. In Robert Campbell we discover ourselves, expand our understanding of the potential implicit in our own humanity; and through his windows we can examine and evaluate decisions he and others made that shape the parameters of our own lives in the place we, and he, call St. Louis. So while the past is a foreign country in many respects, if we listen carefully enough, stare long enough, and stand in Robert Campbell's doorways, we can find harbingers and explanations for our own world and our own time.

The differences between my life and the life and times of Robert Campbell are enormous and quite obvious. But it is our similarities, our connections and common ground, that are more enduring, persistent in my evoking the past through his journal and letters, his mansion, and the remains of both the city and the wilderness he knew.

Robert Campbell's mansion has been undergoing a magnificent renovation, and its continued existence as a memory place in our story is assured. Too many of those memory places have been neglected or purposefully destroyed in the name of progress. In too many instances we have only a ghost, a picture or photograph, to call those places to mind, but these ghosts are often enough to make a viable connection.

The makers of pictures have always rushed to scenes of destruction, and their collections have provided us with vivid glimpses of St. Louis's past. In the 1960s, a photographer named McCrea took his camera to the future site of the baseball Cardinals' Busch Stadium, where the demolition of some of the buildings of Cupples Station, a network of nineteenth-century warehouses, was underway.

One of his pictures caught the sorrow of the moment. Amid the rubble, in a fragment of a bas-relief in the Victorian classical style of intertwining leaves and flowers, the face of an anonymous muse or maiden looks with ineluctable sadness over the remains of the structure she had so recently graced.

In 1894 Samuel Cupples and his partner Robert Brookings started their remarkable complex of warehouses near the Eads Bridge tunnel. At that time the man-made tunnel, which ran under several blocks of downtown

St. Louis, daily accommodated scores of freight trains; and Cupples pur-
posefully built his warehouse complex close to its mouth. Thus trains could
pull right into the appropriate warehouse; spur lines came off the main
tracks for this very purpose, eliminating multiple movement of goods and
ably serving most of the city's merchants.

(By the way, that tunnel still winds usefully under part of downtown;
shored up and refurbished, it serves MetroLink, St. Louis's light rail system,
in its passage between Busch Stadium and the Illinois side of our metropol-
itan region.)

Designed by the local firm of Eames and Young, the architects respon-
sible for some of the Richardson Romanesque mansions of St. Louis's
Central West End, the eighteen warehouses, each five to seven stories tall,
were massive structures strikingly modern yet simple and sturdy in both de-
sign and construction. The individual buildings were by no means identical
but rather coordinated into a related whole. All of them were of brick with
deep-set windows, rounded arches, and the occasional stone molding. Some
of the more prominent facades featured terra-cotta garlands or medallions,
like the one our sad-eyed lady fell from under the wrath of the wrecking
ball. Necessities like fire escapes were cleverly blended into the brick of the
wall, actually contributing to the design. By 1900 Cupples Station was re-
ceiving acclaim throughout the country for its practical utility, the crafts-
manship of its design, and its example of commercial elegance.

But sixty years later some of the Cupples warehouses had fallen into dis-
repair; as locomotives grew larger and larger and the logistics of commerce
changed, the Eads Bridge tunnel no longer brought an endless succession of
freight into the depots; the Poplar Street Bridge spanning the Mississippi
River needed space for its approaches, and the Cardinals needed a new sta-
dium. Some of those outdated buildings would have to go.

And so, slowly they went. In addition to deliberate demolition, a sum-
mer fire in 1965 took its own toll on the Cupples complex. A few more than
half the original buildings remained standing when Busch Stadium opened
in the spring of 1966. For many years baseball fans on the west side of the
stadium could gaze out over the remaining warehouses and wonder whether
they dared walk down Clark Street amid those near-derelict buildings.

The Poplar Street Bridge, having taken the Cupples units in its path, was
finally finished about eighteen months after the stadium. Some St. Louisans
were momentarily puzzled by the sign that indicated the bridge's entrance,
having forgotten that it was officially named the Bernard F. Dickman

Memorial Bridge, in honor of the mayor who cleared the riverfront in the hopes of an eventual memorial to westward expansion. In the sixties we still were quite cavalier about wiping out our architectural past. No wonder the woman in the shattered frieze looked so melancholy.

There is a part of each of us that yearns for permanence in relationships, in places, even in life. As humans we are always changing, growing, developing, or in later life decaying. As an alternative to change, which is sometimes frightening and disorienting in its pace, we seek links, anchors, tangible reminders of the past that are assurances of a future. This is why historic preservation will always have a deep value in a community. This is why the remains of Cupples Station so well serve our region, past, present, and future.

For decades ideas and proposals for redevelopment of the Cupples complex surfaced and sunk and surfaced again. In the late 1990s, St. Louis writer William Gass toured the rotting magnificence of the historic warehouses and noted in a photo-essay that "the buildings of the Cupples Complex are so beautiful, yet every brick is sad." But some of the sadness is being scrubbed and polished and renovated away. In February 2001 an elegant hotel opened in the Cupples complex; office and retail space, housing, restaurants, and a microbrewery are in the mix under serious discussion for the remaining buildings.

Perhaps our classical lady lying in the rubble in 1965 is an image of Mnemosyne, the goddess of memory and mother of the Muses who inspire humans to the highest ideals of the arts and the humanities. A modern novelist invokes her in archaic supplication: "O Memory, who holds the thread that links my modern mind to those of ancient days." Down at the Cupples complex, it's brick that links our modern mind to older days, and with these bricks we can rebuild links from the past to now and into the future.

Like the face in the frieze, a fragment can initiate a cascade of connections, linking us to the past beyond ourselves and into that future of which we are the past. Developing *Seeking St. Louis*, the most extensive exhibition that the Missouri Historical Society had ever undertaken, was a challenge and an opportunity, an experience in exploring the implications of artifacts that bring us stories from the past. The pediment of Colored School No. 4, one of the literally thousands of objects under discussion for inclusion in the exhibition, inspired one of our exhibit staff to muse on the long reach of objects. "This artifact," our exhibit coordinator told me, "is more than a hundred years old, but it has echoes from a hundred years before that."

97

The public schools in St. Louis finally gave names instead of numbers to schools for their African American students in 1890. The building that was once Colored School No. 4 is now L'Ouverture School, named for an enslaved Haitian who had led a 1791 slave revolt against the French on his native island. White hegemony offered little opportunity for black models, and this hero from a distant time and place lent his name to several schools.

The Haitian Revolution was a significant factor in the collapse of Napoleon's plans for an American empire, which in turn led to the selling of French territory that became known as the Louisiana Purchase; and that, of course, had enormous significance in the history of St. Louis.

"So this artifact," the curator continued, "reaches back to the time when this place was becoming a part of United States history. And it stretches into the future as we consider it as an object to tell the story of this place for the people of the future who will visit this exhibit." The pediment adorns one of the "Kid's Places" in the Currents section of *Seeking St. Louis*, inviting school children, and everyone else, to explore one of the invisible boundaries that separated black and white citizens from one another. Some of those invisible lines have yet to be erased; examining the past and the choices our predecessors made in regard to naming schools will generate dialogue on those limits and boundaries yet remaining and initiate appropriate action for positive, effective change. Thus the past, through this mundane and nearly anonymous piece of standard architecture, effects the future through the story embedded in its masonry.

In a search for an appropriate definition of *artifacts,* I discovered a certain inadequacy in most dictionaries: "an object produced or shaped by human craft." The small stone I picked up at Lake Superior on my last visit to Ishpeming was neither produced nor shaped by human craft, yet I consider it an artifact, that is, a mnemonic for my recent past and a link with my predecessors on that magnificent shoreline. The entry in the *Stanford Encyclopedia of Philosophy* approaches a more imaginative perspective: "The study of artifacts (as artifacts) is intrinsically evaluative, since viewing an object as an artifact means viewing it in the light of intentions and purposes."[3]

As a museum professional I have learned the importance of artifacts—how to find and acquire them, how to research their provenance and their history, how to care for and exhibit them. But my most essential experience with artifacts is the gradual and ongoing discovery of an artifact's power to

provide a tangible link with the past, to evoke a response that dissolves barriers between ourselves and the past and each other, to incite us to create an interactive discussion on the common ground of a shared emotion.

The roster of the collections of the Missouri Historical Society is impressive: some 100,000 separate books, periodicals, newspapers, maps, and microfilms; approximately 1,900 separate archival collections; more than 5,000 linear feet of original documents; 430,000 images; 125,000 objects. Yet more impressive than this list of pieces of the past are the more than 661,900 stories embedded in them. It is our job, as museum professionals but more importantly as community advocates who will build a new town square, to uncover these stories and begin the weaving of the variegated tapestry that will adorn its walls.

The places where we live and the stories that we share are elements that link us in a community identity. What has been left behind from the past we can explore together from various perspectives, learning to look from another direction to understand a longtime neighbor's viewpoint, turning around to get the interpretation of a more recent arrival to the community. Yet when we look into the past, or peer dimly into the future, we tend to see a foreign country immeasurably different from our own time. The differences may begin to overwhelm us—until we remember the common humanity we share with our ancestors and will share with our descendants.

Notes

1. Reeve Lindbergh, *No More Words: A Journal of My Mother, Anne Morrow Lindbergh* (New York: Simon & Schuster, 2001), p. 27.
2. Frederick Douglass, "Address for the Promotion of Colored Enlistments," Philadelphia, July 6, 1863, in *Frederick Douglass: Selected Speeches and Writings*, ed. Philip S. Foner (Chicago: Lawrence Hill, 1999), p. 536.
3. *Stanford Encyclopedia of Philosophy*, www.plato.stanford.edu/entries/artifact

CHAPTER 5

Contemplating Change

F OR NEARLY SEVEN YEARS I WALKED THROUGH A SECTION OF
the Missouri History Museum's *Saint Louis in the Gilded
Age* exhibition on the way to my office. Every working
day I was greeted by a laborer circa 1880 gazing at me from the entrance of
the exhibit designed and produced by our staff and installed in a major
gallery in the fall of 1993.

This life-sized photograph showed a man, swarthy and mustached,
hard-muscled beneath his rolled-up shirt sleeves and a workman's stained
apron. I never knew this man's name or any other details of his life yet this
anonymous worker became as familiar as the woman who walks her dog
by my house every evening or the old man selling big, bready pretzels from
brown paper bags at the stop sign on Jamieson Avenue. And I think I know
something about that man from the Gilded Age.

He worked hard, long hours for low wages and in often hazardous con-
ditions, with little in the way of job security or benefits. He lived within walk-
ing distance of his job, in rented rooms or a small flat that had a dirt yard and
a privy in the back. He stopped for a glass of beer at the corner tavern when
he could, and he could sometimes get a loaf of bread on the tab from the lo-
cal baker who lived above the bakery. His wife took in piecework to help with
essential expenses, and his children played with homemade toys. He knew the

worry of a son who broke a school window, camaraderie of an evening's visit on a neighbor's stoop, the joy of a baby daughter's first words, grief in the death of a parent. No, this information isn't in a label in the exhibition. I know this much because I know, from history and from historical imagination, what life was like in St. Louis in the latter half of the nineteenth century.

And I know more. I know he felt pain—feet and back muscles aching from hard labor, a little like mine when I've worked in the garden too long. He loved his children and worried about them—I have children of my own. He laughed at a good joke, wept in times of deep emotion, got hungry, needed sleep. He recognized beauty when he saw it, even if he didn't understand it, and he wondered with varying degrees of doubt what came after this life on earth. I know this much because I know that certain basic human experiences persist through time. The penetrating eyes of this man in the photograph cutout saw a life very different from mine, but I share with him a space, though not a time, and a bond of human experience that makes his story a part of mine. There is not much in St. Louis that this Gilded Age laborer would recognize if he were to return, but what he shares with us persists beyond any of the vast changes in the landscape and the ways of living through the many decades that separate us.

In the collections of the Missouri Historical Society is a clay pot made near St. Louis seven hundred years ago by those people we call Mississippian, the people who built Cahokia Mounds, now a World Heritage Site. We call the pot a beaver effigy pot. No one can know what the people who made the pot called it, for the mound builders were gone by the year 1400 C.E. On one side of the rim the artist created a beaver head and paws holding a stick in its mouth. I observe the human urge to decorate even the most mundane of items, a trait we have in common with those long-departed people. Despite their distance from us, we can know something of them from this little utensil with its touch of whimsical creativity.

The city around the Cahokia Mounds was the largest city north of the Valley of Mexico. It may have had as many as twenty thousand people, a big city by any measure in the twelfth century. The first Europeans to arrive in this part of the Mississippi Valley found none of these mound builders but saw the soaring earthen mounds they had left and made up fantastic stories to account for them. Early souvenir hunters ravaged the mounds for the curiosities they contained. Gradual urbanization eventually resulted in destruction of the largest mounds on the St. Louis side of the river, and

suburbanization either destroyed or encroached on the remaining Illinois mounds. How very little remains of these artifacts, these people.

The Mississippians and their mounds remain enigmatic, but archaeologists are now beginning to explain some of the mysteries, particularly the causes for the sudden disappearance of these people. Analysis of bone material recovered from the sites proves that inhabitants of these mound cities in the later years were suffering from malnutrition. As food became scarce, people left so that by the time the first Europeans reached the continent it was a prehistoric ghost town. The rivers were fished out. All the wood within reasonable distance was harvested and consumed. Game animals within the region had been killed and eaten. Soil depletion had diminished agricultural yields. As the population grew, disease caused by poor waste disposal increased. Archaeologist William Iseminger posits that "there may even have been 'smog,' created by the numerous cooking and heating fires that burned daily, producing a smoky haze at Cahokia."[1] The people left, their technology having outstripped the ability of the place to sustain them.

There is a lesson in this, a pertinent message that has persisted through all the centuries that separate us. The equation that balances people, resources, and technology can be stretched but not violated without disaster, not even by us. Yet, Cahokia was not solely an environmental disaster; it was also a social disaster. Cahokia's community, its human relationships, its meaning as a place for people were all dissipated. The conclusion I draw from this is that communities that are not environmentally sustainable are also communities where the relationships that provide a sense of connectedness, of belonging, of civility, of security are fractured. It was true for the people who had to leave this place centuries ago, and it is true for us today in this same place.

I am intrigued by different concepts of progress and change, and I am now convinced that perpetual progress is not in our long-term best interest. While science and technology have made our lives easier and more comfortable, we need to value something besides the newest technological gadget and the most startling scientific advance. We need to pursue healthier goals than accumulation of wealth, a longer life, and an artificial happiness that has become increasingly self-centered and hedonistic. Further, unending progress is now, according to incontrovertible evidence, at odds with the future welfare of humanity. The earth's resources are finite, and we are already living beyond its means. The consequences of unbridled human activity have already

damaged the planet's ability to sustain life. Will we let this earth become a ghost town?

Ghost towns are a part of the landscape in Montana, where I spent many years. We do not have those photogenic ghost towns in most other parts of the country, but we can all picture them. Buildings of perfectly weathered gray barn wood, doors flapping in the breeze, empty-eyed windows and warped wooden porch steps. The cemetery is just up the hill, the tumbleweed is piled up on porches and in doorways and against listing fences. The whole place looks as if everybody just up and left one day. Such places are all over the West, and I visited dozens of them, captivated by their eerie, desolate character. Perhaps we are all fascinated by abandonment. Who lived in these places? What happened to them? Ghost towns are mysterious, often picturesque, and offer plenty of raw grist for overactive historical imaginations. The truth is prosaic: ghost towns litter the landscape because the mine played out, or the forests were all logged, and the people moved on. Most of these towns weren't built to last anyway, mute symbols of our American bias against staying put. They still stand in the West because the climate is dry and wood-eater bugs like termites and carpenter ants are sparse.

As director of the Montana Historical Society I was responsible for the State Historic Preservation Office, and Montana's ghost towns were the concern of the SHPO. The question of what to do with all those ghost towns was perplexing. There were too many of them, and there was not enough money in Montana, or anywhere else, to stop their gradual but steady disappearance, for even in western climates an untended ghost town only lasts for a few generations. Besides, a ghost town stabilized and frozen in time is not truly a ghost town. A ghost town's charm and magic, partly due to the very process of decay, is in its transience, its fragility, the unanswered questions it poses.

There are more ghost towns in the making all the time, but we are not charmed and enchanted with them. Butte, Montana, was hardly a quaint, deserted boomtown in the 1970s. Once a town of nearly one hundred thousand people, built mostly of brick, it boasted substantial neighborhoods and stores and streetcars and even an amusement park. Then the Anaconda Copper Mining Company strangled Butte nearly to death as it closed its huge copper mining operations. The formerly healthy city was on its way to becoming a ghost town, and we could hardly "preserve" Butte, Montana.

So I learned that bitter lesson for a historian, that sometimes you have to let go of parts of the past. Further disintegration of a ghost town or shifts and alterations in Butte or St. Louis is natural and normal. But there is little charm or magic in the careless neglect and decay of a once thriving neighborhood.

The "neighborhood" where I work has been thriving since 1876. This neighborhood is Forest Park, the crown jewel in the magnificent necklace of parks that adorn St. Louis. In the fifteen years I have been in Forest Park, I have seen a variety of changes in its face and form and function and even in the infrastructure that almost no one sees. For several years I was closely involved with some of those changes, as we on the Mayor's Forest Park Master Plan Executive Committee interpreted and mediated and implemented what the St. Louis regional community—those who truly "own" Forest Park—needed and wanted for this emerald jewel in our city's collection of valuables.

In the winter and spring of 2003 when I drove into the Missouri History Museum's west parking lot, I was usually greeted by busy bulldozers rearranging what used to be the first hole of Forest Park's nine-hole public golf

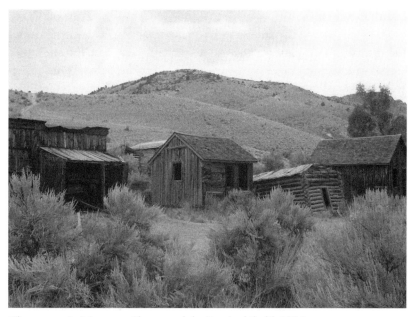

Ghost town in Montana. Photograph by Sue Archibald, 2000.

course. Their presence reminds me that Forest Park, like the diverse community that can claim usufruct ownership of it, is an entity that grows and changes and magnificently survives through the variations that time and its own venerable age has wrought. From its 1876 "wilderness" to its thorough refurbishing as it enters the twenty-first century, Forest Park will maintain its inherent value as a place for all our people.

The changes we the people of St. Louis have initiated in the last several years are worlds away from the vistas that greeted visitors to the 1904 World's Fair. In that period, which has reached mythical proportions in our communal memory, the green oasis at our city's western border had become a wonderland portrayed by a local diarist as "indescribably grand." For nine months Forest Park was a place of enchantment, a celebration of technological spectacle and promises of more wonders yet to come. The world came to St. Louis, and Forest Park was changed forever by its visitation.

Only traces of the 1904 World's Fair remain in Forest Park: the zoo's birdcage, originally erected as a Smithsonian Institution exhibit; the Palace of Fine Arts, now our world-class Art Museum; interesting flotsam retrieved in later years from an archaeological dig somewhere on the park grounds. But the park is a mnemonic for what happened here nearly a century ago. Stand on Art Hill by the statue of St. Louis, itself a copy of one of the signature sculptures of the fair, and look over the lagoon; you can almost see the sparkle of the famous Cascades and perhaps even catch the murmured splash of a boatman's oar as he navigated visitors through the fair's waterways. In some sense, it's all still there, in our myth and memory.

As a historian I had been taught that history is the story of change over time. But I have learned that change is incidental to the human condition, that permanence is the more prevalent characteristic, and that what we share with the past is more persistent than how we differ from those who preceded us here. The people who drove their carriages through the "natural wilderness" of the late nineteenth-century Forest Park, those who celebrated the promise of "progress" in the fabulous white palaces of the 1904 World's Fair, our citizens who watched the metamorphosis of the site into a modern park for all our people to gather and refresh themselves in abundant activities or mere relaxation, and the generations that will follow us to the peace and beauty and community spirit of this very special place all share with us the changes and more importantly the permanence of Forest Park.

Forest Park is thus an anchor for our communal memory. It is a touchstone that can take us back beyond ourselves to share in the story of those who came before us to this place. On a mild winter day in 2001 I invited a longtime friend and supporter and lifelong St. Louisan to share his stories of the city we now both shared. I. E. Millstone was about to celebrate his ninety-fifth birthday, and he had decided to take the opportunity to record some of his memories for the younger members of his family. Forest Park was an essential topic in his story of himself.

"That's exactly right," he responded when I noted his close connection to the park. "I was born in north St. Louis but two or three years later we moved to Kingshighway, when little of the city went past Grand Avenue. At that time the 1904 World's Fair was just over, so the park really only existed from Kingshighway to about where the Jefferson Memorial and the Art Museum are now; to the west it had been cleared of trees for the fair, a sort of no-man's land."

"We've always lived near the park," he continued. "We played tennis in the park. We went ice skating in the park, and the city would have bonfires

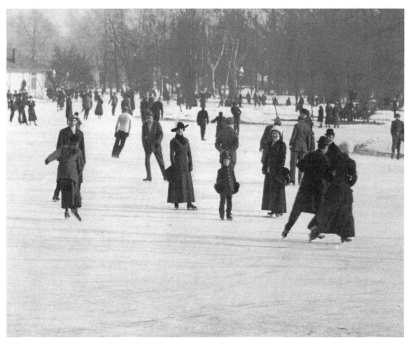

Skating in Forest Park, ca. 1915. Missouri Historical Society, St. Louis.

on all the lakes for the skaters." He lost a skate once in one of the lakes; he thinks it's probably still there, at the bottom of that lake. "On my fifth birthday," he continued, "ninety years ago, my father gave me a new sled and we went by horse and buggy up to Art Hill, and I slid down Art Hill on that sled." On his seventieth birthday, he remembered, his family gave him a sled and wanted him to go back up to Art Hill. I expect he was tempted to try it. Musing on the St. Louis summers before the advent of air conditioning, he recalled swimming in Forest Park. "There was no place to swim in Forest Park, but we used to go into the lakes where nobody could see us."

"I remember the Pageant and Masque," he said, recalling St. Louis's civic event designed to draw together the entire community in a celebration of their shared history. "I was only seven years old; it was 1914. I can visualize it like it was yesterday." He remembered the first opening night at the Muny, the outdoor theater in Forest Park, when he was an usher at the age of twelve. A few years later he learned to drive in the park, a memory that launched a detailed description of the complications of handling an automobile circa 1920s. "I discovered girls about the same time," he grinned, "and we always made good use of Forest Park."

I walked Mr. Millstone to his car after this delightful afternoon of reminiscence. The newly refurbished Dwight Davis Tennis Center, just south of the History Museum, had recently reopened. The roadway that used to lead directly to the zoo had been closed years ago and turned into green space. Parts of the golf course to the west of the museum were already undergoing reconstruction. "It's always changing," Millstone commented, "but it's always Forest Park."[2]

History is not a museum, though a museum may—and should—give impetus to the telling of the story. History is not a chronological story of progress. Rather, history is a conversation between generations about things that endure, that connect us to the past, to each other, and to the future. The stories that I. E. Millstone related to me that afternoon were rooted right here, in the park land around my office. I could walk the same ground he had walked decades before, giving solidity to his memories, making his story a part of my own. Through his stories of this place I could relegate the changes in this land to their appropriate level and discern the more important aspects of human experience, common ground that Forest Park furnished Mr. Millstone and me, a link between his generation and mine, a connection that the mightiest bulldozers couldn't break.

I do not dispute the reality of change, nor do I reject all change as injurious. Change appears to be an elemental characteristic of the whole universe. But when change destroys those qualities of our places that are anchors, referent points for our memories and hence our being, I worry about the effects on human lives, present and future. Change defines existence. An "island" juts out from Marquette's upper harbor into Lake Superior. Actually a point of land connected to Michigan's Upper Peninsula by a narrow neck, its French name, Presque Isle, means "almost an island," but the locals just say island. In the last century this beautiful island was prudently set aside as a city park. Sue and I often stroll along the bluff on the north side and, more cautiously, walk the trail along the cliff edge. The cool, clear waves of the lake crash over the rocks and recoil from the cliff dozens of feet below. We sit in a small clearing in the woods, a favorite spot, surrounded by trees on three sides and the cliff with waves smashing below on the fourth. We look over the lake's stunningly blue waters, alternately angry and placid, curving into the horizon. We come to this place when we visit Ishpeming where we both were born and raised. We sit and sip coffee, seldom speaking. Not that we are without thoughts. Rather it is a time and a place that subdues the everyday world and where communication requires silence. "This place never changes," Sue says quietly as she contemplates the expanse of the lake. "No," I say, "it doesn't." Yet I know that it does. But the yardstick that applies to these bluffs and to the lake itself is not a measure that we can apply to our lives. Lake Superior change cannot be measured on a human scale, because a human lifetime is infinitesimally small in comparison. Time as we measure it has meaning only in relation to a lifetime. It's not that Lake Superior does not change. Change here is inexorable, but excruciatingly slow compared to a human life's passage.

Change in lake time is so infinitesimal from the perspective of a human lifetime that it is undetectable. The changes that injure are those that are wrenching and readily apparent on human scale: the neighborhood where we grew up, lost. Our school, torn down. The elderly cast aside because their stories and experience seem irrelevant to the present. New houses, isolated, without sidewalks, alleys, front porches. The obsolescence of downtowns. The proliferation of automobiles and asphalt. The hours spent in front of televisions or computers. Modern technology may occasionally produce marvels, but technology itself is isolating and now so complex as to be incomprehensible. Mass culture and franchises make places interchangeable.

not necess.

CHAPTER 5

Peripatetic families with two wage earners, detached from extended family, isolated from community, have no sustaining stories and a paucity of places to construct new ones, and no time to do so anyway.

Contemplation of Lake Superior time or earth time or star time or time in the universe is an alternative way in which we can become intuitively aware of time before and after our own life spans. It is the grandest scale of history; history on a universal scale through which we become emotionally aware of our place in the grand order of the universe, understand that we are quintessentially a part of it all, and that we occupy a very small space and endure through a very slight slice of time. This is the time of theology, of poetry, of music, of dance, of sunsets, quiet mornings, of all transcendent moments—those delicious times when we are transported beyond the boundaries of our own lives and when we understand in our very souls that everything in the universe is connected to everything else and that all time is now, and that we are an integral part of it forever.

Hartman Lomawaima, my friend of the Hopi nation, has taught me much about change, continuity, and time. In certain ways he lives outside of time and thus change means less to him than to someone thoroughly en-meshed in the present. One evening we went to Hartman's house in Tucson. He brought us into his bedroom and showed us the trunk at the foot of the bed. The trunk, he explained, contains his wife's burial windings—the cloth that her body will be wrapped in when she dies. He also showed us a flat spiral of basketry that he has made. It hangs over the bed. The spiral begins in the center of the weaving and circles out. He has not yet finished weaving it; the graceful spiral ends at the edge. This is his life. Strange things for the bedroom of a married couple, I was thinking. But the burial cloth and the spiral are both reminders that life is fleeting and that Hartman and his wife are committed to each other until that life is over. These are not macabre symbols but rather graphic reminders of their own values and commitments. Their act is at once personal and communal. With these objects they are repeating in their own time what Hopis have always done, an acknowledgment of their own mortality but simultaneously a reminder of generational continuity and of the values and the stories that tie these people to countless generations of their people. My friend and his wife do live in the present (he's director of the Arizona State Museum and on the board of the National Museum of the American Indian), but in another way they do not live in time at all, for the traditions and stories that compel many of their ac-

tions are generational repetitions extending back to an ancient vanishing point and beyond the finite boundaries of the present into a future, which, at least in this way, will resemble the past and the present.

At Acoma Pueblo sixty miles west of Albuquerque, I had long ago found another instance of being outside of time. In 1973 I drove to the pueblo to interview an Acoma Indian. Sometimes known as "Sky City," Acoma was built hundreds of years ago atop a gigantic steep-walled mesa in a valley surrounded by jagged mountains. The people built here in order to defend themselves from marauders such as the Apache; only one easily defended path descended from the mesa to the valley. But their livelihood was always in the valleys below where they planted and tended crops. I sat with the Indian man on top of the mesa at the edge of the sharp cliff overlooking the valley, surrounded by distant craggy mountains. I asked him about the history of his people, the Acoma. Mostly he told me stories of long ago with little progression. His stories were more akin to our traditions of tales that begin "once upon a time, a long time ago." As I reflect back now I know that his stories—tradition is a better word in this case than either history or story—were outside of time if by time and history we mean a causal link to the present. When the things that matter don't change, tales anchored to specific dates in the past are of no use. But I was a historian and persisted in my efforts to elicit chronology from him. The problem, I later realized, was my own erroneous assumption that the past was past. Now I know that for my Acoma informant and for my Hopi friend, the past is not past: it is present. Through cultural traditions—the Hopi burial clothes, the Acoma man's lack of chronological narrative—the past was reenacted throughout all time. The past was truly in the present, because what was true in the past is true in the present. Change was of little consequence. In remembering the past, the future was also remembered.

But my interview with the Acoma Indian went further. I asked him what he thought of changes that he saw around him. He gazed at the distant mountains. He directed me to look at a series of notches between peaks. "When the sun rises there, I know that it is time to plant the fields. When it rises there, I know that it is time to harvest. When it rises there and sets over there, I know that it is winter." The mountains encircling us were for him an eternal calendar. But the sequence of years was not important because nothing of consequence changed. Those things that were of utmost importance occurred in predictable, repeated, precisely measured cycles. The idea of measuring change through time was of little pertinence to this world.

CHAPTER 5

American Indian culture is not alone in its awareness of beyond time. In my visits to my hometown of Ishpeming I finally realized that Theresa Andriacchi's sense of time did not synchronize with mine anymore and that, like my Acoma friend, she spent much of her life outside of time. Crushed out of the market by the discount chain stores out on the highway, Andriacchi's Store had almost no merchandise, but Theresa, like her father seventy and eighty years ago, opened it every day. She opened it out of a larger sense of her place in life, obligation to family—especially to its deceased members—and her duty to her God, values that are eternal for her, thus unaffected by time passages and unaffected by the marketplace. She opened every morning because people expected it and because during each day an occasional visitor would stop in, continuing in a limited way the social function that the store had always served. It was how she kept in touch. She had no radio or television and certainly no computer in the store. While many might judge that the world passed her by, Theresa did not see it that way. She was finishing her job with fidelity, doing what she was intended to do on this earth. She sat in the window, head bowed, perhaps asleep, until someone entered and spoke. Theresa knew her duty. She was constant. Now is where she was just for the moment. For her, there was no progression of past, present, and future, only eternity and the present. Eternity is where her parents, her brother Anthony, and sister Rose had gone, where she has since gone to join them.

At our very core we are about continuity. We do not exist to enhance the moment, to dwell on the present. Rather we insist upon the continuity of time, the persistence and future of our species, and the preservation of this earth upon which life depends now and forever. We are about the kind of time that can only exist in communities that endure, that are not transitory, that give inhabitants a clear sense of life's transitions, of the comings and goings of generations and the stark but joyful assurance that we too will pass on and what we leave behind will constitute a legacy for all those babies and unborn generations who will surely follow as our legatees. We are advocates for all of the places where we live and work and for the value system inherent in the concept of community.

Sometimes I am accused of looking backward and indulging in nostalgia for those good old days that never existed. I am not, nor do I have any desire to live in the past. Change produces in each of us—especially, I have noticed, when one passes the half-century mark—a longing to go home,

112

nostalgia for what was but is no more. Not only does the past appear to us as a refuge from accelerating change and technology rampant, but it is also idealized through the fuzzy prism of nostalgia, as a fairy tale world where the problems of our own times did not exist. So we mourn change and loss. We know that the past was never a better place, just a different place, yet our minds yearn for places of youth, places that with the passage of years become better than they really ever were.

In seeking to rescue the past from an oblivion dangerous to us, to our children, and to the earth itself, we are not merely indulging in our propensity for nostalgia. Rather, we are looking for legacies worth keeping, in order to make use of the virtues of the past. Peter Calthorpe offers a useful clarification. "There is," he writes, "a fine but important difference between tradition and nostalgia. Traditions are rooted in timeless impulses while being constantly modified by circumstance. Tradition evolves with time and place while holding strong to certain formal, cultural, and personal principles. Nostalgia seeks the security of past forms without the inherent principles."[3] In developing a new town square we must be aware of the profound and substantial principles we seek to emulate rather than merely harking back to some rosy golden age that is nostalgic fiction. Nor can we simply trash the past; I believe that we have done some things poorly but we have also done some things well. It behooves us to consider which is which, to rectify our mistakes, and the mistakes for which we bear our ancestors' burdens, and to build upon those real treasures that they have bequeathed.

Perhaps this is history's attraction—the fleetingly glimpsed sense that the story began before we arrived and that there are chapters before and after the ones that we write with our own breath. Many fewer of us now live in the midst of those extended relationships of family and enduring friendships where we are surrounded by birthing and dying and hence fewer of us can perceive life as a moving ship in water; breaking open in front where the bow splits the water and closing in behind where the wakes merge and finally no mark remains of the ship's passage. This sense of movement through time reinforced by the entries of babies and exits of others inculcated an intuitive sense of history, a sense of place, a sense of belonging, and a sense of connection. This is how communities are built and sustained. This is how humans relieve isolation and pursue true happiness. History, or remembrance, is the crucial ingredient. But this sense of time and continuity requires a stable place because in order to witness life transitions people

 must stay put, and it requires an enduring network of familial connections and friendships. If we can no longer obtain an intuitive sense of time passage, continuity, and context from the community around us, we will have to obtain it in other ways; and we will have to make efforts to do so. We will have to become more cognizant of the crucial uses of the past, and we will have to compensate for the diminution of the awareness of time past and time future in our daily lives. In coping with change, we must keep in mind the things that do not change and build them into our present for the future.

Notes

1. William R. Iseminger, "Culture and Environment in the American Bottom: The Rise and Fall of Cahokia Mounds," in *Common Fields: An Environmental History of St. Louis*, Andrew Hurley, ed. (St. Louis: Missouri Historical Society Press, 1997), p. 56.
2. Author's conversation with I. E. Millstone, 2001.
3. Peter Calthorpe, *The Next American Metropolis: Ecology, Community, and the American Dream* (New York: Princeton Architectural Press, 1993), p. 23.

The Call of Wildness

"IN WILDNESS IS THE PRESERVATION OF THE WORLD," wrote Henry Thoreau in one of his later works. Yet even when Thoreau retreated to a cabin near Concord, Massachusetts, in the mid-1840s, true wildness was getting harder to find in New England and in other parts of the United States as well. Towns, villages, and farming were overcoming the native wilderness—and even Thoreau turned farmer at Walden Pond, growing vegetables to support himself during his two-year sojourn "away from civilization," and venturing to town for staples and supplemental income.

Not only transcendentalist philosophers but all humans must seek solitude at times. A man I knew in my youth, and somehow know better now, was one of those people who insisted on this necessary solitude.

John Voelker, an attorney, writer, and raconteur, best known as the author of *Anatomy of a Murder*, grew up in my hometown a generation before me. There was a kind of friendship between John and my father, although not a warm one, possibly because my father defeated John in a county election before I was born or perhaps merely because John was an eccentric, a loner, a remote kind of man. My clearest childhood memory of John Voelker is one of a winter evening as he wrapped himself in one of our Hudson Bay blankets and, having drunk far too much bourbon, told outrageous but perfectly

formed stories long into the night. As an adult, after John had died, I got to know him better, through his writings and his unpublished manuscripts generously given to me by his widow. I found in his "Testament of a Fisherman" an expression of not only the joy and thrill of trout fishing but also of the need for wildness in human life:

> I fish because I love to; because I love the environs where trout are found, which are invariably beautiful, and hate the environs where crowds of people are found, which are invariably ugly; because of all the television commercials, cocktail parties, and assorted social posturing I thus escape; because, in a world where most men seem to spend their lives doing things they hate, my fishing is at once an endless source of delight and an act of small rebellion; because trout do not lie or cheat and cannot be bought or bribed or impressed by power, but respond only to quietude and humility and endless patience; because I suspect that men are going along this way for the last time, and I for one don't want to waste the trip; because mercifully there are no telephones on trout waters; because only in the woods can I find solitude without loneliness; because bourbon out of an old tin cup always tastes better out there; because maybe one day I will catch a mermaid; and, finally not because I regard fishing as being so terribly important but because I suspect that so many of the other concerns of men are equally unimportant—and not nearly so much fun.[1]

All people seek such places; without them life becomes overwhelming, the spirit is subdued, and something unquantifiable but crucial is lost. John's place was in the primitive, isolated woods of Frenchman's Pond. But such a place is completely inaccessible to most of us. Where do we go for wildness, as the traditional definition so rarely applies anymore? Another quote from the Walden transcendentalist may more closely approach a twenty-first-century definition for wildness as a tonic for human needs: "Live each season as it passes; breathe the air, drink the drink, taste the fruit, and resign yourself to the influences of each."

* * *

The author "fishes because he loves to." Photograph by Sue Archibald, 2000.

The Upper Peninsula of Michigan is like no other place in my experience or in my imagination. If one side wasn't attached to Wisconsin, it would be an enormous island in the Great Lakes. It's our country, my wife's and mine, especially the northern end of it, that cold, craggy edge defined by Lake Superior. Like New Mexico and Montana where I have also lived and worked, the U.P. has few people; it's a land still boldly defined by nature, a wild place like many places in New Mexico and Montana. The other-worldly desert does not claim any part of Michigan, nor do the Rocky Mountains rise from the edges of the U.P., but Lake Superior does, giving the U.P. as powerful a sense of place as the desert and mountains and plains, different, but just as awesome and distinctive. My first winter in Montana was a surprise: not nearly as bad as I expected. But I had experience. U.P. winters are worse; they begin sooner, last longer, and the snow gets deeper and heavier than in Helena or Billings.

Up there in the U. P. we have a "camp," that primitive isolated form of getaway place indigenous to the U.P. Ours is on the Dead River, a remote location where it is possible to run into grouse, eagles, moose, deer, and bear.

CHAPTER 6

I kept a journal on Labor Day weekend, which we spent at camp a few years ago. "Camp," I wrote in my journal, "demands attention to life's basic requirements in ways that our lives in St. Louis do not. As I get older I pay more attention to what I once regarded as small things. Now I do not think they are so small." Basics consume most of the day. Just getting to camp is time consuming because of its remoteness, not just from my home in St. Louis but also from Ishpeming and the other small towns in the U.P. The blacktop ends a few miles from Ishpeming, and then it's washboard gravel with variations of dust clouds and mud to be deftly dodged. One right turn and there the gravel ends, replaced by a single-lane two-rut road the rest of the way to our camp. Just getting groceries from town is a three-hour trip; in winter it would consume a day. At camp heat doesn't come at the flick of a switch or the twist of a thermostat dial. Warmth requires wood. To get warm here I have to lay a fire. It takes hours to heat water for the sauna. Nights are cold; I cannot just get out of bed at night and stagger down a hallway to the bathroom. But there is a wide variation in temperature, so I become more conscious of clothing and choose carefully what to wear in conjunction with what I'll be doing, where I'll be going.

This place assaults the senses with unaccustomed smells, hues, textures, and sounds. The bracken, a fern species, is dying this Labor Day weekend; its browning leaves in late August are fall's first sign. Sheets of gray slate protrude from the ground, and the granite is trimmed in pale green lichen. Spruce trees in a drizzle have a delicious odor. Standing in front of our cabin in that light drizzle, I can smell smoke from the sauna stove fire. The generator, and the refrigerator and the television it operates, and our car out in the back all seem incongruous intrusions. This is a different kind of awareness, an experience of a world I came from but to which I cannot return. Yet despite the gulf, it is still home. I am still a part of nature and of wildness even though I have lost the skills and knowledge and prowess to live as a part of it.

At camp time slows down. I am interested in time because history requires chronology. Modern physics concludes that time in precise packets of seconds, minutes, and hours that extend into days and decades and millennia does not exist. We all decry the escalating pace of modern life. The intriguing thing about camp is that if you slow down, listen carefully, and let yourself be in the place, time really does slow down. I move more slowly, and getting clean or warm or fed uses up the day. Just doing the dishes takes

longer because we must heat water on the stove, not merely turn on a faucet. Time's meaning as a measure of accomplishment is lost. I pay less attention to time here. I do not have a schedule, and it doesn't matter what a clock says. I just need to do the things required for basic needs. I do not wear my watch, until our afternoon trip to Ishpeming.

During my youth we spent summers at our camp in the woods. My family's camp required most of the same relinquishing of modern conveniences. So going to camp now is also a memory-recall device. The inconveniences, the expendable clocks and watches, the marvelous odors and colors are timeless. Here at camp I can lose track of my age. I could be any age, or no age. It doesn't matter. It's all the same. Here in the drizzle of a northwoods late August I can pretend that I am five or fifteen. With its cargo of fifty-plus years my body argues at some exertions and deprivations, but I can still make it do almost whatever I want. So here I can pretend to be ageless, as long as I do not look in mirrors.

But the trip to town obliterates feelings of agelessness. Sue's mother and uncle both suffered serious strokes and are in a nursing home in Ishpeming. But it's not just mom and unc. It's all of the old, sick, demented, lonely, and dying. Here is the essence of time: it is lifetimes. It is our own aging that we measure, that inexorable individual march to the grave. Except for this looming truth, time does not have meaning. We think that we measure something outside of us with our clocks. What we really measure is our own lives. The tragic destruction wreaked by time is poignantly evident here in these nursing home beds and in these people, their lives over but waiting for death, and in the eyes, voices, and body language of family members and friends who visit and are suspended, afraid to grieve yet but without hope for reprieve. It is hard to think of the future here.

But at camp, death is not so out of context. It does seem to have a purpose. There is a cycle of life and death all around me: trees and bracken changing color in autumn anticipation; insects, snakes, deer getting their bodies ready; even a subtle change in the sound of the wind and the angle of the late summer rain. While everything in wild places changes with seasons and life spans, nothing really changes in dramatic ways. I am vividly aware of the profound impassable gulf that bars me from this world. But simultaneously these places are full of hope. Time in these places is not linear; it is cyclical. Everything sympathetically vibrates to seasonal cycles. What dies is replaced. There is assurance of continuity, of a future that will be

much like this present. We are so focused on lifetimes and acquisitions in the little time allotted that we lose sight of continuity, even when we look in the eyes of our children and grandchildren, and we often act only for the short term. When I look at my own children, and now my grandchildren, I think of Louise Erdrich's enchanting words in *The Blue Jay's Dance*. "He and she see," Erdrich writes, "the next world and the next reflected in the ocean of their newborn's eyes."[2]

On a trip to Montana, my first since I left in November of 1988, Sue and I landed in Bozeman. We drove to Dillon, made a detour to the upper waters of the Big Hole River, went through Jackson, up to Helena and eventually headed north to Seeley. We fished the Clearwater and the frigid lakes in the high country and drove through miles of Mission Mountainsides blazing with scarlet wildflowers. The experience raised many of the same feelings as our Michigan camp. I think I had stayed away because I did not want to be reminded of what I had lost in leaving.

At the Montana Historical Society shop Sue purchased a recording of Buffalo Bird Woman and brought it on our Labor Day trip to camp in Michigan. On a wet cold morning she played it as we sat near the fire. Buffalo Bird Woman is a story of one Hidatsa Indian girl, but it is also the universal story of persistence and survival informed by awareness of continuity. Life is a repetitious sequence of survival efforts: keeping warm, getting food, staying healthy, following the hunt, planting, and propitiating God, all done with only the technology at hand. It is a story of humans who still directly and intimately participate in the natural life and seasonal cycles of our planet where there are no light switches, gas stoves, furnaces, automobiles, or supermarkets. It is a good story for the wildness of the U.P. or Montana, and a good story to take back with us.

We stand on the camp porch looking through the spruce and maple at the Dead River. The temperature is in the forties, cold and wet. "This is the stuff that turns to snow. We could be here all winter," Sue teases. I try to imagine what that would mean. How cold would we be? How much wood would we need? How often would I need to shove wood into the fire during the night? What would a midnight trek through snowdrifts to the outhouse be like? How often would we heat the sauna? The sauna might be the only time we felt truly warm. How frequently would we be able to get out of here to purchase food and other supplies? I suppose that for most of the winter I would either wear snowshoes or ride a snowmobile. I pushed my

fantasy further and imagined surviving entirely by my wits with no tether to any other place, as the Hidatsa in Buffalo Bird Woman did. I concluded that I do not have the skills and training to live here without sophisticated technology. I would need a snowmobile, gasoline, propane, a chainsaw, a rifle, an automobile. Could I even be responsible for my own warmth for a year? I couldn't really live here without a supply line back to my usual world, any more than astronauts can live independently on the space station without a supply line to earth.

Nevertheless, I would like to try living here for a season, because I fear that I, and maybe all of us, have lost something important in a hurry-up world, a sense of wildness perhaps, something deep and natural, untamed. I want to be able to see and feel and hear and smell small changes in the world around me, and I know that to do that I have to both tighten my focus and lengthen my attention span. Just a glance will not suffice. The changes I want to really notice take more time. Just when did the bracken begin to change? I missed seeing the moose making those tracks in the mud. I have not really watched the drizzle turn to snow. I do not know what a blizzard is like close up without a retreat and refuge. But intuitively I know that this is my world, the world from which we all at some time came, that world that made me, and the world to which I belong.

I think that we feel the wilderness with a mixture of fear and intimacy. We embrace it as home but know that we would likely die there. We are fascinated knowing that a deer, a beaver, or a frog knows instinctively how to survive. We seem to notice only the big things: a volcano that shoots ash all over Montana, the 1993 floods in which the Mississippi gushed water over farmers' fields and whole towns in Missouri, or the fires that savaged Montana in the summer of 2000. Only the big things circumvent the technological barricades that we have trusted to protect us from the earth's rhythms. We react with fright when the earth forces us to acknowledge our impotence. We build the dikes higher, imagine that wildfires are just a consequence of poor policy, and redouble our efforts to predict earthquakes, volcanoes, hurricanes, and tornadoes. Focusing on the earth's threats, most of us miss the small things. In this way we become something apart from the earth that sustains us. Yet this, the earth's wildness, is where the things that really matter happen. But worse, we behave as if the earth is not particularly relevant. While this is an ecological debacle in the making, the fact that we have lost our primeval ties to our home on this earth, the places we inhabit, is of equal importance.

A few years ago I was in Alaska, not for the first time but on a trip longer and more extensive through more of the land of this extraordinary state. We took the blue and yellow Alaska Railroad the entire thirteen hours from Anchorage to Fairbanks and back, with multiple stops on the return trip. All of Alaska calls for superlatives. It is enormous, comparatively unsettled, with amazing topography of gigantic mountains and peaks surging heavenward, blue glaciers, ocean tinged by the unforgettable sky, and flora and fauna of a most interesting variety, and, perhaps most incredible, the upstream struggling of the salmon in a deadly race against the genetically timed deterioration of their bodies, toward their goal of an exhausted reproduction and then swift death in the river of their birth. But what always overwhelms me most in this overwhelming country is the quality of the light: bright, brooding, and haunted, a constant Arctic twilight in a luminous gray tone.

Alaska is far from Michigan's Upper Peninsula or anywhere else in the lower forty-eight, and seemingly distant from our concerns. But contentious national debates rage over oil drilling in the far north and construction of a six hundred thousand-acre missile range to be carved out of Alaska's wilderness. Yet all that really remains of "wilderness" that was once nearly the whole of our country is quiet, perhaps desperate, hope for Alaska. Alaska has become a symbol for our wrenching fears. If we cannot save Alaska from our own rapacity, some people feel, then we are doomed.

But others see despoliation of this final frontier as the price of progress and the sucking out of its oil reserves as the greater good for the greater number. Wilderness, like relationships, morals, and community itself, is a value and not an article of exchange and hence has no market worth. Although of indeterminate economic worth, we all know in our secret souls that Alaskan wildness is beyond price, just as we instinctively know that our homes and our own towns incorporate the kind of value that is not really measurable, just as we intuitively know that those values of home and community are singular determinants of our own physical and emotional well-being as surely as the survival of salmon depends on the purity of northern waters and the success of the summer spawn.

The Alaska Railroad train rocks along slowly. Speed is not measured by miles per hour, but instead by rhythmic variation in the sounds and vibrations of the track under rolling iron wheels. For those accustomed to velocities of seventy miles per hour or more on interstate highways, the train

moves more like struggling salmon in a swift upstream current. The train rolls on, north and south, through tiny towns, occasional road crossings, countless square miles of moose-filled wilderness. At times the train tracks hang precariously on mountainsides, the wheels squealing in a struggle to respond to the demands of sharply curved track steering away from the beautiful, threatening abyss. Then the train is almost coiled like a blue and gold snake. Double-decker cars carrying crowds of tourists from cruise lines were hitched to the rear, and from our car I could see the end of the last car arced around the rail behind us. Hundreds of tourists get on and off the train at Talkeetna, Denali, and Fairbanks where buses take them aboard vacuum-like from the train platform and disgorge them at hotels. On the way north I chatted with a member of a tour group. He was frustrated with the slowness of the train. "I will never ride this train again," he said. "It just creeps along, and it is boring. Next time," he swore, "we will pack our gear and ride our motorcycles. We could make this trip in six hours instead of thirteen." He was incapable of looking for moose, gazing into the water as we crossed bridges, seeing the brilliant red salmon moving upstream, or just

The Alaska Railroad train. Photograph by the author, 2001.

standing on the bouncing platform between the cars to smell the pure pine and peer into undisturbed forest. He lives in a world of fast highways, cell phones, high-speed Internet connections, handheld computers, online banking, that world that values innovation, change, and speed. And he cannot slow down, even in Alaska. Much of Alaska is a slow world. Anything worth seeing in Alaska requires patience and discernment; the beauty of Denali, for instance, is sometimes cloud-enshrouded for weeks. The moose, though an Alaskan native, rarely wanders the streets of a town. You have to watch for this extraordinary beast, sometimes even becoming, as the moose is, integrated with the landscape. If my fellow traveler could not see this Alaska, how much more difficult must it be for him to really see his own familiar neighborhood and to let it own him the way Alaska "owns" moose.

After two days in Fairbanks we boarded the southbound train back to Denali. Denali, not an actual town, is the main entrance to Denali National Park. In addition to a train stop, it is a bustling staging point for tourists who rest before boarding buses to see a bit of the park. Now, because of a tourism boom, there are nondescript hotels, restaurants serving mediocre food, rafting franchises, and cheap entertainment. We stayed in a not-quite-finished hotel. Gigantic slabs of mountain were moved to make room for the hotel and its parking lots. The road to the hotel twists up that ravaged mountainside, which periodically releases rocks that careen into the roadway, especially during a rain. Our room was adequate. A sign in the bathroom admonished us to save the environment by reusing our towels in order to use less water for laundry. How ironic. Wilderness was abused, overrun, and devastated to build this place, a destructive intrusion into a place of wildness. And now those who profited from the destruction want to appear environmentally sensitive and, not incidentally, save money by reducing the amount of laundry. It is not an oil well or a pipeline but it is another kind of despoliation. But what is worse than what it does to the land is what it does to our souls. In rushing to such places in hordes with demands of speed and luxury, we destroy the very values inherent in wilderness that we were seeking. Most of us do not protest. We just accept what we see. We are desensitized, inured, accustomed to such treatment of the earth, our only and irreplaceable home. We see our own communities wrenched apart piece by piece by developers, and land is put to its best use for malls, expressways, subdivisions, corporate office parks, with acres of asphalt, lots of places for cars but few for people. Most of us suspend judgment and excuse our own

passivity with the palliative that there is nothing we can do to prevent it. Or, it's progress, we say unconvincingly. Few of us protest, and even fewer of us say what needs to be said about Alaska. Perhaps too few of us understand.

When I was the director of the Montana Historical Society in Helena, I was sometimes invited to spend weekends at the Lazy El, my friend Bill MacKay's ranch in Roscoe near Red Lodge. I was awed by the chance to sleep in the cabin full of Bill's C. M. Russell memorabilia, but what really overwhelmed me was Bill's relationship with the Lazy El. On one gorgeous spring morning we set out to see that beautiful land: verdant green foothills, expansive vistas, cattle in small silhouette, wafting smells of pine and wet grass. But I could not take my eyes off of Bill. On that morning in the foothills, jostling in an open-sided jeep, Bill was transfigured into a man I did not recognize. His eyes, his whole body was more animated, focused, intensified. His descriptive monologue was a romantic sonnet. He knew the hillsides intimately, as precisely as he knew the contours of his own hand. To say that Bill and this land were inseparable is an understatement. We do not have a word to describe Bill and this land as a unit. Maybe to call them an ecosystem is more appropriate, but that does not encompass Bill's emotional intertwinement with this place. He didn't so much own the land as grow out of it with an abiding love of the place that was layered over time, as he lived his way into it. The man was the land's steward but the man himself was a product of the land. The relationship was novel to me. Bill did not discuss this intimacy but was certainly not self-conscious about it. It just existed, naturally. For Bill at least, raising his cattle was a means of sustaining the relationship. Bill and many other ranchers have always been land stewards, and good ones. They cannot be otherwise, for the land worked on them and made them that way. It is so much more than stopping the car at a turnout in the Beartooths and breathlessly exclaiming, "Isn't it beautiful!"

Wallace Stegner summed it up in his "Wilderness Letter." I pray that he was right.

We are a wild species as Darwin pointed out. Nobody ever tamed or domesticated or scientifically bred us. But for at least three millennia we have been engaged in a cumulative and ambitious race to modify and gain control of our environment, and in the process we have come as close to domesticating ourselves. Not many people are likely, any more, to look upon what we call "progress" as an unmixed

blessing. Just as surely as it has brought us increased comfort and more material goods, it has brought us spiritual losses, and it threatens now to become the Frankenstein that will destroy us. One means of sanity is to retain a hold on the natural world, to remain, insofar as we can, good animals. Americans still have that chance, more than many peoples; for while we were demonstrating ourselves the most efficient and ruthless environment busters in history, and slashing and burning and cutting our way through a wilderness continent, the wilderness was working on us. It remains in us as surely as Indian names remain on the land. If the abstract dream of human liberty and human dignity became, in America, something more than an abstract dream, mark it down at least partially to the fact that we were in subdued ways subdued by what we conquered.[3]

At a meeting of the Minnesota Association of Museums in 1999, I told my colleagues that there are old ways of remembering Minnesota. The Federal Writers Guide to this state was published in 1938. It includes a historical survey that provides insight into an older way of thinking about Minnesota, a way of thinking about this state's past and future that is no longer workable. The authors describe the state's vast natural resources: fur-bearing animals, lumber, iron, fertile soil, salubrious climate, and copious water.

Those who first appreciated these resources did not keep their discoveries to themselves. They knew that only with the help of many thousand men could they hope to take its riches from the earth, so they recruited labor throughout the United States and Europe. The industrial and commercial history of Minnesota thus became the story of those who built up lumbering, milling, mining, quarrying; of the rise of cities and villages around these industries; of smaller manufacturing and commerce to supply living needs; and of bankers who held the purse strings for the whole enterprise.[4]

Minnesota's Works Progress Administration guide expresses an older attitude toward place, a definition of place as potential shaped by a nineteenth-century wilderness experience in which unexploited land seemed infinite and cheap. Our predecessors in this place and in others

built our communities, our states, and our nation on this simple assumption. There was so much land and so much unused potential that it could never all be used up. But it was abused, despoiled, and nearly consumed. And when it was nearly gone, we romanticized it. Perhaps in our romanticization of what we have nearly obliterated we will shape new values and new stories that will inform our futures. I hope so. The new ethic can be sensed in a 1997 Minnesota guide published by Fodor's:

> Atop Lake Superior lies a wedge of Minnesota known for its shape as an arrowhead. Despite the work of fur traders, loggers, and miners, the region retains the character of the great northwoods, where thousands of lakes still sit in basins scoured from bedrock, and rivers sparkle and tumble through rocky rapids. It is to the arrowhead that people travel to canoe, hike, snowmobile, and ski in the closest approximation to true wilderness that still exists in Minnesota. For many Minnesotans, the northwoods is the quintessential picture of Minnesota—not only how we imagine our state to be, but also how we wish it to be, still forested, still wild, a place where loons call and wolves howl.[5]

It is good that we have retreats like the northwoods in which to glimpse how the land used to be—unless of course we love it to death, as we have so many places by our sheer numbers and our quest to "get away from it all." I recall one of my first trips to Yellowstone National Park. Well grounded in the literature on the early trappers of the West, I eagerly anticipated an awesome, astonishing landscape of boiling springs, spouting fountains, smoking pits and mud pots, the sharp smell of brimstone. I knew, of course, that the land had changed significantly since John Colter and his like had passed by; but I was not prepared for the miles and acres of asphalt that led me to Old Faithful, the long lines of impatient tourists, the multiple signs telling me where to go and when the famous geyser would next perform. I even overheard a youngster ask, "When will they turn it on?" The air smelled of exhaust fumes, not sulphur.

Our first national park was established by Congress in 1872. In that era when most Americans saw the West as a land still to be conquered, settled, farmed or ranched or mined, this geological wonderland was set aside for a different kind of taming, a domestication into a "public park or pleasure ground for the benefit and enjoyment of the people." One western newspaper

was elated: "to it will come thousands from every quarter of the globe." Roads, bridle paths, even branches of the railroad were eagerly expected, and the government was granted power to lease certain areas for buildings, the proceeds to go for park management and road construction. Even in our nineteenth-century awareness of the need for areas protected from so-called civilization, we were beginning to lose our grasp of the essence of wildness and its importance to the human condition.

Standing among the sightseers at Old Faithful's safety railing I remembered something the great naturalist John Muir had said: "A thousand Yellowstone wonders are calling, 'Look up and down and round about you!'" In 1898 Muir could still discern vestiges of the wilderness and sense the primordial wonders of this place. A hundred years later as I walked the carefully marked path through the steam-spewing flats back to the cunningly designed lodge with its prepackaged snacks and souvenirs, I felt a sense of loss, a feeling of disappointment and sadness at this travesty of Yellowstone wonders.

I think of my first visit to Sanibel Island by ferryboat, and that lovely island now nearly sunk by condominiums, palatial homes, high-end specialty shops, and traffic jams. I think of the time tickets, the shuttle buses to the Sequoia groves, and the hoards of automobiles that both clog the roads and mar my memories of Yosemite National Park. If we don't stop this chasing around for answers to quests we haven't formulated and realize that our problems come along with us, Minnesota's northwoods will look like Yellowstone National Park and Sanibel Island. Can't we stand still in our own places, understand what is missing, and seek to remedy the shortcomings?

But it is not just our wild places that are diminished and endangered; communities large and small are at risk. My own hometown is now hardly a community at all: its downtown is eviscerated by new highway-centered development, and the population, although now stable, is no longer consolidated inside the city limits but instead scattered, cast over the surrounding landscape in a small town variation of big city sprawl. And Minnesota, "the land of 10,000 lakes," is not immune. The Twin Cities are among the most sprawled regions in the United States. Very soon Minneapolis-St. Paul will have a half million more cars, and in twenty-five years, 650,000 more people. Meanwhile rural communities will lose population, the urban core will continue to decline, and rich agricultural lands will be converted to sterile suburbia. But what happens to communities in this process, the ties of daily familiarity, the sense of obligation to neighbors that undergirds democ-

racy? Who will pay the costs of roads, bridges, sidewalks, if there are any, libraries, schools, parks, sewers, water lines, streetlights, in this uncentered metropolis? What air will we breathe? What will prodigal frenzy make of our earth, and what will we have left to bequeath to our children?

And what stories will we tell of our place? The very biggest loss is storied places. In losing these places we lose ourselves, our sense of self, our connections to each other; and we are bereft of the solace of community, the care of others in an isolation that no Internet chat room, video screen, or a thousand visits to the north country can ever replace. Gail Rixen of a small town in Minnesota wrote of such things in *Pictures of 3 Seasons*.

Fossum

It's all gone now but the name,
sold out.
They came in on wooden wheels
and drove away on radials,
I just moved down the street
and sat down.

The new highway took business to bigger towns,
left us sitting like dolls on the empty streets—
dolls, who once fixed working parts
and put things in motion.

Sometimes when light comes in the shop window
and lands right there,
I can see Mabel in her rosy apron
and the stances of old friends.
Then I can smell the heat in the coals,
feel the weight of the hammer,
and the metal that made our workings turn.

These days my new birdhouses swing in the trees,
pretty and empty, no good to anything.
Iron's dependable, keeps to its bounds.
Circumstance roughly pounds
the shape of my days.[6]

Yes, but she is a poet, and poets indulge in such wistful nostalgic longings. Then why is it that so many contemporary guides to Minnesota and every other state feature nostalgia and offer travelers places that reek of wistfulness for the past and promise ease from the cares of our present world? The AAA guidebooks are renowned for their accuracy and general helpfulness, and I always find them an excellent resource—and an interesting barometer. The Minnesota section of the *2001 North Central TourBook* had, of course, advertisements for Valley Fair and the Mall of America, the ultimate symbols of the growing sameness of our nation and our world. But the real features focused more on history than anything else. Here is just one example, the entry for Owatonna.

Legend has it that frail, sickly Owatonna, daughter of the great chief Wabena, was restored to health by the local *Minnewauan*, or curative waters. Travelers still come to drink from the healing springs at the northeast side of town, where a statue of the princess stands in Mineral Springs Park.

Owatonna also is the home of the 1880 "Old 201," the locomotive once driven by the legendary engineer Casey Jones. The engine is preserved in front of the 1887 former union depot at the intersection of US 14 and I-35.

The Village of Yesteryear, 1448 Austin Rd., encompasses 19th and early 20th-century buildings, including a firehouse, two schoolhouses, a railroad station, a farm machinery building, a general store, a smithy, a church and Dunnell Mansion and Museum. Guided Tours are available.[7]

Does the Village of Yesteryear and its many counterparts reflect the demographics of baby boomers immersed in self-indulgent midlife crisis? And will this too pass with the boomers themselves? Or is it a dark reflection of what we have done to our places and to ourselves? Is it a longing for storied places, havens of permanence in an impermanent world, a primal urge perhaps to find a place that matters, a place that extends out of the present into the past and into the future, a place that even for a moment emancipates us from our solitary confinement in a forlorn present where change seems to be the only constant and nothing endures for a decent interval?

Maybe our current fascination with the Lewis and Clark Expedition is a manifestation of our longing for the wildness from which we have severed

ourselves and thus have suffered long-standing residual phantom pains, or perhaps it is fascination with the elemental survival skills of the Indians and the members of the Corps of Discovery. The Lewis and Clark Expedition has always had all of the makings of an epic adventure story, but our present intrigue with the story proceeds from a resurgent interest in a radically different America than the one we have fashioned about us and in the more intimate relationships between humans and landscape than those we now have.

Both Meriwether Lewis and William Clark were agents of the Enlightenment sent west by the master at Monticello, our nation's quintessential Westerner who never trekked west of the Blue Ridge in Virginia. Thomas Jefferson sent Lewis and Clark to measure, map, describe, catalog, and thus make the West known and useful. These were rugged men to be sure, capable of surviving by their wits. Yet, as we now know, they could not have survived without the Indians, the people who really knew how to live with what Euro-American standards deemed limited technology.

The expedition members spent the winter of 1804–1805 at the Knife River Villages. The next spring they entered territory unmapped by Europeans. From this point on, Lewis and Clark did not know where they were going. Directions from the first Americans were now essential to expeditionary success and personal survival. Clark sat down, one can imagine by a fire, with some Mandan men. "Draw me a map of lands to the west," he must have asked. One of the men, Sheheke, obliged. But it was a map unlike any Clark had previously seen. It was not a neat grid, oriented in cardinal directions imposed on Western geography. Clark's sextant, octant, surveyor's compass, artificial horizon, and chronometer were fixers of latitude and longitude. Sheheke's map did not work that way. Sheheke's map did not focus on scale and compass directions, but instead described human interaction with other people and with the landscape along the route. Sheheke's map was, as Missouri Historical Society project historian Carolyn Gilman described it in her plans for the Bicentennial Exhibition on the Lewis and Clark Expedition, "the diagram of an event in time as well as a portrayal of land forms. It was a journey chart illustrating the experience of traveling to the Rockies." Indian maps contained village names, travel routes, and sites of mythic and human events. Indians described land as a vessel for their history, religion, and individual experience. Clark learned to read this map and to understand it as a visual representation of a story that

was also a part of the instructions for getting from one place to the next. It conflicted with his "enlightened" propensity for grids and measurement but he learned how to read it. Clark became part Indian. He rediscovered an older, variant way of describing both routes and relationship to land as the vessel of human experience. It reminds me of Bill MacKay's story or my own camp narrative. These ways reflect a respect and interconnectedness that a Rand McNally cannot. I doubt that Clark ever forgot Sheheke's map. Yet when Clark drew his 1814 map of lands traversed by the Corps of Discovery, he left out everything he learned from Sheheke: the historical and mythic sites were all gone and so were the hundreds of tribal settlements, Indian place names, routes, and trade centers. It was now land without a history, an empty land ready for settlement. Clark's map was a guide to distance, boundaries, and American names—and an opportunity tragically neglected. How would we be different, how would this land be different, if we really regarded land and community as the vessel that contains and shapes our lives, the crucible of generations, the essential flux and catalyst of life? Montana author Bill Kittredge puts it another way in *Who Owns the West?*

We go into wilderness, I think, to renew our intimacy with a world that is natural and perhaps sacred. To me sacred means necessary. We evolved in nature with other animals (think of them as our companions in the vast universe). Isolate us from nature too long, as individuals, as societies, and we start getting nervous, crazy, unmoored, inhabited by diseases we cannot name, driven to thoughtless ambitions and easy cruelties. This is not, I think, sappy talk, or overstated. It's only true. We feel it, we see it everywhere, every morning in the newspaper, so many gone so frantic.[8]

My caveat to Kittredge's stirring words is that nature is not someplace else. It may be awesome and overwhelming in Montana and Alaska and Michigan's Upper Peninsula, but nature and that quality I am calling wildness is everywhere. It is on your city street and at your neighborhood community center, in my urban backyard in St. Louis and in Sue's eyes.

An exhibition of photographs by Brent Phelps entitled *The Journey of Discovery: Following in the Footsteps of Lewis and Clark* was at the Billings, Montana, Western Heritage Center in the fall of 2000. Phelps's images are spectacular evocations of places traversed by Lewis and Clark, but they are more. They are images of time passages. His pictures admit and en-

compass change. He leaves conclusions about whether the change is good or bad to the viewer. Nor is it my purpose to conclude whether change is good or bad. We can judge the consequences of change for ourselves and for our home, the earth. We can evaluate the stories that justify what we see. The change in Phelps's images captures consequences of a certain story that defines our beliefs about progress, land, change, and the course of the future. If we are not willing to make judgments and then make choices and course corrections in the present, we will be victims of chance, prisoners of the past, captives of our history like people in Northern Ireland, the Middle East, or those in St. Louis who are still in the grip of a racist past.

We cannot and should not return to the world of Lewis and Clark. We cannot undo what has been done even if we wanted. However, we need to learn that place matters and that wildness is essential. The wildness I speak of is not the same as wilderness. Rather, it is the recognition that we are a product and part of this earth. In a time when place seems to matter little, when communication is instantaneous and work is completely portable, in a time when everything seems transitory and the speed of change has led us to conclude that the past is no guide to the present and the present is not a useful guide to the future, we must redefine our relationships to our place and to each other. Wendell Berry writes of this in *The Long-Legged House*:

> Seen as belonging there with other native things, my own nativeness began a renewal of meaning. The sense of belonging began to turn around. I saw that if I belonged here, which I felt I did, it was not because anything here belonged to me. A man might own a whole country and be a stranger in it. If I belonged in this place it was because I belonged to it. And I began to understand that so long as I did not know the place fully, or even adequately, I belonged to it only partially. That summer I began to see, however dimly, that one of my ambitions, perhaps my governing ambition, was to belong fully to this place, to belong as the thrushes and the herons and the muskrats belonged, to be altogether at home here. That is still my ambition. But now I have come to see that it proposes an enormous labor. It is a spiritual ambition, like goodness. The wild creatures belong to the place by nature, but as a man I can belong to it only by understanding and by virtue. It is an ambition I cannot hope to succeed in wholly, but I have come to believe that it is the most worthy of all.[9]

Our ambiguous attitudes about nature contribute to our problems with place. Are humans a part of the natural world or are we separate and apart from it? Are we somehow the "other"? Much of our history demonstrates that we behave as if we are the "other," to the degradation of place and of our planet. Exploitation and consumption take precedence over other values inherent in place. In fact we call more sophisticated forms of exploitation and rising rates of consumption "progress." We behave as if there are no limits, as if this earth's resources can be stretched infinitely.

My colleague and friend Dr. Peter Raven, director of the Missouri Botanical Garden in St. Louis who has been named one of the planet's saviors, puts it something like this: Imagine you are in space looking back at the earth, far enough away that it appears to be the size of the moon as you usually see it. All is silent and dark. Our planet appears as a small disk, an iridescent blue ball in a black sky, small, limited, and finite, and it is our only home. This is all there is.

This is only part of what I mean by wildness. Wildness is not a place, a descriptive adjective, or an attribute of the primitive. Wildness is a virtue that each of us can, indeed must, attain. More even than love of place, wildness is a profound acknowledgment that humans are intertwined with geography; that is, we occupy space in time. We do not exist in a virtual world. We may spend large chunks of our lives in a virtual world where we maintain relationships and do business detached from place, but as long as we have bodies we will have to be somewhere. That somewhere is the earth, and it is in the company of others. The history of life on the planet is embedded in our genes. The stories we weave about our lives, our narratives, our histories are not disembodied. Our lives and all lives are rooted in place.

One need not live in the wilderness to acquire wildness. It does not matter whether your place is Bill MacKay's Lazy El, a suburb in Billings, our camp in the Upper Michigan northwoods, or the St. Louis City neighborhood where Sue and I live. Wildness means that wherever we live we accept our responsibility for our place. And I do not mean just recycling our newspapers and soda cans or sweeping our part of the alley but rather the larger issue: responsibility for the whole health of our place. We belong to the earth. That is our wildness. Wherever we are we must be responsible for making a good place to live, a truly good place, where we know each other and create community, where we accept personal responsibility for the common good, and where we look beyond our limited lifetimes and make it our business to

Sue and Robert Archibald's "camp" in the Michigan northwoods. Photograph by Sue Archibald, 2002.

bequeath good places to those who will stand in our place in years to come. They are places that are not used up, places of empathy and justice that emphasize relationships and mutual obligation and concern. They are the places where we adhere to the most fundamental axiom of humanity: leave this world and all its parts in better condition than you found them.

"In Wildness is the preservation of the World," wrote Henry Thoreau. A century later Wendell Berry added a corollary: "In human culture is the preservation of wildness." Live into, not merely in or on, your place on this planet, make yourself a part of it, and pass it on.

Notes

1. Robert Traver, *Anatomy of a Fisherman* (New York: McGraw-Hill, 1964), p. 10.
2. Louise Erdrich, *The Blue Jay's Dance: A Birth Year* (New York: HarperCollins, 1995), p. 6.
3. Wallace Stegner, *Sound of Mountain Water* (Garden City, N.Y.: Doubleday, 1969), pp. 147–48.
4. Federal Writers Project of the Works Progress Administration, *Minnesota: A State Guide* (New York: Hastings House, 1938), p. 89.

5. Greg Breining, *Minnesota* (Oakland, Calif.: Fodor's Compass American Guides, 1997), p. 223.
6. Gail Rixen, *Pictures of 3 Seasons* (Minneapolis: New Rivers Press, 1991), p. 39.
7. *AAA North Central TourBook* (Heathrow, Fla.: AAA Publishing, 2001), p. 124.
8. William Kittredge, *Who Owns the West?* (San Francisco: Mercury House, 1996), pp. 107–8.
9. Wendell Berry, *The Long-Legged House* (New York: Harcourt Brace, 1969), pp. 149–50.

Sustaining the Future

W E LIVE IN A SOCIETY OF CO-OPTED WORDS, WORDS whose meanings are twisted and contorted in an effort to obfuscate truth and shape public opinion. No word is more twisted, convoluted, and tortured than *sustainability*.

Leo Drey owns gigantic parcels of timberlands. He is a lumber man and wealthy because of it. He and his wife Kay are environmental activists in St. Louis; they have supported environmental causes with their dollars and their souls. She has protested the chewing up of wetlands and farmlands for highway construction and extensions of sprawling suburbs, the incineration of the cancerous residues from the remains of Times Beach, and the potentially dangerous cleanup procedures used to dispose of radioactive wastes at Weldon Springs, a munitions plant of World War II and the Cold War era. Leo has donated huge chunks of pristine southern Missouri land to the state park system and has contributed generously to political efforts to influence environmental policy.

Leo and I meet in my office. He is a slight, lean, soft-spoken man. These outward characteristics belie his profound and unshakable commitment to planetary health. His donations of spectacular land to the state parks add to the quality of life of all of Missouri's citizens while protecting beautiful and contemplative places. Yet he is not an impractical man. Leo is wary of the word *sustainability*. At our first meeting I was new to the word and

came perilously close to innocently repeating the timber industry's perversion of its meaning. "Sustainable yield" is really a euphemism for a sort of tree crop. It has nothing to do with respect for the inherent value of nature and planetary health. It means maximizing timber production by planting seedlings instead of just leaving denuded land behind the timber harvest. Related words, Leo chided me, but *sustainable yield* is not *sustainability*.

Now, years after my conversation with Leo Drey, I am not so certain that sustainability and sustainable yield are so different. I think that perhaps sustainability in popular understanding now means some sort of planetary farming: the notion that humans are farmers tilling the earth for their own benefit but doing so in a way that guarantees that something will be left over when the current generation of farmers passes on. Would that we were so wise. Would that we clearly understood the long-term consequences of biotechnology, genetic engineering, and biological and chemical tinkering generally, and even more importantly the values upon which such attitudes are based. Is the planet really our property to do with as we wish? Or are we obliged to consider the future of the planet and all its life? Does the planet incorporate transcendent values beyond the human life that it sustains?

I wonder what sustainable yield would mean if we applied it to Lake Superior. I suppose it would mean that we cease to regard the lake as something essential in its own right and instead calculate its capacity as a water reservoir for the use of human beings. This is not far-fetched. A recent headline in the *Marquette Mining Journal* announced that the United States and Canada are going to study Great Lakes water diversions. "The Great Lakes are full of fresh water," the story proclaimed, "at least six quadrillion gallons full to be exact. . . . Now the United States and Canada are going to look at whether any of that is excess and what might happen if water is allowed to be shipped from the region by the tankerful."

Before the end of each visit to Ishpeming, I walk along Lake Superior and evaluate its importance to me. It is a humbling experience, for I am diminished by my own insignificance in the presence of such power, the majesty, the near-timelessness of this magnificent lake. Yet it is also exhilarating, for this lake expands me, merges me with a force larger, older, stronger than the boundaries of human life. Here on these shores I began to learn to know who I am and to discern my place in the order of the universe. Lake Superior broke its waves against all the years of my youth and still to-

day refreshes and sustains my spirit. Could my spirit bear the use of this magnificent lake as a catch basin?

Water in my city home seems further removed. I am utterly oblivious to the subterranean sequence of events kicked into motion when I set my hand to the shiny kitchen faucet and turn it clockwise, and I am clueless as to the consequences of a solitary toilet flush. I carefully set sprinklers in the yard on a hot summer morning and watch water squirt over my yard, run down the street gutter, and disappear in the drain grate near my driveway. And I don't know what is in the dark sewer underworld, although I have known the occasional putrid stench from the basement drain when a blockage causes backup. I am not odd in my ignorance. Most of the over two and a half million people who live in the St. Louis metropolitan area are unaware of the complex system of Missouri and Mississippi River intakes, the hundreds of miles of mains that deliver clean, clear water when and where we want it, and the vast system of drainage that directs the wastewater through treatment plants and back to the river. We just assume that the water delivered from faucets, or swirling like an inverse tornado in toilet bowls, or gushing into our tubs will be crystal clear.

Yet all of us know that the answer to "where does water come from" is a lot more complicated than the quick and easy flowing response that comes with a simple faucet twist. All children wonder where the rain or snow comes from. Or why rivers never seem to run out of water or about the source of the seemingly unending supply of water that comes into our homes. And many of us adults don't really know either.

I recall my amazement at wells. At my family's camp, even though it was located on a lake, drinking water came from a well. The lake water wasn't clean enough to drink, dad believed. I got a hint of why, when he said that we needed to move the outhouse away from our camp. Dad was very cautious about such things, and I understood that he did not want the outhouse to drain toward the well or the swimming area. But the well was only a hundred feet from the lake. Why couldn't we drink the lake water, while the well water from the nearby hole was fine? The well water looked different. Lake water had an amber tinge, as did water in all inland lakes in the Upper Peninsula. Dad explained the color was related to dissolved minerals and organic materials. But well water was crystal clear and so very cold as we pumped it up and watched it spew from the pump lip into galvanized buckets that we then breathlessly carried up the hill and hefted to the kitchen

counter. We put aluminum lids on the buckets and used a graniteware dipper when we were thirsty or needed water for coffee. The well water, dad said, was the same water that was in the lake, but it was filtered through fine sand and coarse gravel as it slowly seeped underground, and it was not stirred up by the winds and waves of the lake. Unspoken but implicit in all of these half-understood explanations was dad's concern that water that was not clean would make us sick and ultimately the importance of clean water.

Surely dad's explanations and my understandings of amateur hydrology were not quite scientific. But my conclusion was right; the relationships between water, rain, snow, rivers, lakes, streams, wells, natural filtration, outhouses, and drinking water were much more complex than a cursory consideration divulged. And that clean water was necessary for a healthy life. It's a lot more complicated than a twist of a faucet handle. I am no expert on the history of the St. Louis water supply and water treatment facilities, but I do know that I get clean water from the pipes coming into my house. I see three magnificent water towers, which are really standpipes, in our city. Although these beautiful standpipes are no longer in use, they do bear witness to nineteenth-century efforts to provide a healthy supply of clean, crystal clear water.

Water clarity is no small accomplishment. Dip a glass into the Missouri River at St. Louis. It appears to be about one part water and nine parts mud. The Missouri joins the Mississippi just north of the city, turning the mighty Mississippi into that "strong, brown god" of T. S. Eliot's poem. That murky liquid was our drinking water until the beginning of the twentieth century. The coming of the Louisiana Purchase Exposition, our famous 1904 World's Fair, was an urgent impetus for water clarification. The exposition's planners had designed the fairgrounds with a motif of cascading fountains and a chain of elegant lakes and lagoons. They squirmed at the image of Mississippi mud cascading through the decoratively lit water features of the fairgrounds. After many trials and experiments, the local scientists and engineers (and politicians) found a treatment that worked, assuring the fair of its pristine fountains and, almost incidentally, providing clean water for the St. Louis population.

Certainly, concerns for public health also stimulated the search for clean water. Water treatment plants replaced private polluted wells and cisterns, and underground sewers and waste treatment supplanted open sewers and filthy street gutters. The common cesspools, privy vaults, and outhouses that littered the backyards of overcrowded tenements and even private homes

eventually disappeared in the wake of indoor plumbing and the complex system that went with it. I have toured the Chain of Rocks plant on the Mississippi at St. Louis, and I know about the Missouri River plant at Howard Bend to the far west of the city. I also know that St. Louis now boasts of the purest, cleanest water in the country.

But even before my acquaintance with the science and history of water treatment, my earliest camp experiences with wells, wooden outhouses, and finally the long-awaited septic tank left me with the vivid sense that clean water and good health were opposite sides of the same equation. However, the issue of sustainability is more complex than clean water and good health. I am not a scientist, but sustainability is only in part a scientific issue. Rather, I am a humanist and deeply interested in humans: how we perceive the world, how we make sense of it, what motivates us, and how we meet our responsibilities to provide for our own lives but also to live in a sustainable manner for future generations. We know how to avoid water contamination: don't put dirty or unnatural stuff in it. We know how to treat wastewater so that it is even cleaner than before we used it. We know why wetlands are important. We understand rivers as ecosystems. We understood what we did to Lake Erie when the fish disappeared and the Cuyahoga River in Cleveland caught fire. We know what organic runoff is doing to the Gulf of Mexico. We can see the algae blooms in the "dead zone" in satellite photographs. The question is not for the scientist but rather for all humans: if we know what we are doing to the earth and its store of life-giving water, why don't we stop it? The simple answer is, we don't want to. We might have to sacrifice something to do it. The question is, can we exercise enough collective self-control to avoid further disasters and ameliorate current ones? In a larger sense, can we reject the notion of ownership of our place and its resources on this planet in favor of a usufructuary right, the right to use the planet and its resources, including water, without diminishing them? We have not lived this way. Instead we have repeated the shopworn and highly inaccurate mantra that "the earth belongs to the living."

I am a community advocate first and foremost. But I am also an advocate of saving the earth and its variety of resources from rain forests to the layers of the atmosphere, whales and wolves and human beings. And I have been involved in city planning, park planning, mass transit, government reform, environmental efforts, the school board. I see the deprivations that communities suffer in the loss of place, whether the magnificent place of

Lake Superior or the communal space of a town square. And I am convinced that good places for people and environmental advocacy are complementary elements. I am also convinced that there is a value in wilderness, that is, places imbued with a wildness untrammeled by human activity. Setting aside a parcel of "open space" here and "green space" there is not a solution, for by this very action, however laudable and appreciated, the transformation by humans begins and does little to halt the wholesale process of privatization, environmental degradation, and massive land consumption while deprivation of place continues unabated.

In the 1890s and early twentieth century, St. Louis was a leader in the parks and playground movement. These "open space" efforts were made to ameliorate the worst effects of an industrial city on its humans—overcrowding, smoke pollution, and lack of opportunities for outdoor recreation in natural settings. The elimination or even curtailment of problems of dense population and pollution were not the object, but rather mitigation of those effects through opportunities for escape. Nineteenth-century zoning was not a solution, for that zoning simply attempted to separate noxious industrial facilities from residential development. Those who could afford it insulated themselves in private places while the poor lived in crowded and generally dirty tene-

Children at a St. Louis playground, ca. 1910. Missouri Historical Society, St. Louis.

ments. In St. Louis those tenement dwellers could occasionally escape to a magnificent assemblage of city parks.

So what is the purpose of open space and parks now in the twenty-first century? Most regions have great expanses of privatized open space. This open space is a consequence of our unbridled pursuit of the suburban dream. Our post–World War II vision of the ideal home is largely one of space. The larger the lot, the more desirable the property, an acre, two or three acres, ten if we can afford it, what historian Kenneth Jackson called the "crabgrass frontier." In our region in the last fifty years, the land area that we occupy has increased by several hundred percent while population has increased by less than 100 percent. When we measure by this standard, we have plenty of open space, but it is neither accessible nor is it respectful of a natural environment. In fact, the opposite is true. Suburbanization, given its penchant for privacy and personal ownership, severely restricts its abundant open space. Suburbanization destroys natural environment, both initially and in its subsequent reliance on private automobiles, prodigious consumption of fossil fuels, and continual highway development. Land is destroyed and the air is fouled—even if the air is cleaner than in turn-of-the-century St. Louis and our people are wealthier and healthier.

Urban abandonment in the city of St. Louis. Photograph by Sue Archibald, 2003.

The other side of suburban development is urban abandonment. The City of St. Louis has lost nearly two-thirds of its population in fifty years. For me this is an environmental debacle.

Waste is not just a matter of how we consume new resources; it is also a question of how we use or don't use those resources in which we have already invested time, dollars, and other resources. Suburbanization might be more acceptable to me if I didn't dwell on its detritus. I drive around the City of St. Louis amid abandoned and underutilized infrastructure and resources: houses, factories, stores, schools, churches, parks, streets, sidewalks, sewers, water pipes, utilities, power lines. I remember working with developers to reuse historic properties when I supervised the state historic preservation office in Montana. In most cases, when a careful financial feasibility study was done, reuse did prove more economical. But often I could not convince developers that reuse of a structure was an economically viable alternative to demolition. But in one sense the demolition advocates were not wrong. There was and is a bias in favor of the new and against the old. You can see it at work in the classification of office space in downtown St. Louis or in any of the older metropolitan areas. No old address is as desirable as a new address in a bare shiny office park or a spotless suburban tract.

So without intention we have two types of open spaces. We have far-flung residential areas with expensive suburban real estate and enormous infrastructure costs, and we have abandoned space that nobody wants at any price and a deteriorating infrastructure serving far fewer residents than it was designed to support yet still incurring heavy expenses. Both are forms of waste. In this sense we already have more open space than we can handle, and we pay an extravagant price for it.

While the environmental costs are high, the costs in community loss are also enormous. It is not accurate to blame all ills that afflict contemporary communities on this process of dispersal and abandonment because many other factors have contributed: television, air conditioning, two wage earner families, the vagaries of the job market, and more. Underlying all of this is the American penchant to emphasize individual rights over common good, and often short-term gratification over long-term benefit. As Americans became wealthier in the post–World War II period, they were able to exercise expanded individual choice. This is not a new feature of our characters, but rather an elaboration of a long-standing tendency. It took a relatively short

time for thirteen ocean-hugging colonies to gobble the width of an entire continent. By 1891 the frontier was declared officially gone. What we see in the far-flung and wasteful spread of the St. Louis metropolitan area and too many other regions is our own iteration of extreme individualism expressed in urban geography. The common good rarely supersedes individual rights in public policy decision and nowhere is this more apparent than in land use decisions.

In America, individualism has always been at odds with community, never more so than now. Yet democracy depends, as it always has, upon voluntary self-sacrifice for the common good. Decline of community, well documented in recent studies, is an indicator of the health of our democracy. One good reason for that decline is the simple fact that we do not live together. In short, we have too much suburbanized open space and too much abandoned open space, no town square where we congregate, build relationships with each other, and form community.

I admit my own bias. After a youth spent in the heavily forested, sparsely populated, margin land of Michigan's Upper Peninsula and a chunk of adult life in Montana, where there are thousands of square miles of wilderness, I lived in a St. Louis suburb and now in the City of St. Louis. I know now that I am not a suburban person. I disliked the impersonality, the monotony, the homogeneity, even the neatness of it. I did not like not being able to walk anywhere, and I did not like the neighborhood hubbub about real estate values. And I did not like the commute, the constant in and out of automobiles. Those who live in such places, and they are now most of us, have made a Faustian bargain for perceptions of security and an acre or two or more of the American dream. As for me, I want to mingle with and enjoy my fellow humans or else I want solitude. I want the vibrant life of a city, or I want complete escape.

At its core the question of how we use and allocate space on the land is a question of values, the values we embrace in our own lives. Most importantly, it is the question of whether or not we deem the quality of the legacy we leave to our children and our neighbors' children to be worth considering.

Our lack of concern about space, open or otherwise, is also a product of our vagabond lifestyle. Places are just real estate when we move, as I have, multiple times in a lifetime. We don't stay long enough to invest ourselves, our experiences and memories, in the land and to bury our loved

ones in it. If no place is really ours, then no place really matters. This question of ethics and values is one factor that obstructs the development of a new land ethic.

I have often thought that in St. Louis we are not very good at seeing the whole problem, or perhaps the enormity of it overwhelms us. When I was president of Citizens for Modern Transit, the local light rail advocacy group, I found that many of my colleagues saw "transit" as identical with a public transportation system. But I saw transit as more than efficient public transportation. It is also a land use issue, an environmental concern, an opportunity for denser housing and thus better community, a potential antidote to urban sprawl and the decline of the city and its close suburbs. Yet some mass transit supporters had difficulty seeing the environmentalists' causes, for instance, in relationship with their own. To me it was like a bowl of spaghetti shared at a large gathering: as you took your own portion out of the bowl, you couldn't really know which spaghetti strands you would be affecting. It's all one dish. It's all one common cause.

Making the city into the landfill for the whole region's problems is directly connected to this issue of land use and abuse. Because of cheap land and subsidized development, escaping problems is easier in the short term than facing them and solving them.

Both clean water and open space of all kinds are crucial for recreational, environmental, and spiritual reasons. Yet advocacy of these essentials will just amount to blowing into the wind if we do not act to face the whole set of interrelated problems that confront us. The problems we face are not intractable: zoning and taxation policies can change, transportation funding formulas are not immutable, park funding can increase, air and water pollution is as yet still reversible, and we can adopt growth boundaries if we think they will help.

I am a historian, and I am convinced that the study of the past ought to lead to something more than nostalgia, something other than a confirmation that we are the wisest, most sophisticated generation ever to roam the planet and that we have progressed further than any before us. Anthropologist Claude Levi-Strauss once observed that history is a wonderful discipline, provided you get out of it. He meant that we ought to draw useful conclusions from past human behavior. Not only do I believe that people in the past had faculties and capabilities and behaviors like ours; I believe that people in the future will, too. And so I have been involved in

all those issues of persistent community concern, although I am certainly not an expert in any of these areas.

For me, history is a process of sorting out what we have done well and what we have done poorly. If we can just respond appropriately to those questions, we will be well on the way to finding answers. We know what our problems are and we know the range of useful solutions. What we lack is the determination that can only proceed from a base of public, not professional, consensus around both the precise natures of our problems and specific remedies for them.

Historically the St. Louis metropolitan area is about as well planned as it could be. There are plans in desk drawers and filing cabinets everywhere, testimony to the efforts. I know some of these plans very well because I have been party to their development. But these well-intended, often intelligent efforts have been for the most part futile, mere documents lying neglected and ignored in a bottom drawer. A big part of the problem is process and public expectation. Who in this region is authorized to implement a plan, and who does the authorizing? Like many other regions we seem to have a good many leaders, or would-be leaders, and very few followers. The results are competing plans that fractionalize leadership and confuse the public. Failure of planning efforts has less to do with the specifics of any plan but rather with planning processes that do not galvanize public support either around problem identification or resolution. All those plans in file cabinets and desk drawers are the property of the planner or the committee that developed them. Often they have neither public nor political support necessary to bring them to the light of day, much less to the community's betterment.

Part of the problem is the rush toward professionalization in the past century. Every profession has evolved a set of best practices that reinforce professional standards. Only those who meet those standards and adhere to best practices are admitted to the inner sanctum. It has happened in the planning business and in the museum field. We become the experts, the authorities, and the professionals; everyone else is an amateur. Amateur once simply referred to someone who was involved for the love of it, rather than for pay. Now it means uninformed, inexperienced, untrained, lacking true knowledge, even careless and sloppy. The problem with our definition of professional is that it excludes the public. So we end up doing things to people instead of facilitating public process that rightly belongs to all. Too often "public process" is something to be managed so that the result supports

147

a predetermined course of action. Public meetings become rancorous and difficult, for people know that they are being manipulated. We need to take a cue from the medical professionals who worked harder than any other profession to erect barriers in the paths of patients who wanted a role in their own health care. Now doctors and insurance companies are insisting that people accept personal responsibility for their own health and health care decisions. Can't we also ask people to assume personal responsibility for the health of their neighborhoods and communities, the quality of the air they breathe, the purity of their water, the amount of the taxes they pay, the hours they spend commuting, the quality of their own lives? In short, can people become their own planning experts? Expertise is something to bring to the conversation with fellow citizens. It does not provide a special authority nor does it offer a bigger stake in the outcome. There is evidence that indeed people will not have it any other way.

Professional planning grows out of the assumption that there are scientific and predictable ways, understood only to experts, to plan and direct people's lives. A corollary of that assumption is that planning is so complex that it can only be left to experts. Planning by experts presumes a source of legitimizing authority, which traditionally emanated from corporate and political power structures. Zoning ordinances, legislation, and appropriations are politically established. But we now live in a time when people mistrust both politicians and corporations. Corporations are no longer attached to places as they once were, and more than ever shareholders insist on exclusive attention to the "bottom line." So even if citizens were willing to authorize CEOs to make planning decisions, corporate executives see few rewards in considering community needs. Similarly, in my region at least, politicians have neither the power nor the authority to make planning decisions.

Over the past fifty years America has become democratic, and multicultural, in ways that the founders could not have anticipated. Minorities of all kinds and interest groups of all stripes now insist upon involvement in decisions that affect their lives. Citizens demand to participate in all such deliberations and not just in a passive, reactive way. They insist on being part of the process from the beginning, before the issues are defined and alternative solutions framed. The future will be even more radically democratic. Experts will provide information and facilitate discussion, but they will attempt to preselect options only at the peril of scuttling the plan. The process is about trust and relationship building; and if we can create processes that

build in ownership, then the product, or plan, will have the required support for implementation. Conversely, if the process is wrong, the plan, no matter how good it may be, is dead on arrival and will join other dusty blueprints in rarely opened desk drawers and eventually end up in the archives of the state historical society with other good but unfulfilled ideas.

The positive side of all of this is that citizens will fill the leadership power vacuum left by corporate change, political suspicion, and governmental fragmentation. In democracy, noted de Tocqueville, that observant Frenchman who wandered around America in the early nineteenth century, individuals are weak and can accomplish nothing; but in association with one another, they can accomplish anything. The new authorizers and the new sources of power will be "we the people."

There has been a lot of theorizing in recent years about the putative civic disengagement of Americans, a notion popularized by Robert Putnam in his book, *Bowling Alone: The Collapse and Revival of American Community.* Yet, while participation in bowling leagues and fraternal organizations is down, the last few decades have seen the creation of a plethora of cause-oriented citizens groups focused on every imaginable issue: civil rights, freedom of speech, environmental concerns, water quality, farmland and wetland preservation, transit advocacy, neighborhood revitalization, and issues of every other brand. Some of them engage in the politics of obstruction and confrontation, but others have positive agendas. If these groups, and others, are not included in the process, even the best of planning will be ineffective. And the process does not begin when most of the planning is complete. It begins at the first meeting when priorities are discussed and set. A friend of mine puts it this way: "Either we all get on the same train, at the same place, at the same time, or the train is not going anywhere."

A few years ago I served on a small executive committee charged with development of a master plan for Forest Park, this region's premier public park and home to many of its large cultural institutions. We endured close to three hundred public meetings, with the involvement of thousands of citizens. Because of its popularity for dozens of uses, Forest Park's thirteen hundred acres is contested ground. Some people threatened to chain themselves to trees. Some people insisted upon larger parking lots while some insisted on banning motor vehicles. Others wanted more wildlife habitat or bigger soccer fields or more golf holes, bike trails, jogging paths, picnic areas, tennis courts, and so on. I was initially skeptical that the process would

produce enough consensus around any change to permit implementation of any plan. When the process came to its laborious and welcome end, it was apparent that the process had discredited the extremes. Forest Park would not be treated as wilderness for trees and wild beasts, nor would huge chunks of it be paved with asphalt like the shopping mall parking lots. Common sense prevailed. The process was an orchestrated free-for-all, and it was risky because even the range of possible outcomes was not predictable at the outset. But when it was completed, we had a plan and all the opponents on every side had had multiple opportunities to take their best public shot at both the process and the conclusions. No one could say, "I wasn't allowed to express my opinion." So the plan was developed, and the process itself had elicited the public support necessary for its implementation. This was alarming for the experts because their opinions had to enter this fray on equal footing with the points of view dearly held by so-called amateurs and with no guarantee that "expert" judgment would prevail. While the process had the necessary support of the mayor, it was ultimately the public who gave the plan authority and credibility. The plan is now in progress, with an encouraging absence of effective opposition.

When I hear of planning efforts in the St. Louis metropolitan region, I am convinced that we do not ask the right questions. We plan highways, airports, downtowns, bridges, light rail, parking facilities, and all forms of infrastructure, public facilities, neighborhoods, whole communities. We worry about poverty concentration, air quality, commuting times, emissions control, urban sprawl, exurban spread, crime, safety, and sustainability. Some campaign for open space and green space, while in the City of St. Louis we have dozens of square miles of brown space. But do we ever add it all up? I fear not. I think that most of what we do is piecemeal. Do we really believe that population density is good or bad? We talk regionalism except when it comes to building affordable housing. We want good air quality but we are planning to widen Highway 40 and build more bridges while we have a nearly bankrupt mass transit system. We consider transit and roads and bridges as simply ways to allow people to travel between places without considering them as land use planning tools. And we do not consider the reciprocal relationship between a rotting urban core and escalating burdens of subsidized exurban development.

The biggest environmental debacle is not contaminated industrial sites, poor water quality, wetlands destruction, or radioactive waste; rather it is the

prodigal waste of existing infrastructure combined with the simultaneous investment in new infrastructure on the fringes of the region. The City of St. Louis once had more than three-quarters of a million residents and the infrastructure to support them. Now it has just over three hundred thousand people, with rotting infrastructure and a tax base too small to maintain what remains. Yet all of those abandoned or underutilized streets, sewer pipes, water lines, business blocks and industrial facilities, and neighborhoods represent an extraordinary investment in both renewable and nonrenewable resources, the energy to make them, and the tremendous human labor required to build them. But we abandon an existing investment and then replicate the whole thing somewhere else. We have papered over the escalating infrastructure costs with taxes for almost as long as we can, and we have unnecessarily depleted the earth's finite resources. Unfortunately the future will pay the price.

We all need to be reminded to be citizens first and experts second. We cannot plan without a compelling public vision that garners public support with the process that created it, the force and logic of its conclusions, and the encouragement it delivers to people's collective aspirations for a better place and a better future. Adhere to a vision that focuses on the quality of relationships, rather than size, travel times, population density, speed limits, growth boundaries, or even air quality and other quantifiable indicators. Good places that emphasize relationships inherently consume less and will leave something worth having to the unborn generations. This is our most sacred obligation. We do not really own our places. We just temporarily occupy them. We did not create them. All we can do is build upon what we have inherited. We do not have a right to obliterate what we were given, and just as we inherited this place from unknown generations, others we will not know will live with the consequences, good or ill, of what we do here. We will be accountable for how we leave our places, even if we leave them just as they were.

We have good plans, a superfluity of them. What we lack is the will to implement them. Seeking and claiming that will, supplying that determination may be the most powerful planning strategy that we can enact.

In one sense it is too late. The earth is already a museum, an artifact recreated by humanity, for even those places that are not yet transformed continue to exist only because humans have chosen to leave them alone. I think of the Bob Marshall Wilderness in Montana that is wilderness only in the sense that humans have decided that it should be left alone for the time

being. Or consider Yellowstone Park, a place that is set aside but is nevertheless loved to death by the hordes of people who descend upon it. Yellowstone's Old Faithful rather forlornly performs its natural geyser functions in the middle of the parking lots. I believe that the notion of wilderness whether in Montana or the Upper Peninsula or anywhere else is really obsolete because humans have the power now to destroy the planet, whether instantly or slowly. This fact of the twenty-first century places special burdens upon us. In this new century we must recognize our new obligations of stewardship and admit that we now possess the power to determine both whether humanity has a future and whether anyone will want to live in the future we are preparing. We must cease the specious argument over whether global warming is real, or whether the rain forests are crucial, or whether humans are causing species extinctions at an accelerating rate. We all know the answer to each of these questions is yes.

Sustainability in its broadest sense is not a political idea. It is a concept that insists we behave in ways that are good for humanity. True sustainability requires that as a species we look to the future in ways that we have not had to until now. We have had the luxury of behaving as if resources were unlimited and as if tomorrow would not come. Now we are embarked upon an age of limits in which our behavior and rates of consumption of resources and our population must be circumscribed lest the next species extinction be our own. We will now have to consider the long-term consequences of our actions. And we will have to disabuse ourselves of the century-old notion that science and technology will always rescue us from our excesses and stretch resources far enough to obliterate the eternal truth that testifies to the earth's limited ability to compensate for our behavior.

There is no evidence that the consumption binge of the postindustrial era has produced a happier humanity. In fact there is evidence to the contrary: materialism and individualism have produced isolation, loneliness, and uncertainty. Experts tell us that television and the Internet, where we spend so many of our hours, contribute to our isolation from each other. We go faster, get more information, travel farther and more frequently, make more money, and consume more. Consumption feeds economic growth but threatens finite resources—and it is no substitute for Lake Superior. Has our frenzied consumption taught us to value the things that are beyond price?

My perspectives as a public historian combined with my community activity have helped me acknowledge that places that truly assist in the pur-

152

his position

suit of happiness are inherently less demanding of the earth's resources. Happiness is an imprecise term, always relative and temporary. For me it is a fleeting sense of fulfillment and well-being. For most of us happiness involves the solace of relationships with others of our species and the security of belonging, plus a sense of rootedness in a place. The community disintegration of the past fifty years has increased our living standards and expanded economic opportunity, but it has also resulted in the disappearance of the places that sustain relationships, foster behavioral norms, and consume less of our planet resources.

The changes in my city of St. Louis are statistically dramatic: the population of the St. Louis metropolitan area has increased by only about 35 percent since 1950 but the land area occupied has escalated by nearly 400 percent. I do not know what the comparable statistic is for other regions, but I do know just from looking around that the trend is the same. Proximity to shopping, churches, schools, and to each other does not matter as much as it used to. Automobiles compensate for distance, and the television watching that occupies an extraordinary percentage of our time is solitary anyway. By all accounts communities based on common place and ties of familiarity have dissipated. Where we live simply does not matter much anymore. But we have paid for mobility and enhanced personal choice. Democracy depends upon the free association of individuals perceiving bonds of common interest and acting upon the common good. Without places that support that free association—places that nurture familiarity, create firm but informal bonds, and promote a sense of continuity and a dedication to the common good—without these places, not only are individuals powerless but democracy itself is threatened.

A personal price accompanies the social cost. Individuals are forced to depend upon their own devices and the faceless mechanical market to satisfy nearly all their needs. Personal security diminishes. Extended families are a casualty of mobility. Charity that once began at home is now by default a responsibility of some level of government. Inhabitants of houses on the same street are not sufficiently familiar with one another to be truly called neighbors.

St. Louis Hills, where I live now, may be an anomaly but nearly everything I need except my job is within walking distance. Although I have little time to regularly devote to neighborhood affairs, I do keep in touch. Neighbors gather to plant flowers and tend the flowerbeds in nearby Francis

Park. Neighbors clean and tend the lilies and other water plants in the beautiful long, narrow ponds that stretch down the center of the park. Neighbors walk in the park and talk in the park. The neighborhood association publishes the *Hill Street News* devoted to topics of common interest. There are regular meetings where neighbors meet, drink coffee, plan social events, and discuss improvements, crime prevention, and maintenance of streets, sidewalks, and other common areas. It is the kind of neighborhood where, as I discovered, if your section of the alley isn't up to snuff, someone leaves a gentle reminder on your doorstep. And neighbors can walk to church, the Tom Boy grocery, video stores, Ted Drewes' Frozen Custard, restaurants, the public library, and the laundry. All of these activities support ties that bind. And while this neighborhood is not as tightly knit as it once was, you can still sense the possibilities here of a place where people really live and where bonds of trust provide support, familiarity, neighborliness, and a quality of life that depends on relationships, not on quantity of possessions. The qualities of this neighborhood are different from those of an isolated subdivision. Houses are not set back from the street as far. Lots are smaller. There is more pedestrian traffic on the sidewalks. Garages face alleys, not streets. The neighborhood is a mix of single-family homes, duplexes, and apartment buildings. Consequently the place is a mixture of people. Young and old live here, and the incomes of residents vary widely. You have to get along and follow the rules to live in this place because there are too many people too close together to do otherwise, and neighbors are on the lookout for those who do not take care of the place.

I do not want you to have an idyllic image of St. Louis Hills. Development took place here on the cusp of the onrushing automobile age. There is more segregation of residential uses from commercial and retail uses than in older neighborhoods. And for the most part the place is nearly as automobile-dependent as a suburban development. Yet here you can walk to some place that matters without taking your life in your hands on high-volume streets without sidewalks, and you will meet your neighbors. The neighborhood does suggest another way that is less consumptive of resources of all kinds, less damaging to the air, and most importantly more conducive to friendships and relationships that sustain human happiness and upon which democracy depends.

Ironically the same trends that weaken the ties of community are also threats to the planet and future generations. Far-flung communities dependent on cars are necessarily accompanied by environmental degradation and

prodigious consumption of finite resources—not just the gasoline for our cars but also utilities, services, and facilities of all kinds. The cost of this new infrastructure is compounded by the waste left behind. And what about the land necessary to support all of this new development? Look at Ishpeming or Negaunee now, at the underutilized and abandoned buildings, the vacant lots where buildings used to be. They represent waste of resources. Then imagine the infrastructure underground, still there, still maintained with many dollars but now in minimal use. Every structure above and below ground represents an investment of resources that cannot be replaced, investments of energy for manufacture, materials for construction, and human labor. Further, they were often built to last in a style and of materials that we do not and even cannot duplicate in a throwaway world. These places give us a specific identity, a sense of place, a presence of the past, a reminder of those who preceded us, and an aesthetic that cannot be found at an ever-duplicated Wal-Mart or McDonald's. We cannot afford this anymore. This is an age of limits, and we must learn to reuse, adapt, and be less obsessed with what is new. Otherwise we imperil ourselves, undermine the relationships that are the true source of happiness, and bequeath a tenuous world to our children and theirs. Is this how we define progress?

For Michigan's Upper Peninsula these issues are even more important because the specialness of this place will never be its status as an economic power center, a cultural mecca, or a snowbird resort, or for its shopping pleasures. The specialness of this place is in the solace of quietude, the grandeur of the lake, and the still unspoiled splendor of the vast spreads of land. And even here the contest rages between development and protection of the land and water that are the U.P.'s heart and soul: debates over water diversion, continued efforts to control sea lampreys, potential gas and oil extraction from under the Great Lakes, development on the Marquette lakefront, mercury contamination, conflicts between snowmobile interests and public safety—and I might add conflicts between snowmobiles and the solace of quiet spaces. A recent *Marquette Mining Journal* story quoted the lieutenant governor as saying, "I believe that in the next twenty years areas like this—Marquette and Escanaba—are going to explode. There are a lot of people who love to live in this environment."

If this place "explodes," as our lieutenant governor gleefully predicts, the very attributes that make Marquette so attractive to insiders and outsiders alike will be shattered by "improvements." If my experience in

Montana is a harbinger, land will be parceled, real estate prices will inflate, and local people will be priced out of the market. The lakefront, and perhaps the lake itself, will be developed beyond recognition. The U.P. will be loved to death, and our children and their children will be the poorer.

There is another way, a way that we all must espouse no matter where we live on this earth. It is to acknowledge that we do not own this place or any place just because we are alive and here. The earth, our home, has endured for millions of years; it was home to others before we were here, and it will be inhabited by still others when we are gone. The dead, the living, and the unborn all have equal rights to be here. We, this generation, are trustees, not owners. Our sacred duty to those who come after us is to leave this place in better condition than we found it. We must be sure that it is a place with healthy forests, cleaner water, purer air, and with better communities and solid families, with more tolerance for difference, more justice and compassion, a greater sense of civic obligation, a more thoughtful use of finite resources, a place even more capable of sustaining lives of a decent quality and just as capable of providing solace in beautiful, quiet spaces.

Sustainability is not about saving the planet. The earth will survive for its allotted time, with us or despite us. Sustainability is about human happiness. Sustainability is really about saving ourselves.

CHAPTER 8

Touring a Culture

IN A GLOBALIZED, HOMOGENIZED, GOLDEN-ARCHED, WAL-MARTED, car-oriented nation with places bereft of relationships, we have lost our way and lost parts of ourselves. Our stories are impoverished, and we seek escape, solace, and a better place. St. Louis boasts the Jefferson National Expansion Memorial, best known as the Gateway Arch, an incredible tourist draw if there ever was one. I am not an "Arch basher" but rather I am entranced by the nearly erotic lines of Eero Saarinen's great catenary curve. Yet this arch that commemorates St. Louis's preeminent role in western settlement required demolition of what remained of St. Louis's nineteenth-century rivertown, the nexus of east and west. The real place is gone, in its stead a Museum of Westward Expansion, which some wags have called a memorial to those who left St. Louis. With the disappearance of the real place, the stories of that place were dissipated, and gradually St. Louis's relationship with the river was distorted. Somewhere in America there must be places where tradition persists, where the old is not always discarded to make way for the new, where intergenerational connections are intact.

These connections are maintained by the culture of a place and a people. A standard dictionary definition—"the totality of socially transmitted behavior patterns, arts, beliefs, institutions, and all other products of human work and thought characteristic of a community or people"—dryly suffices. But culture really itself has no simple definition; a story always goes with it.

The Gateway Arch, St. Louis riverfront. Photograph by Sue Archibald, 2003.

When I was a boy, snow first came to the U.P. in October, and it stayed until late spring. Blizzards gave us a delicious sense of isolation, quiet time like Christmas Eve when everything seemed suspended. We dug in the drifts on the south side of the hill crest and brought candles into our lairs, unconsciously emulating many of our fathers, miners in the miles of iron ore tunnels beneath us. I vividly remember the head frames that towered over the surface openings, the rumbles of the afternoon blasting, the reddish tint of ore dust that appeared on the snow crust a few days after each snowfall. Deer hunting, skating, rabbit hunting, ski jumping, tobogganing, fishing, pasties, cudighi sausage, saunas, St. John's Church and School, abandoned mine pits, the boat called *Henry Ford the Second* loading iron ore from lowered chutes in Marquette harbor where one year the ice stayed until June. Around all of these places and things we "Yoopers" developed our stories; we absorbed the place, imprinted it, and created ourselves.

My father's story began in Minnesota, a part of the north country where I have connections that are as deep as my attachments to any place with the exception of those that bind me to my original home in the U.P. I often gaze at a picture taken in Barrows, Minnesota, a photo of a log cabin with white window trim and a front porch clear across the front. This cabin is where my fa-

ther was born in 1913. His father, Ralph, was a young mining engineer and geologist, a recent graduate of Lehigh University, at work for the M. A. Hanna Company, whose Barrows mine was short-lived and never amounted to much. It is hard to imagine dad as a Minnesota native since it seemed to me that he must always have lived in Ishpeming. Still, I can imagine life in the Minnesota north country: largely dependent then on iron mining and lumbering—long, cold winters, forests, lakes, sparsely populated loon country with accents all its own, just like my own hometown. In fact, many of the families of mine managers that I knew in the U.P. had first lived in northern Minnesota towns as the men wrestled up the corporate mining ladder. Even the description of Hibbing at the turn of the nineteenth century in the Works Progress Administration guide to Minnesota would have served Ishpeming in its early years just as well.

Miners and lumberjacks, men from nearly every country in Europe, swarmed to the town. Saloons outnumbered the stores. In the "snake rooms" adjoining the bars, many of the patrons slept off their drunkenness on the floors, pillowed on their baggage. Foreman looked over the huskies crowded in these rooms to pick their crews, and then herded them into camps and mines. One saintly Lutheran clergyman, failing in his search for a friendly home to shelter him on his first visit, was taken in by a bartender who furnished him a sleeping place on the floor of his already crowded saloon.[1]

The north country—Minnesota's and Michigan's—is momentous and memorable, made so by the unusual topography, and the piquant flavors still of underground mines, clear water, abundant wildlife, an outdoor lifestyle. The language lilt is so distinctive that my speech still carries a touch of it, although I have not lived in my own north country for more than thirty years. Once I phoned Duluth on business after a very long absence from the U.P., and the accent of the woman who answered immediately made me homesick.

My dad knew the Minnesota north country well, both as a boy traipsing across the private land of my rich uncle, Clement Quinn (land that is now Tettegouche State Park), and then later as a small iron mine operator on the Minnesota iron range and in the Upper Peninsula. As a boy I made countless trips with him from Ishpeming to Duluth and then up to Virginia and Evelyth. A few years ago I came across a poem by Connie Wanek that encapsulates the outdoorsy, nonchalant, tough climate and culture of the area.

159

Duluth, Minnesota

A moose has lost his way
amidst the human element downtown,
the old-timers waiting out January
at the bar, the realtors and bureaucrats
with their identical plumage
(so that you must consult your Roger Tory Peterson)
hopping up the steps of City Hall
eating Hansel's bread crumbs—
poor moose, a big male who left
his antlers somewhere in the woods,
He keeps checking his empty holster.

People suffer the winters
for this kind of comedy.
Spectators climb the snowbanks,
dogs bark, the moose lowers
his shaggy head, his grave eyes
reminiscent somehow of Abe Lincoln.
Fireman, police, reporters, DNR,
two cents worth from every quarter,
till the moose lopes down Fourth Street
toward St. Mary's Hospital Emergency Entrance
and slips into an alley.

Later, the same moose—it must be—
is spotted further up the hillside.
It's a mixed neighborhood; a moose
isn't terribly out of place.
And when he walks calmly up behind
one old man shoveling his driveway,
the Duluthian turns without surprise:
"Two blocks east," *he says,*
"Then you'll hit a small creek that will take you
to Chester Park, and right into the woods."
He adds, "Good luck, now."[2]

Culture is place specific, but "Minnesota" is just a political boundary circumscribing multiple landscapes, climates, peoples, and experiences and hence incorporating multiple cultures. By definition, culture is indigenous. It is created by that wondrous, even miraculous interaction of people, place, and time. It transcends generations and grows by accretion, each generation receiving, transforming, and transmitting. And it is fragile and by no means uniform.

In 1966 I went to Northfield, Minnesota, to attend Carleton College. Northfield is a college town strung between Carleton and St. Olaf's Colleges. Hilltop colleges aside, the most prominent feature of the town's silhouette was and still is the Malt O' Meal plant. I suppose there are some apparent similarities between my childhood mine shafts and Malt O' Meal's grain elevators, but the comparison was lost on me, especially in the springtime as the manure smells wafted everywhere and seemed especially concentrated in my dorm room. This was no mining town. And to a north country boy it was hot and humid. The town felt different and, insofar as I thought about it then, I knew that it was built by different people, differently occupied. The land was so flat, and instead of forests there were fields in every direction. I was not used to such horizons. In my north country, vistas ended in close-up trees, unless I looked out over Lake Superior to the horizon where lake and sky merged ambiguously. While I know that ethnically Northfield was not so different from the north—after all it was and is the home of St. Olaf's—culturally it was another part of the world. I don't think there was a saloon or bar in town, although there was a municipal liquor store—college students fondly referred to it as the "Muny." In those days the cerebral and eccentric Carleton students were just tolerated in what was a conservative town. St. Olaf's was much more the darling of the "townies." Although we at Carleton were isolated by the almost monastic quality of the strictly residential campus experience as well as the traditional divide between town and gown, I did get a visceral sense of the place, a sense that the natives and permanent residents had absorbed into their own sense of themselves, as I had in Ishpeming.

A little volume by Janet Martin and Suzann Nelson entitled *Growing Up Lutheran* celebrates, while it gently parodies, the extremes of a sense of identity. It might have been written about Northfield or the surrounding communities. It's a description of the Annual Meeting of the Eidfjord

Lutheran Cemetery Board. After election of officers the board moved onto the rest of the agenda. This was the first issue:

What would they do if the Swede's side (the part of the cemetery located on the south side of the church) filled up before the Norwegian's side on the north? Oscar pointed out that this was a real possibility because "most of the Norvegians live to be 84 to 97 years old on averch." Bardolph said, "Well, even though prices keep going up and up, the Swedes will just have to start a cemetery of their own."

Adolph said, "Well, we aren't going to let them be buried on the north side. I couldn't rest peacefully with them by my side." Marvin Rustad, who wasn't an officer and was the second youngest on the Board, said, "On the other hand, they couldn't live together in life so maybe they can in death. It might be a start." Sometimes he got a little too liberal for the others, but he was real good at reading aerial maps of the cemetery. No action was taken on this issue as usual.[3]

Growing Up Lutheran is written lovingly by Lutherans I take to be about my own age. It contains the kernels of truth that are the grist for Garrison Keillor and "Lake Wobegon." I do not give these examples to poke fun. But instead I want all of us to acknowledge the obvious: all people have culture.

I remember an exchange in an appropriations committee of the Montana legislative assembly when I was director of the Montana Historical Society. As I recall, the exchange was precipitated in a debate over a set-aside of the portion of the revenues derived from a tax on coal mined in the state. Representatives of the Arts Council were making their best case for why Montanans, especially those in rural areas of the eastern plains, would benefit from access to more culture. A legislator from way over east, nearly on the North Dakota border, observed that "out where he was from they had enough culture." Many of us in the hearing room snickered. But now I think he was right. The implication was that his people either didn't have enough culture or that the culture his constituents possessed was somehow of an inferior sort. Those of us who snorted were dead wrong.

People respond to landscape and to each other by creating their own ways of coping, celebrating, worshipping, mourning, building, creating,

working, and behaving. These patterns, created by people but shaped in place, are culture. Carol Bly, a native Minnesotan, wrote of these things in *Letters from the Country*.

> In the countryside we get the point of normalcy. We garden happily. We sit on the farm stoop in the evenings. We know some body secrets which city people likely wouldn't guess, such as that delicious, repairing thing to drink at noon during harvest is very hot coffee, not sugared cold drinks. Or when the field work is so hot one's eyes are sour with sweat and the body so exhausted at night that you stagger gingerly to the pickup, then the good thing is not the instant hot bath so dear to urbanites, but to sit on the ground and slowly dry and stiffen. I was disconcerted when this was first shown me. Then in the 1960s, nutritionists explained that the sun's benefits have a chance to be absorbed when you don't bathe right away. So this sitting around dirty and fragile with tiredness was sound instinct the whole while. Everyday virtues, everyday feelings, with no sharp changes, are our genius in the country.[4]

Culture of this sort is indigenous; it rises from time, the seasons, the landscape, and the experience of people in a particular place through time. Of course culture is also portable and adaptable, as immigrant experiences, in Minnesota and Michigan and nearly everywhere else, verify. But culture of this sort cannot be displayed or toured without a profound diminishing consequence, for although indigenous culture is ever changing, it is also delicate, fragile. Culture made into an artifact, put on display for others to gawk at or even trample, is culture distorted if not destroyed.

"Cultural tourism" has an impressive ring to it, worthier than "travel industry," more substantial than "vacation planning," much more exciting than "educational travel." Perhaps therein lies the danger. Perhaps that term as well as that trend is too attractive.

The needs and goals of the travel industry and the needs and goals of the cultural community are distinctly different, but we can define some common ground, discern some intersections, and act upon them for the good of both the culture and the tourists so many of our museums want, and need, to attract.

Northfield and the northwoods is not the only Minnesota on my mind. Minneapolis and St. Paul were my first big cities. They are closer to the

Upper Peninsula than either Chicago or Detroit. My relationships with the Twin Cities have endured. More of my family is here than anywhere else. My oldest brother, sister-in-law, nieces, and nephews are all here. So are my daughter and son and seven grandchildren. After I spoke at the Minnesota Governor's Conference one year, I spent the following afternoon at my grandson's third-grade class.

Minneapolis and St. Paul contrast with the rural pieces of Minnesota. There nature prevails in the northwoods winters and stunning summers or on the flat, humid agricultural prairie. Here, in the cities, humans prevail for the most part but must yield dominance in the grip of plummeting temperatures, blizzards, or occasional tornadoes. Here though, like in St. Louis, we have largely insulated ourselves from the vagaries of climate.

I do not know the Twin Cities well. I know the airport, the interstates, a few suburban communities. I have stayed in downtown hotels and walked the skywalks. I admire the Minnesota History Center. I've been to Fort Snelling and sailed on Lake Minnetonka. I know the reputation of the Guthrie Theater, and I've visited the most prominent cultural institutions. Those cultural places I know in the Twin Cities are meant for me. They are public places built for visitors of all kinds. My presence as a tourist neither changes nor diminishes them. But such cultural places are places of reflection rather than the stuff of real lives, except to those who work in them. They are places where cultural tourism can by multiplied manyfold without deleterious effect upon the lives of Minnesotans. People do not live in cultural institutions; people live in the urban neighborhoods and suburbs of Minnesota's cities, the northwoods towns, the agricultural communities.

Cities too are crucibles of indigenous culture. Their culture has been refreshed in our nation by trickles and floods of immigrants who repeat the experiences of all our ancestors, except an American Indian's. Cities are wonderful time capsules and also incubators of America's future. I am now a deeply committed city person who episodically escapes to wilderness solitude for restoration and perspective adjustment. I am not a suburban person. I have tried that and concluded that suburbs, exurbs, whatever they are called, are stifling places of sameness offering perceptions of security in an extraordinarily segregated environment that sharpens distinctions between rich and poor, work and home, and gradations of skin color. Further, suburban amenities are identical everywhere in this nation; Minnesota will not attract tourists or residents here based on its suburban amenities. Perhaps

the Mall of America is an exception but only because of its extraordinary size, but not because the Mall of America offers merchandise that cannot be found in any other medium-sized American city. There is just more of it in one place.

I have spoken about culture, place, and community all across the country. It is always hardest for me in Michigan's Upper Peninsula, because this is my place, although I have not lived there for more than three decades. My emotions are tangled here near this lake, these hills, these forests, the loons, the wildflowers, towns, and people. I cannot be objective about this place. It is too close. It is on the inside of me, the crucible of my earliest and formative memories. This place is implanted in the memory neurons of my brain. It is my life's mnemonic device. The ground contains my ancestral bones.

My story of this place is entwined with another's. John Voelker, the district attorney who wrote *Anatomy of a Murder*, was almost fifty years older than I. But our lives overlapped, are overlapping these many years after his death in this place we both called home. Several years ago I had a research assistant in Marquette who wrote her master's thesis on John Voelker. In the process she came to know John's widow, and it was through her that I acquired from Mrs. Voelker an unpublished manuscript by John, written under his usual pen name of Robert Traver and entitled "Burning Earth." John set his autobiographical fiction in our town of Ishpeming, rechristened Chippewa in the manuscript. In "Burning Earth" John tells the stories of our place; eerily, for me, he also describes the house I later grew up in and the man who built it. This is his sense of place—a place that I knew well:

> Virtually all of Chippewa was undermined by a maze of stopes and drifts made by the burrowing miners. The actual mine diggings were so far down in the earth that the mining company engineers had long ago assured the townspeople that there was no danger of a cave-in. Since the mining crowd seemed to live placidly enough all over the town in "company houses," the townspeople gradually forgot about the possibility of danger. Like Paul [Paul was John's alter ego in some of his writings], most of them had never thought of it because they had never lived anywhere else. Even the dull thuds of blasting heard regularly each day, shuddering and reverberating far underground, gradually became so common a part of the daily round as to excite

CHAPTER 8

no special notice—unless too many dishes rattled and fell in the pantry. If the dishes were broken, as they occasionally were, some of the braver and more articulate of the townspeople might write an irate taxpayer's letter to the editor of the Iron Ore. "Dear Mister Editor: The other day my Aunt Minnie's china bowl was broken. . ." The lion-hearted might even write to H. Hall Keith, the stern-visaged superintendent of Chippewa's biggest iron mines, who lived in a large house on the big wooded estate on the south edge of town. Paul had often stood in awed silence as the great man whirled by the Biegler house to the Blueberry mine office driven in his fine rubber-tired carriage. With his pointed beard, H. Hall Keith looked like the picture of the reigning head of the House of Windsor. . . .

The town's planners, being practical ore diggers, had not gone in for conferring difficult, romantic and guttural-sounding Indian names on everything, as had so many other Michigan towns. There were available no picture postcards of quaint Michimillimackinac Hotels or romantic Ossingowanamacachoo Lakes which tourists could mail from Chippewa; just plain Taleen House or Mud Lake or Commercial Hotel or Lake Bancroft. In fact there were no tourists. At this time no efforts were made to lure other restless Americans to the place; there was no cheering Chamber of Commerce or Chippewa First League; the town's soothing properties for hay fever had not yet been properly appreciated.[5]

One of the critical determinants of my place, whether it's "Chippewa" or Ishpeming, is trout fishing. I learned to trout fish in the Upper Peninsula and tried to perfect the craft later in Montana. John was a veteran trout fisherman and wrote a plethora of fishing stories set in the U.P. in addition to his "Testament of a Fisherman." I discovered that Norman Maclean, author of A River Runs through It, also knew John Voelker. I found in Maclean other words to describe the attraction of the trout. "In my family," he wrote, "there was no clear line between religion and fly fishing."[6] Trout and trout fishing stories are a feature of the U.P. just as surely as Saturday night saunas, towering snowbanks, pasties with ketchup, Finnish-tinted accents, and the red ore dust of my childhood.

But this is not the end of my story about trout fishing and my place. Shortly after moving to St. Louis from Montana in 1988, I met Wayne Fields,

a professor of literature and a writer. I discovered that he had a camp in the U.P., his refuge and a place of solace. Wayne is an introspective man, a trait that was eloquently clear in 1990 when he published *What the River Knows: An Angler in Midstream*, because for Wayne the waters of the Upper Peninsula became a life metaphor. This notion made sense to me for whom the jutting peninsula, with its sharp, jagged outlines, is the nurturing natal place of normalcy that I carry in me. Here is one of Wayne Fields' metaphors:

Big beaver marshes supposedly dominate the last miles of the stream. The Forest Rangers know little about these waters, their firsthand information limited to an occasional aerial view, but they speak dubiously of fishing much beyond the hatchery and warn of a long chain of ponds, unwadeable stretches of dead water. I realize my mistake. I had thought of this as a mountain stream, like the headwaters of the Missouri, where the river begins with clear springs breaking out of living rock, and a person can step from one solid bank to the other over a narrow brook already leaping with hope and promise toward the journey ahead. This is the illusion, always unstated but always assumed, that has led me to make the trip the hard way, to work against the current toward that fantasized source. But I have come to accept what I should have recognized from my own knowledge of this terrain, what I have looked at on the map without seeing. An uphill struggle does not necessarily, or even usually, mean movement toward high ground. My path has always been away from the bright waters paved with stones and fingerling trout that I found below Highway 16; from the start I have been headed toward waters that are swampy and stagnant, thick with silt and debris, and any fisherman—any psychiatrist—knows that turbulent waters are less to be feared than waters that are unmoving and unmoved.[7]

Geography determines the potential, even the mindset of a place, and often the human economy, and is a highly influential factor in a sense of place. The forms and characteristics of the place are the vessels of our thoughts, not determining thought but contributing to its contours. This Upper Peninsula of Michigan is my norm. There is a particular brand of insanity inculcated in me as a result of spending the first eighteen years of my

life here in this place where winters can usurp nearly nine months of the year. Yet subsequently I have measured the severity or mildness of every winter of my life according to this scale. It is like the fever thermometers we all have around our homes with the red band marking normal at 98.6 degrees. My winter gauge reads normal here. I really do fondly recollect the swirling tornadoes of snow and the numbness induced by the wicked combination of wind and below zero temperatures. I especially liked staring out of the second floor window at night into the spiraling snow that danced in the winter light.

Summers, although short, unpredictable, and punctuated by drizzle and cold snaps, were delicious and spectacular in contrast to the winter, attaining a special quality because here in this country they are like a rich delicious dessert that remains special only if you do not overindulge. In the U.P. we never overindulge in our summers. All seasons here are marked on my thermometer. I measure autumn by the intensity of the colors of leaves on hardwood trees. I can smell fallen leaves, musky, damp, enchanting. I long for the rush of snowmelt when spring literally becomes a torrent of water and then a riot of wildflowers—trillium, dogtooth violets, arbutus. Hilly, wooded, lush terrain is my standard of beauty. Granite-rimmed and icy, Lake Superior is what every lake should be. While I love the subdued umber and olive desert tones and the sensuous adobe of New Mexico, New Mexico could not compete with this place. In Montana I drank in wilderness, longed for the times I could chase cutthroat trout in mountain streams, respected the arrowlike dignity of lodgepole pine and even felt that exhilarating sense of individual diminishment on the eastern Montana plains that made me feel on top of the world as the earth curved away from me in every direction; but there were always days when I would have traded it all to hear a loon's crazy call while lying on a Hudson Bay blanket on a Lake Superior bluff.

Geography and a sense of place are not just about natural setting and the reverie of our natal places. Place is one factor in culture, setting patterns that endure for at least a lifetime. My wife and I were teenage sweethearts. We grew up in Ishpeming and graduated from Ishpeming High School together. As I wrote this upstairs in our house in St. Louis, Sue was at the kitchen counter making pasties. Occasionally I make rutmouse the old Yooper way: you boil the spareribs, take them out of the water, and bake them. You put potatoes and rutabaga in the sparerib water and mash them,

using the delicately flavored water as the liquid. People in St. Louis say that Sue and I have accents and sometimes we use words that others don't understand; *pank*, for example. (As I recall, to *pank* is to tamp down the snow with the flat end of a heavy shovel to make it the exact firmness needed for sled runs.) We both have snowshoes, and our house has a slightly woodsy U.P. edge to it: Sue's photographs of Lake Superior, chunks of different types of iron ore, a coffee-table book on the Great Lakes, stones washed smooth by Lake Superior. Being from the U.P. is not just a statement about where we used to live but instead it is a statement about who we are and what we value.

Ishpeming is where it is because of iron. The settlement began nearly a century and a half ago as a series of scattered "locations" or small, preponderantly male settlements surrounding a shaft that extended down below ground into the ore body of the iron range. Cornish, French, and Irish came first and then Italians, Finns, Swedes, and Norwegians. Gradually the "locations" coalesced into a town with a commercial district, the town of Ishpeming that I knew. It was a typical small town of the time, tightly knit, nosy, neighborly, with class and ethnic jealousies. But it had a real downtown, and you could walk anywhere because the town was so compact.

Lake Superior breaker. Photograph by Sue Archibald, 2003.

People knew each other. There were clubs of all kinds, scout troops, ladies' groups, men's clubs—formal and informal. Then there was the regular street life. Stores were in part social institutions, locally owned and operated by your own friends and neighbors. And there were churches everywhere, most associated with an ethnic group. I am describing the typical web of relationships that created a community in those days.

Ishpeming was typical but made different, as all U.P. towns are, by the environment. We are woods people. Hunting, snowshoeing, skiing, fishing, canoeing are part of our culture, as is camp, that peculiar family institution of this place where communal town life is suspended in favor of a sort of sylvan isolation where the restraints of town life do not apply. Camp was not as rustic nor as uncivilized as that other U.P. institution, deer camp, that exclusively male place, inhabited only during deer hunting season where at least half of the Ten Commandments were temporarily suspended by common agreement.

So Ishpeming as I have told it is a distinctive place. Ishpeming has geography: hills, ancient rocks remote and glaciated, iron ore, streams, bluffs, all particularly arranged. And Ishpeming has weather: long, hard, snow-piled-up winters, late springs, as well as abundant wildflowers, unpredictable mosquito-infested summers, and falls of subdued splendor. But Ishpeming also has generations of people like John Voelker and me and our parents and grandparents who toughed it out at least for awhile, storied it, and built things on it and under it. Two stark stone and concrete mine shafts remain to remind residents of what once went on below ground, and some people now want to make them into a historic site to attract tourists. We were all in turn shaped by Ishpeming: by its weather, its geography, what was built there, the stories that were told there, and its nowhere-repeated mix of people who settled there and had children there who became a sequence of generations that still endures. What makes a place? The first quality of space that determines boundaries of human relationships with place is geography and natural history: the lay of the land, its climate and seasons and cycles, its water as ocean or lake or river, its wildlife, its proximity to other places, and its natural resources. Human culture is inseparable from geographical place. People create places, and places make people. And that's what makes a culture.

Culture is a story in common. It is shared spaces and places. It is history, music, geography and landscape, folk traditions and grandparents' stories, and

up in the U.P. it is pasties, saunas, trout fishing, Lake Superior, "camp," blizzards, and a peculiarly wonderful lilt in the U.P. voice, a homemade mixture of sounds from the disparate voices of all who came here and made this place.

Ishpeming is a place that Sue and I can never really leave behind, nor do we want to. John Voelker tried to leave the U.P. and couldn't. Chicago made him lonesome and came to represent everything he detested. He went back to his ancestral clapboard home on Barnum Street in Ishpeming and was elected prosecuting attorney and continued to pursue writing and trout fishing. This place was so integral to his being that he was bewildered, disoriented, and unhappy in any other place. Elsewhere he could not be himself because this place was inside of him and he buried in it. And it wasn't just the land and trout. It was the people, the way of life, the values and culture of the place. Personality, perspective, values, and well-being are related to place and an individual sense of what is normal.

In the preface to *Small Town D.A.*, John describes his place and his attachment to it:

> The setting is the rugged iron-mining, logging and dairy-farming county of Iron Cliffs lying in the equally rugged and sprawling Lake Superior district of the Upper Peninsula of Michigan. The people are mostly Finns, Scandinavians, Italians, French-Canadians, Irish and Cornishmen—and some interesting scramblings thereof. Throughout the Upper Peninsula (simply U.P. to its inhabitants) these nationalities predominate roughly in the order named. . . .
>
> I like being D.A. and I loved—and still love—living full-time in my native Upper Peninsula. A clue to my eccentricity perhaps lies in the fact that the U.P.—besides being a wildly beautiful place—possesses three of Nature's noblest creations: the white-tailed deer, the ruffed grouse and the brook trout. I photograph the deer, mildly hunt the partridge, and endlessly pursue the elusive trout. Thoughts of Washington have left me rather cold ever since I learned that fishing in the Potomac is more apt to produce a despondent and mildewed congressman than a trout.[8]

The cultural attributes I have described are encoded physically in my body, in chemicals, in neurons, in identity, and in personality. Memory and identity are not disembodied; rather, they are the sum of unceasing physical interactions

of experience, place, and people. No two people experience these things identically. People who grew up in Ishpeming together are not clones, but they do have much in common. What they have in common is what we call culture. What I have described is the nexus between culture and individual identity. If "cultural" defines shared space, common ground, intersecting experience and memories, then culture is what creates community. And this is the purpose of museums, history and any other kind. We do not exist to provide rose-tinted views reflected through a rearview mirror. We exist to reinforce culture, build community, and define common ground; to facilitate community discussion about our burdens and our legacies and how to discern the difference, and to consider what we have done and what we can do better.

Ishpeming is encoded into me, but this does not necessarily mean I love it. Several years ago I interviewed A. E. Hotchner, a St. Louis native, a prolific writer whose works include *King of the Hill*, a story of his youth during the Depression in St. Louis. While popular and well written, it is a story of despair. Hotchner's mother was in a TB sanitarium and his father, an undependable traveling salesman, was on the road. "Hotch" and his younger brother lived alone in a boardinghouse most of the time doing what they could to find food, stay warm, hide from the manager of the decrepit building, and avoid eviction. "Hotch," I asked, "how is it that despite the awful times you had in this City, you are now describing St. Louis to me in such loving terms? Do you love or hate St. Louis?"

"I have never thought about whether I love or hate St. Louis," he responded. "St. Louis nurtured me."

What an interesting word to explain the relationship between a person and a place. It is not about love or hate. My mental picture of nurture is of an infant suckling a mother's breast. Love does not describe my image; my image is of life. Love and hate are insignificant to birth and to nurture, inappropriate to the relationship between a person and his place.

I try to strike up conversations with taxi drivers, hoping for insight into their places. The cabby who picked me up at Memphis's Peabody Hotel for my ride to the airport was born in Memphis. "I've never been anywhere else," he told me, "except when I was in California during the war."

"You must like Memphis," I responded.

"What's to like," he said. "I don't know if I like it or not. I never thought about living anywhere else. I know every street in town and I know every corner in the place." He continued to talk about Memphis, about

things that happened in his lifetime, the good and the bad. He talked about family, about his wife, about her illness. Asking him if he liked Memphis was a foolish question. He could not be who he was and live anywhere else. In a very direct way he was Memphis. All of its history, buildings, people, climate, events, location conspired in his lifetime to make him who he was and he in turn changed Memphis by living his life in this place. This place and this man have an intimate life-generating relationship just as surely as an apple and its tree. As we neared the airport he put his hand on his head and said thoughtfully, "You know, mister, I never thought about whether I like it or not." He gave me a very thoughtful smile as he dropped me off at the airport curb.

I think of my friend Bill MacKay and his Lazy El Ranch in Montana and a Sunday morning, as we bounced across the Beartooth foothills in a worn jeep, Bill talking without ceasing. His relationship to the land was one of unbounded intimacy. To say that places and people are related is inaccurate and inadequate. People and places are inseparable. To say that there is an indissoluble relationship between people and their places on this planet is to state the essence of life. The relationship is elemental, obvious yet profound. Maybe Hotch's word, *nurture*, is the best one-word description of this relationship.

I spent a summer on Mackinac Island, between the upper and lower peninsulas of Michigan, working for the Mackinac Island Carriage Company. No motor vehicles, except for emergencies, are allowed on the island lest the imposed serenity be disturbed. I remember waiting, dressed in top hat and tails, for the morning's first ferry on my new antique-style carriage, on Huron Street near the docks. Then the first boat pulled in disgorging the "fudgies," the island's slang for tourists, some of whom headed for our buggies for a tour. I provided a narrative of sorts as we went up the hill in front of the Grand Hotel, into summer home neighborhoods on top, around by the fort, and back down. Occasionally a group would splurge and rent me, the carriage, and its two horses for a day. I remember one particular group of five from Chicago who climbed on with bright red coolers. The gin from those coolers flowed into potent concoctions of fruit juice all day. We drove to every corner of the island, the passengers progressively more inebriated, until by day's end two of them were happily stumbling along behind the carriage rather than in it. Perhaps this typifies what we mean by "cultural tourism" at its worst. But a contemporary Michigan

guidebook extols this form of touring (minus the gin) with recommenda-
tions to "stroll a bit through some of the galleries and souvenir shops, then
take one of the carriage tours that give you a good overall view of the island
and a bit of information about its history; by then it should be just about
time for lunch." It suggests a tour of the island's historic fort and "If you
have the time and don't mind paying a couple of dollars for the privilege of
sitting in a rocking chair, you should spend a few minutes on the broad, pil-
lared verandah of the Grand Hotel." And finally, "Conclude your day trip
with a stop at one of the many fudge shops, a specialty of the island." The
fudge is delicious, but it doesn't travel well. "Culture," in general, doesn't
travel well.

I wonder about the tourist experience as outlined in this guidebook. I
think this is cultural tourism, but I am not certain what culture is being
toured. I recall the supervisor of the hourly carriage tours telling me that this
business was really like the carnival business; that we had a short season,
that a lot of money had to be made in three months, and that it was like a
staged show. The Mackinac Island State Park Commission and its staff do
fine work in their efforts to restore, preserve, and interpret the historical fea-
tures of the island included within the park. Historical authenticity is on dis-
play here because of the diligence of the commission, but I doubt that
visitors segregate the authentic. Rather, they experience Mackinac as a
seamless whole and what results, to paraphrase the title of Michael Sorkin's
book, is "a variation on a theme park." Fudge shops, souvenir stores, bicy-
cle rental stands, golf courses, ice cream parlors are interspersed with fur
trade warehouses, eighteenth- and nineteenth-century military posts, and
the Gilded Age retreats of the wealthy. In a real sense everyone on Mackinac
Island is in costume. The boundary between history and fantasy is ill-
defined. This is integral to the compelling argument made by David Ashley,
in his book, *History without a Subject: The Postmodern Condition.* While
his argument is complex, he concludes that, "little remains to prevent cul-
ture from being merchandised as entertainment in all spheres of life." In a
1988 *Detroit Free Press* article, filmmaker and sociologist Michael
Loukinen observed that "On all sides, you hear that tourism is to be the
U.P.'s salvation. Yet as the crowds come north of the Mackinac Bridge, first
in summer and now increasingly in winter, the things they come to savor—
the uniqueness, the isolation, the remote ways of the logger/trapper/fisher-
man—are vanishing."[9] This is destruction of culture. It is a steep price for

tourist dollars.

This is not confined to the U.P.; it is an inevitable consequence of the conversion of culture into a commodity for restless wayfaring consumers, and it is repeated all over our nation. I have witnessed it on the clogged roads of state parks and in the long lines at the ticket booths of historic recreations; and I have contributed to it. In the summer of 1990 I packed my family into a Dodge Caravan and set out from St. Louis on a twelve-day vacation. We drove thousands of miles from one tourist destination to the next: Niagara Falls, the Adirondacks, Mystic Seaport, Plimouth Plantation, lobsters and L.L. Bean in Maine, down the coast to New York City and Ellis Island, south to the beaches on Maryland's eastern shore, Norfolk and the Naval Base, Monticello, across the Blue Ridge Mountains, then finally a race over Tennessee and a turn north back to St. Louis. At every stop we fidgeted in waiting lines, we listened to rote recitals of fact and non-fact, we dutifully checked off another site in our itinerary. What we encountered were symbols of culture on display and sometimes for sale, but not real culture. What I experienced was cultural tourism tinged with craziness and a version, perhaps extreme but not atypical, of the American search for the real, the authentic, for a sense of belonging somewhere.

An article entitled "Developers seek feeling of small-town America" was published in our local paper a few years ago. It was about a planned corporate community. "So instead of having to get into a car," one project architect observed, "you'll be able to walk or ride your bicycle to work, to your home, or to do your shopping. And in the process," he continued, "we're expecting this town center to become a gathering place." Despite my suspicions of motives and hype, it is a nice idea. Yet, I look around my city, other cities, and thousands of towns around our nation, and I compare this nice idea with the abandonment of downtowns and neighborhoods and the disappearance of the stories, context, continuity, and common ground that once existed. It is the Arch story writ large. We abandon places of tradition and then struggle mightily to find substitutes for what we have discarded. This is unconscionable waste, and it rips people from those very intangible things that make life worth living.

Jerry Herron of Detroit wrote a book called *AfterCulture: Detroit and the Humiliation of History*. The title scares me, perhaps because it reminds me of St. Louis or Ishpeming and too many other places. The book is a painful lesson of cultural and historical destruction in Michigan's metropolis. Herron reflects on another book entitled *Detroit Images*, a volume of horrendous

images of urban destruction. Why would anyone publish such a book, he asks.

It's because the longer you look at this place, the greater the loss there is to account for; and it's impossible not to take the loss personally, particularly if you are white and middle class and not bound to remain here, except in memory. And it's there, in memory, that Detroit exists, for the majority of its citizens, who have chosen long since to live somewhere else. But taking leave of the place is not so easy as just changing an address, which is the point Levine [celebrated poet, Philip Levine, a native of Detroit, who wrote the afterword of *Detroit Images*] makes, quite eloquently, in closing his expatriate's reflections:

"I see the lights of a city that gave me a life I loved, a place I called mine and came back to year after year until I could no longer find it. In this collection of photographs I possess a portion of all that survived, wounded, complex turbulent, this great piece of America that refuses to go away. As long as the boy and young man are alive in me, I'll carry it with me as it was, a city of wonder, the place of first loss, my home."[10]

And so if by culture we mean places in common, shared narrative, an enfolding sense of belonging, neighborliness based on familiarity, connections between generations, persistence of tradition, respect for continuity—then we have a crisis in Detroit, Ishpeming, St. Louis, and all across this land. It is a cultural crisis brought on by preoccupation with the "I" instead of the "us," an uncritical willingness to embrace technologies, from automobiles to television and the Internet, that may not be good for us, and the building of places that isolate us instead of encouraging us to create familiarity and trust. Culture is further destroyed by homogenization. One place becomes indistinguishable from any other place, and traditions are cast off. This is our business, the business of all of us and especially of museums.

Middle age is a time of wonderment about many things, some of them morbid, others just quiet and contemplative. For me it is a time of intense interest in roots, in the significance of place, in the value of stories, in the importance of identity. The scary part of middle age is that I think now about the time I have left. In my stiff bones and achy shoulder I now fi-

nally know that I will not escape the universal death sentence. But free-
dom comes with this recognition, freedom to say what is really on my
mind.

I have the advantage here. My lifework does not depend on tourists.
Although I am president of a large urban history museum and have always
made at least a part of my living this way, I long ago realized that those to
whom history really mattered were those who both made decisions and lived
with the consequences. Those visitors who view history from the outside in did-
n't make the choices and don't live with the consequences. It's history without
the juice. So I have gone for history with the juice, history primarily for those
who live the story. So since my life's work is culture without the tourism, it is
easy for me to hurl admonishment. But those admonishments are no less valid.

We cannot manufacture culture nor can we resurrect it, really. Culture
cannot be imposed; it must be an organic expression of people's aspirations,
values, fears, and accumulated wisdom. We can be facilitators. We can be ad-
vocates for good places. We can support judicious preservation of symbols
of the past. We can urge a slowdown in the rates of change so that change
does not obliterate the past and isolate the present. We can protect gathering
places that encourage interaction and support public policies that encourage
intergenerational connections crucial to the transmission of culture.

If thoughtful marketing of tourism will help, I favor it. But we must not
overwhelm special places, for we will destroy them. We must also realize
that putting a living culture on exhibit will destroy it. While it is possible to
tour the sites and scenery of the U.P., it is not possible to tour the culture
without distorting it. What remains of John Voelker's or Norman Maclean's
worlds will not survive vicarious and specious enjoyment by thousands of
tourists. We must be clear that when culture becomes a commodity and a
parody, like Sorkin's "variation on a theme park," it has begun the painful
process of destruction.

Yet there is something important that we can do for travelers in our mu-
seums and other places. It is the same crucial task we must commit ourselves
to in our own communities. Our message to our visitors from across the
country and to those who live next door is that we must learn to build com-
munities that tie us to each other. We must reinvigorate that sense of civic
obligation upon which democracy depends, seek common ground, and es-
tablish connections with those who share, or have shared, our place. We
must build new and healing narratives, learn to share our own story and to

share in the stories of other peoples. We must consider what all our children, grandchildren, and beyond will need to live decent lives, with each other, in good places and on a healthy planet.

We must seek to protect culture, preserve tradition, build community, advocate for the long view, and oppose those forces that sap the human spirit and humiliate history in places like Detroit and St. Louis and Ishpeming. We can do this with stories that we help our communities create, and with artifacts of every kind that take us out beyond ourselves yet speak to us more of similarities than of differences—these are our tools for invigorating the human spirit and dignifying history. These are our tools for building the new town square.

Notes

1. Federal Writers Project of the Works Progress Administration, *Minnesota: A State Guide* (New York: Hastings House, 1938), p. 322.
2. Connie Wanek, *Bonfire: Poems* (Minneapolis: New Rivers Press, 1991), p. 44.
3. Janet Martin and Suzann Nelson, *Growing Up Lutheran* (Hastings, Minn.: Caragana Press, 1997), pp. 116–17.
4. Carol Bly, *Letters from the Country* (New York: Harper & Row, 1981), p. 169.
5. John Voelker, "Burning Earth," unpublished manuscript.
6. Norman Maclean, *A River Runs through It* (Chicago: University of Chicago Press, 1983), p. 1.
7. Wayne Fields, *What the River Knows: An Angler in Midstream* (New York: Poseidon Press, 1990), pp. 135–36.
8. Robert Traver, *Small Town D.A.* (New York: American Book-Stratford Press, 1954), p. 9–10.
9. David Ashley, *History without a Subject* (Boulder, Colo.: Westview, 1997), p. 11.
10. Jerry Herron, *AfterCulture: Detroit and the Humiliation of History* (Detroit: Wayne State University Press, 1993), pp. 206–7.

A Wonderful Place

ILLINOIS, INDIANA, IOWA, MICHIGAN, MINNESOTA, NEW
Mexico, Ohio, Pennsylvania, Texas, Virginia, Washington,
D.C., and others—I have explored these and other places
and their pasts in order to speak to their people about the vital importance
of creating the "new town square." Perhaps I have examined my own home
of St. Louis, Missouri, most thoroughly of all. Each has, or should have, its
own identifying characteristics, and many do. However, too many of the
cities and towns I have explored have developed a merging sameness, a ho-
mogenization that is both debilitating and frightening. Too often only rem-
nants of individuality help me determine where I am.

G & W Sausage is on a nondescript side street in south St. Louis. Rows
of homemade sausages dangle from the ceiling. The flooring is worn but
spotlessly clean. The only fixture, besides the oddly anachronistic fluorescent
ceiling lights, is the glass-fronted L-shaped butcher case, gleaming white, and
behind it the butcher blocks and slicers. Even early on a Saturday morning,
one of the butchers will offer you a beer or a shot of schnapps, on the house,
probably with a trace of southside German accent. And some customers ac-
tually use German to place their orders for knockwurst, weisswurst,
bratwurst, blood sausage, liverwurst, smoked chops—none of it labeled with
national brands or packaged in hermetically sealed plastic. There is always a

long line of locals and occasionally some strangers. But G & W is a little piece of the past, a relic hanging on because some people refuse to substitute rings of Eckrich Sausage and Johnsonville brats for what they remember as the real thing.

We've lost most of the sausage places like G & W, along with historic river-fronts, neighborhood corner stores, downtown shopping, chunks of neighbor-hoods, and even whole communities. Some parts of my city, and yours, look like ghost towns, whole chunks abandoned and nearly uninhabited.

Abandonment of places is not a new characteristic. Henry Shoemaker saw it a hundred years ago. Born to wealth in New York in 1880, Henry Shoemaker became a Pennsylvanian through and through. He established and led numerous organizations including the Pennsylvania Alpine Club, the Pennsylvania Folklore Society, the Pennsylvania Conservation Association, and the Pennsylvania Federation of Historical Societies and Museums. He spent his money on conservation and history causes and went to work as this nation's first state folklorist. For almost all of his seventy-six years he sought out and preserved stories of the old times and the natural world, convinced of their value and determined to prevent the total loss of the past in the countryside to "progress."

G&W Sausage is a little piece of the past. Photograph by Sue Archibald, 2003.

Progress was a theme in *Pennsylvania Cavalcade*, published by the Pennsylvania Writers Project in 1942. The final essay describes a behemoth construction project that must rank on the top ten list of the most important in the United States in the last century. "The Pennsylvania Turnpike, or Superhighway," the authors note, "is a broad, comparatively level pathway of smooth concrete sweeping for one hundred and sixty miles over Pennsylvania's valleys and under its mountains from Irwin, east of Pittsburgh, to Middlesex, near the Susquehanna River." The writer continues, "Throughout the highway's length there is not a railroad crossing, street intersection at grade, or stop light. Routes US 11 and 30, which parallel the turnpike, have more than nine hundred road and street intersections, twelve railroad crossings, and twenty-five traffic lights. But once on this turnpike, the motorist has nothing to halt his progress." The essayist concludes with prescient hyperbole. "Offering maximum of speed, safety and comfort, this highway may form the nucleus of a network of similar roads that eventually will cover the nation."[1]

Shoemaker grudgingly accepted the inevitable highways, including the Pennsylvania Turnpike, although he worked assiduously to preserve the landscape and scenery and gave them names from history, folklore, and nature. He once said, "No one can be truly happy who does not live in an atmosphere of the past, whether it be mental or actual. The mechanical world may pile up bank accounts mountain high for the few, but it brings monotony, dreariness, empty pleasures, short life for the many." Shoemaker's biographer, Simon Bronner, says that "My exploration of Henry Shoemaker's life and career reveals how American and Pennsylvania traditions were shaped and packaged to inspirit the land, provide a hedge against rapid industrialization, and instill civic values and regional pride." Shoemaker combined natural and cultural conservation, anticipating our own day when prodigal resource consumption creates a Tour Book mentality in which rootedness and a sense of place are replaced by a frenetic seeking for what is gone. "This is an age of hurry," he wrote, when travelers "must tell the number of miles traversed on their excursions, not what they saw. To fully appreciate every vista, every cloud, every bird, every butterfly, every lofty pine," he continued, "the pedestrian method is supreme."[2]

Henry Shoemaker was an advocate for storied places, for the idea that places take on meaning because of the significance humans assign to them. He believed humans are compelled to care for places because places acquire

a certain sacredness in their association with experiences that are significant to individuals, neighborhoods, communities, and regions. Perhaps we haven't valued place very much. We are not serfs bound to the lands of a feudal manor as many of our ancestors were, and perhaps our abandonment of place is one way we define freedom. Mobility may be as much a component of our definition of freedom as the right to march to the ballot box on election day.

Change appears to be a defining characteristic not only of America but of the whole universe. But must change destroy those qualities of our places that are anchors, referent points for our memories and hence for our being? Like many others, I worry about the effects of change on the quality of human lives that are being lived, and will be lived, in places like Cincinnati. Nearly forty years ago writer Dick Perry wrote an engaging book called *Vas You Ever in Zinzinnati?* In 1966 Perry worried about change that would ultimately destroy Cincinnati by making that place indistinguishable from every other place.

> Beyond the downtown area and the near-in communities of Cumminsville, Riverside, and the rest, Cincinnati's innocence has been bulldozed away and ticky-tacky houses have taken root. In such look-alike subdivisions on this city's periphery, Cincinnati has traded its innocence as a down payment on a power mower. By the time our great-great-grandchildren are middle-aged, Cincinnati—and all other cities—will have ceased to exist as separate and distinct personalities. There will be no way to tell them one from another. American cities, as television programs do now, will look alike.[3]

But people have been living around Cincinnati and all our other urban areas, and worrying and criticizing, for thousands of years, first in huts scattered in villages, then in log cabins, and now in air-conditioned comfort with nary a fire pit or horse and buggy in sight. Frances Trollope observed this about Cincinnati in 1832: "I am sure I would have liked Cincinnati much better had the people not dealt largely in hogs. . . . The annoyance came nearer this: if I determined upon a walk up Main Street the chances are 500 to one my reaching the shady side with brushing by a snout fresh dripping from the kennel. . . . Our feet literally got entangled with pigs' tails and jawbones."[4] Not many hogs are wandering downtown these days.

Contrast Mrs. Trollope's view with a passage from Dorothy Weil's *The River Home*, a description of downtown one hundred years later:

> In the forties, downtown Cincinnati was the place where everyone shopped and went for entertainment. There were five big movie theaters—one the Albee, was a true cinema palace with oriental carpets, crystal chandeliers, a grand staircase, tapestries, and fake Louis XIV furnishings in the long halls. There was a small jewel box of a theater, the Cox; a large theater for big plays and musicals, the Schubert; and a third theater notorious for bad acoustics. . . . Around [Fountain] square were thriving buildings and shops; the Gibson hotel, the Albee, Potter's Shoes, Planter's Peanuts, Maude Mueller candies. There were over half dozen department stores: upscale Pogue's; Mabley-Carew with its big corner clock (the only reminder still there); Rollman's, a step down; Shillito's; Bond's; McAlpin's. There were several men's stores: Dunlap's and Burkhart's, and two ultra-stylish women's stores: Jenny's and Giddings.[5]

Real names for real places, memory anchors that connect us with the past if only those connections were not completely severed in our ghost town downtowns and forgotten town squares.

It is all gone: the keelboats, the hogs, the sputtering gaslights, the people and the busy downtown of the 1940s; but so are the fearsome summer epidemics, circumscribed opportunities for women, slavery, short life expectancies, and the deaths of so many children. The acrid, sulfuric black smoke is gone too. Your town, my town, all towns continue to change.

We cannot be Luddites, people who resist all change. It is not change itself that disorients; it is the rate of change that leaves us afloat without anchors or life preservers. Change is not a new phenomenon. What is new is the accelerated rate of change that grants no respect or credence to our needs to remember and to know who we are. Places that change too quickly are not imbued with memory; they are no-places and to most people such places are interchangeable and do not matter very much. We will not care about our cities or towns or neighborhoods unless we attach our lives to them; and we cannot attach memory and identity to places that are transient and impermanent. Good communities require places that have enough permanence to

offer memory anchors, places with which sustaining relationships can be constructed and a sense of community incubated.

"It was a wonderful place to grow up," Helen Traubel wrote of her childhood neighborhood in St. Louis, "wide asphalt streets, big overarching poplar trees, long green-shaved lawns, houses of brick or clapboard with wide porches, and the smell of cooking coming out under the fretwork along the eaves."[6]

The future New York Metropolitan Opera star was born in the flat above her father's drugstore in 1899, although she preferred 1903 as her birth date. The Traubels were a southside German family, and Helen's childhood resonated with the Teutonic culture that permeated St. Louis in the early twentieth century: the German language still spoken among themselves by most of her neighbors, the singing societies and *turnverein*, the Liederkranz clubs and beer gardens—festivals and *gemütlichkeit* on every possible occasion.

In her 1959 autobiography, which she loyally called *St. Louis Woman*, she links her earliest memories to the sounds of her city: "the singing, the clang of the streetcars, the clop-clop of horses, the hiss of carbonated water into a soda, the tinkle of a piano or a guitar, the strong sound of a baritone in the distance—the list," she rightly claimed, "was endless."[7]

"Next to sounds," Traubel wrote, "I can recall smells most vividly: the high smell of spice, the low rolling smell of bitter drugs, and the heady tickle of soda water." Her father's drugstore, a two-story brick building where a surgeon rented the three back rooms and the Traubel family lived in the six rooms of the second floor, was the center of Helen's youth. Even after the family moved when Helen was six (or maybe ten), she and her brother would ride the streetcars (a nickel a ride, she noted) from their new home several blocks away to sit at the imposing nickel-marble-ebony soda fountain and devour their daily allowance of ice cream. Many of us remember a drugstore with a soda fountain, but could we find one today? And if we did, it would likely be standard issue from the franchise mold and hardly describable as "imposing."[8]

An alley ran in back of the Traubel property, and, Helen wrote, "during the languorous summer months we were visited by watermelon men, cherry men, peach men, apple men, and berry men." She commented particularly on the "rather unmusical voice" of one of the strawberry sellers[9]—and many St. Louisans can recall an early morning summer sound elongated

through their own alleys in less than melodic insistence on the availability of fresh strawberries. Our early morning summer sounds now most frequently consist of the whirring of the air conditioner.

"So much of what I recall of the past is rose-colored," she admitted in her book,[10] an admission I believe most of us could make. And could she visit today, she would find a trucking establishment where for twenty years her father had kept his drugstore and hear the roar and rumble of automobiles in place of those clop-clopping horses. But her remembrance of home, even rose-colored, is not mere nostalgia. She surely knew, as we do, that we can't go home again, nor do we really want to. But the memory of home has its own validity. Home is where people and place are embedded in each other, where the very soil encloses, embraces, and reinforces memory and identity, where neighbors are committed to the place and understand that their individual welfares are linked, impelling them to sacrifice for each other. This is the essence of community, the incubator of security, the bedrock of democracy, even the crucible of art; and it requires permanence, not the transience that too often demolishes the landscape of home. Change is inevitable, but it must not overwhelm continuity, for then real community will die and humans will be deprived of an opportunity for happiness, freedom, and growth.

Helen Traubel achieved renown for the beauty and splendor of her voice and also her ability to translate her operatic magnificence into the more mundane medium of popular entertainment. Her star in her hometown's Walk of Fame reads in part: "With her joyous confidence and booming laughter, Helen Traubel broke down barriers in a stratified society." Surely the community that surrounded her in her early years, with its premise of permanence and a rate of change acceptable to the human psyche, nurtured that confidence and probably too that booming laugh and heroic voice. Community, whether the tightly knit, German-flavored one of Traubel's youth or a modern version that we can make today, is essential to the human condition. We, too, can break down barriers, not on the stage of the Metropolitan Opera or television's popular entertainment shows, but right here in the place we live now, making it a place like the one that Helen Traubel remembered with such affection. We can make this modern community one that our children and grandchildren can remember and can say, "It was a wonderful place to grow up."

In preparing a new exhibition for the Missouri History Museum, we listened to hundreds of St. Louisans describe their city, their region, their

neighborhood and how those places had changed. We talked with several members of the Ross family who once lived in Mill Creek Valley, an African American neighborhood west of downtown St. Louis. "That was our world, and I had no idea what was outside that little world." Mr. Ross remembers growing up secure and happy in a St. Louis neighborhood that has been obliterated from the urban landscape, forgotten by many of us, and remembered by too many of us as "the slums."

Mr. Ross's world ran west from the outskirts of downtown about fifteen blocks and some eight blocks south to the railroad yards. Mill Creek Valley had a variety of cheap tenements but also in and nearby were family dwellings, small businesses, and institutions such as Vashon High School, the Pine Street YMCA and the Phyllis Wheatley YWCA, churches of several denominations, all for black people in our segregated city. Mill Creek had a strong sense of history—Scott Joplin and others played ragtime and jazz at Tom Turpin's Rosebud Cafe; Roy Wilkins and Josephine Baker were born here—and a strong sense of community.

The Mill Creek Valley neighborhood, primarily home to what we call "the working poor" but also to men and women in many professional positions, had all the features that a true neighborhood requires, and so many of the people who grew up there cherish the memories of their childhood and the sense of security that pervaded the community.

"Back then," a Ross cousin recalled, "it took a community to raise a child. Your neighbors just felt responsible to punish you as if you were their own. That community raised all of us. And," she added, "we were respectful so any neighbor could say 'Get out of the street' or 'Stop that noise' and we did it."

"And we didn't have to lock our doors."

"Everybody was treated like family," someone else added. "In the summer when you were out playing, wherever you were, that's the family you had lunch with."

Mill Creek was not without its problems. Housing was often substandard and overcrowded—"eleven people in three rooms" was one memory. Indoor plumbing was nonexistent, city services like trash pickup and street repair were often sluggish, and ingrained prejudice against African Americans was rife in St. Louis, a sad circumstance that I perceive as one factor in the demise of this heavily African American community. When urban

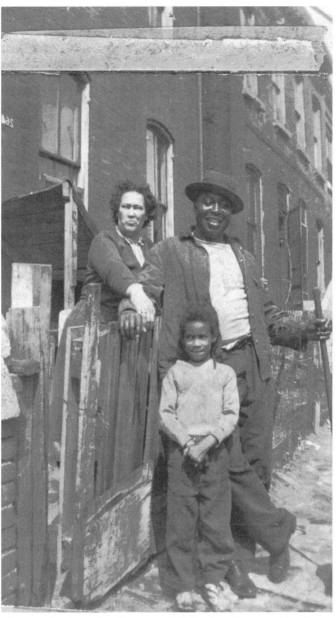

The Ross family at their house in Mill Creek Valley, ca. 1955. Loan from the Ross family.

renewal advocates looked at Mill Creek, they saw the ills and the hazards, not the neighborhood and its sense of community. No doubt many of them sincerely believed bulldozers to be the best solution, but, as one Mill Creek resident said some forty years later, "They just came in and took over. They could have at least talked to our parents."

The places that people make, where the communities develop and thrive, can never be static, but change must not overwhelm continuity as it did in Mill Creek Valley. If we continue to allow that, we jeopardize the bonds of civic life, impoverish relationships with people and places, and endanger democratic institutions and the very foundations of this civilization. Civic life depends upon shared places that are repositories of common memories and shared experiences. Mill Creek was such a place.

"Your role models were right there in the neighborhood," one woman explained, with a charitable perspective on the pervasive prejudice in St. Louis. "We had doctors, lawyers, policemen and policewomen, people with their own businesses, living right in the neighborhood with us. Dry cleaners, stores—we always supported our neighbors' businesses." Not that she was advocating a return to exclusion for African Americans or anybody else, but, she said firmly, "people need to stick together a little bit more."

Many people who grew up in the Mill Creek neighborhood have contributed to the well-being of our region in hundreds of ways, and most of them four decades later still treasure their childhood in "the slums." "When you're living in a slum," one woman mused, "you don't realize it's a slum."

Of course there's a certain sentimental nostalgia in recalling the days of a happy childhood, but the recollections are nonetheless real and even palpable despite that often rosy tint of the past. "We had the bath house; we walked there, and to the YMCA, the library across the bridge on the south side, to the movies—I think we had about three movies. We walked to school and down to Union Station on Sundays, dressed always in our Sunday best. It didn't seem like a long distance. We just took our time and had fun."

We don't need any more slums in St. Louis. Crumbling, boarded-up buildings and vacant, trash-encumbered lots are ugly and dangerous; people need clean streets and at least something more than minimal amenities in their homes and neighborhoods. But urban renewal, however crucial to urban survival, has another side, and that other side is the potential abandonment of community and neighborhood, a loss that will reverberate throughout our region and into at least the next generation.

"I thought it would be there forever, like a heritage," Ms. Ross sighed. "Even if we moved away we could go back and say, 'See this is where I used to live, this is where we used to play' . . . you know." I do know. If we lose all the physical remnants of what has gone before, we lose our anchors with the past and risk getting marooned in a bleak and isolated present, with little hope for the future of community and neighborhood. Mill Creek is a ghost neighborhood, with no vestige of its history in our landscape. Will other former neighborhoods and communities haunt us, or will we learn to favor a sane salvaging instead of wholesale obliteration?[11]

I calculate that I spent more than thirteen hundred days, over thirty-one thousand hours, in St. John's School between first grade with Sister Maria Therese and eighth grade in Sister Louise Gertrude's room. More than four whole years of days within those walls and for the most part with the same forty kids. I learned to read in that building. And when I left I was ready for algebra. It was an old, forbidding dark brick school originally built in the 1880s to serve mainly the offspring of Irish immigrants who came to labor in the iron mines. By the time I came along, most of the students were second generation Italians, a few French who went to Mass at St. Joseph's, the French Church, and some holdover Irish. I knew every inch of that school. It was three stories and a basement, four classrooms and cloakrooms on each floor with a kitchen and gathering room for parish affairs and parents' meetings. The bathrooms were in the basement—a space divided in two by a wall that defined the girls' and boys' sides. The "schoolyard" was the street blocked off by orange horses at either end before school, at noon, and at recess. As a mirror of the basement division, and evidence of the sisters' suspicion of unsupervised contact between boys and girls, the street too was divided into boys' and girls' territories by the ubiquitous orange horses. My mom worried about St. John's, a firetrap she thought, and now as I consider the building I know that her worries were founded in reality.

I was at an age of naive belief. The sisters were holy people and the hallway that led from the first floor of the school to the convent was for me a stairway to God. Only on special occasions did any of us cross that divide. In our rather bare and certainly computer-less classrooms we sat in those hard wooden school desks that are such desirable antiques these days. Sitting still for six hours in one of those was an acquired skill. Although the desks were perceptively bigger as the students passed from primary to middle to upper grades, they were "one size fits all" within each classroom. The

desks were bolted to the floor, and space between was cramped. We crammed papers, books, pencils, and more into the tiny shelf beneath the desk. The monotony of class was often broken by a loud crash as a classmate's randomly stuffed desk disgorged its contents to the floor in a mini-avalanche precipitated by a slight movement of its inhabitant.

Mr. Helgren was the janitor at both the school and the church. Each evening he swept eight classrooms with huge mops and sawdust compounds treated with oils that emitted unforgettable smells. St. John's has other near-tangible memories for me: bells rung by hand out the windows signaling the start of class. Long wooden poles that reached to the top of the high windows, inserted into holes to open them on stuffy days. Distracting smells of spring through those opened windows. The double-line boy–girl parades to church during Lent and other holy seasons. Crushes on girls. Spelling tests. Tight, unrelenting discipline. Starched black habits and jingling rosaries. Prayers and prayers and more prayers. Grace, and Valerie, Nicky, Gordon, and Patti, and Diane in steel leg braces to support legs shriveled from polio. And Sister Louise Gertrude, now living in a nursing home for the Sisters of St. Joseph in St. Louis. At ninety-three years old she hardly remembers St. John's and me at all. But I was there; I know I was. Wasn't I?

Sister Louise sits in the wheelchair; her face is animated with a familiar smile. Now her black veil is short and not stiff with starch, and she has dropped the Gertrude from her name. Sister, do you remember Diane, Father Spelghatti, my mom, my dad, St. John's? "I do not remember very well," she says. "I have to tell you, I don't really even remember you. What did you say your name was?" How would she have known me? I wasn't Bob or Robert or Dr. Archibald; I was Robin then. "Robin Archibald," I respond. Her face arcs in smiles. "Oh, I remember you," she almost giggles. "The stories I could tell." But she won't, or can't. I give her a hug and a kiss.

St. John's School and Convent were demolished after I left Ishpeming for college. The diminutive downtown block was leveled for a gas station. Although the house I grew up in still stands, the core of my childhood town is gone. The reference point for my memories does not exist, and the red brick building that held a large portion of eight of my early years now exists only in imagination. Places like St. John's don't just stand for memories. Their presence both confirms and stimulates the process of remembering. The disappearance of that building deprives me of memory and diminishes my own sense of identity.

Our childhood homes, neighborhoods, and towns do not exist anymore. The people who lived there then are gone. Nothing is the same, not the sounds, smells, buildings, trees, and not the people. Those places only exist in memory. Memory is not a photograph or a movie, not a dictionary or encyclopedia or a library. Memory is a process of remembrance through which each day we confirm the world and our place in it. Memory is interactive, ever-changing, a radiant explanation for our lives. I think of my memories as those towering summer clouds that I can conjure into infinite images of real things. But like clouds, memories cannot be captured and made to stand still. Mind and memory do not exist in confined physical space but rather they roam all over, seeking sense, meaning, confirmation, and connection. There in mind and memory are all those gradations of light admitted as sight, and nuances of sounds, high-pitched like screeching chalk on blackboards or low like thunder's rumble, sensation like the touch of another or of the wind, the smells of the world like saffron and sweet spring peonies, or the starched clean smell of grandmother's house, or the taste of wild raspberries picked from thorny brush.

But, like clouds, with time they all whirl and dissipate if they have no containers to retain their shapes. When places disappear or are no longer recognizable, they cease to be referents for memory. Memories without places are disembodied, unconfirmed, unverifiable when ripped and sundered from the crucibles that shaped them. We all have those treasured places, treasured because they unequivocally confirm who we were and thus who we are.

I may be able to live without St. John's but I cannot live in a world that contains absolutely no reminders of who I am and where I came from. I would be a stranger in an entirely strange land without tangible reminders to reinvoke my past.

Further, when we treat the past as if its only function is to impede our desire to do whatever we will in the present, how do we regard the future? We will behave as if the future will take care of itself, but it won't. The future is going to happen right here, and it will have to build upon what we leave behind. I worry sometimes that at least in the physical fabric of our places the future won't be much worth having. It won't be built to last and mostly it won't be at all attractive. Consider the physical appearance of those once grand downtown department stores. Compare that image to a huge, anonymous box of a store out along the interstate. Our lack of concern for the future is reflected in our

thoughtless disregard for the past. It is also reflected in the ugliness of our aesthetically bankrupt architecture that violates every human sensibility except acquisitiveness. If the places we make are our gift to the future, we are leaving a sad and paltry legacy.

Remembrance is what sustains civic obligation, community, and democracy itself. Disregard for what is necessary for remembrance imperils it all. We need places that sustain the mystic chords of memory, for without those places to strike those chords, what happens to the intricate arrangement of reciprocal obligations, developed in such places as local sausage shops and neighborhood movie houses, that sustains individuals, communities, even nations? I know change will occur. Ghost towns will melt into the landscape. Decrepit school buildings will be torn down. Downtowns everywhere will change beyond recognition. Neighborhoods will be fractured or demolished. Or as that architecture student claimed, "it doesn't matter where I live because the people who live next to me are not my community."

When they were in their seventies and in mediocre health, my grandmother and grandfather had to move from the house where they had raised eight children. As I wrestle now with the sense and meaning of that move, I can see it as part of a larger process. Negaunee where they lived was, like Ishpeming, an iron mining town, by then a town on a foundation of earth riddled with enormous caves and tunnels where the ore had been removed. The town was held up by giant pillars of iron left standing in the subterranean caverns to prevent the surface from caving in and dropping huge chunks of the earth into the abyss below. I think my grandparents' move was one of the last steps in a continuing process whereby the mining company condemned the land and took the houses as soon as possible until my grandparents' house alone stood in the way of the company's removal of the last subterranean columns of iron. That removal, which would feed high-grade iron to Pennsylvania's furnaces, would ensure that the land of Negaunee would sink into a useless and abandoned pit.

Great-grandfather Quinn had lived next door to my grandparents. When he died his house was torn down. Old Mrs. Maas, on the other side of the Quinns, died, and her house went down too. Years earlier my great-grandmother's body had been dug up and removed from the cemetery that had once been somewhere beyond the end of the street. Across the way Georgie Ethier's house was gone, and others too. My grandparents' house stood in a wasteland that was already condemned, but the mining company

decided not to wait until these last residents died. Grandmother and Grandfather were forced out, and their neatly painted green house with its careful off-white trim and tidy little yard was gone in a pile of sinking rubble.

And now my grandparents' street is a street of tragic forgetting, a place unmade, made into a no-place. Now on my infrequent trips to Michigan's Upper Peninsula I drive to these places, struggling to remember who I was then, that time when I thought pits that marked old mine shafts' openings and sinking ground were normal and chain-link fences with red and black signs reading "Danger, Caving Ground, No Trespassing" were commonplace and unremarkable. Now they infuriate me. They are symbols of a wanton and inexcusable desecration and destruction of place.

I can accept change but I also know that indiscriminate change will destroy us from the roots up. We need a new ethic that respects and proclaims the innate needs of people to remember and to be surrounded by those places that confirm ties of memory so essential for love, stewardship, community, and even democracy. We will have to insist upon rates of change that do not violate our fundamental humanity and let enough of the past persist so that we will know who we are and so that future generations will also have connections to the past and respect for the future.

Yet even places that have not suffered severe and crippling abandonment have experienced the kind of losses that are endemic to our vagabond culture and its declining sense of community.

Maquoketa is a small town in Jackson County, Iowa, that exists as an agricultural trade center and a county seat. As I prepared to talk with the people of Maquoketa about community and their own story, I wondered how their downtown was faring. I searched websites, found census data, and looked at pictures of Maquoketa on my computer screen, but I did not yet have a sense of the town. I detected a Wal-Mart on the outskirts of town; such stores always hurt small locally owned businesses and add a heavy dose of impersonality to both daily commerce and the community life of every town where they open. I saw the golden arches; I could find the same burgers and fries here that I can find in every other American town. But the pictures on the Internet were too small and too indistinct to tell me if the downtown is dying like so many others.

The picture came into sharper focus when I called a longtime resident of the town and engaged in a half-hour chat. Downtown, she told me, is relatively prosperous, and she described the commercial establishments and the

traffic that poured in from the surrounding areas. I began to suspect that Maquoketa grew as other smaller towns in Jackson County withered, becoming the center of a widening circle of trade made possible by improved roads and more automobiles. Yet despite economic survival, this place has not escaped the undermining of community that has afflicted our nation for more than half a century. I discovered in my conversation with an announcer at the local Jackson County radio station that Saturday nights in downtown Maquoketa are subdued compared with what they once were. Downtown is not the community gathering place it once was. And I wondered if neighbors really have time to "neighbor" any more? You know, calling over next door to share some pleasant gossip over the coffee cake you just baked.

Or consider farm life a half-century ago. Trips into town were usually weekly sojourns when the comparative isolation of farm life was broken by shopping, banking, visits with friends, a real excursion and not just a ride in the car. Now a ten-mile drive to town is routine every day of the week. In one sense, cars allowed us to accelerate construction of virtual communities; we no longer relied on just neighbors for friends, and downtown became obsolete as a social place.

I looked at a page of photographs in Maquoketa's Sesquicentennial Program. The photos were taken in the 1930s. The American Bank at the corner of Main and Plat was built around 1920. It looks like a bank, solid, permanent, bold, strong with three-story columns facing the street. Its very structure says that this is a safe place to deposit your money. It is a marvelous part of the streetscape, a harmonious stretch of building facades that form a consolidated, well-decorated line extending for several blocks—nothing like today's strip malls. Then, an image of a street celebration on Main Street. The street is filled with people talking, walking, and milling about. The next photo shows both sides of the street lined with people watching the American Legion Drum and Bugle Corps pass by. At one time Maquoketa's downtown was civic space, a space set aside not just for buying and selling but also for social and civic activities. That's what downtowns were for once. They were where we built and reinforced community, civic pride, civic obligation. These streets were where we learned that together we could be greater than we ever could as solitary individuals. Why else would town builders go to the trouble of making such elaborate buildings downtown, add that useless decorative stonework at significant cost?

Why are so many old schools works of art and beauty while most new schools are nondescript? Modern churches do not elevate the spirit by their very architecture the way the old cathedrals and even neighborhood church buildings did. Or compare a new plain-fronted court building tucked away in a strip mall with the imposing presence of The Courthouse in the town square. What values are we expressing in our modern civic architecture?

When we wonder what has happened to community, we need to search inside of ourselves and examine the choices we have made. What we express in our architecture is too often a statement that beauty is secondary to efficiency, that beauty adversely affects the bottom line, that community is secondary to commerce. We don't think about messages to the future because we do not build to last that long. We may look at what has happened with regret. Yet we often feel that forces are at work over which we have no control, that the fates of our communities are determined by decisions made by others. Most of us do not design buildings or plan towns or own conglomerates. Yet my own experience is that we, and no one else, are responsible. Officials elected by us decide on zoning laws that determine the spatial arrangement of our towns. We decide where we want to live. We chose to buy more and bigger and unhealthier cars and drive them more. We welcomed the chain store instead of supporting the locally owned businesses. We decided not to go downtown on Saturday night. We are not victims in all of this; rather, we are the active agents. We ourselves undermined community incrementally through the thousands of choices we made or did not make.

We cannot and should not recreate the past; it was not after all a better place in many respects. Yet we will have to make different choices now if our communities are to survive, if we are to be happier, and if we are to live in a way that guarantees that the future will be a place where our children will want to live. Can we understand as we tear down and build that some places are good for people and some places are not? Can we remember our needs for beauty, relationships, and a sense of belonging to each other? We must make sure that when we are in Maquoketa or St. Louis or Cincinnati or Pittsburgh, we know we are not anywhere else.

While my observations often seem awash in pessimism, I have not despaired. My travels throughout the country, my acquaintance with communities who do cherish their traditions and seek to build upon their revered stories, provoke an unfailing optimism that we and future generations can

survive and flourish. The new town square is not beyond our reach; in many places the building, or the rebuilding, has begun.

I have been involved with a community housing and social service organization in St. Louis called Beyond Housing and headed by my friend Chris Krehmeyer. Recently his work was focused on Castle Point, an unincorporated area bordering the city, where eleven hundred families live. When Chris first met with residents he told them that his organization would either rehab buildings or construct new housing in Castle Point. The area was experiencing declining real estate values, escalating percentages of absentee landlords, increasing crime, and declining test scores in schools. Chris is really interested in increasing the capacity of communities to solve their own problems; but he assumed good, affordable housing was the appropriate response to perceived poverty. Residents reacted negatively to Chris's plan. "The problem," they said, "is not the housing; it's the garbage." As Chris learned more about the issue, he realized that there was no municipal trash pickup because there was no municipality. Residents felt that the trash strewn in vacant lots, streets, and backyards was the number one problem contributing to community decline. Some residents contracted with private trash disposal companies, but most did not. And as Chris asked more questions, he discovered that in most cases money was not the problem; those who did not contract for trash pickup could have afforded to do so.

The problem was a lack of community. The absence of any sense of obligation to neighbors or commitment to the common good, or even a perception of a responsibility to one's neighbors to just pick up the trash. This was a place where people who lived close to one another did not know each other. The solution was to create activities for people to do together and accordingly to create places to gather. So with Chris's assistance the people who lived in Castle Point built a community center. In time, peer pressure within the community resulted in nearly every resident paying for trash pickup. Chris and his colleagues had realized what they had known in theory for a long time: a community's needs do indeed go "beyond housing."

Benjamin Sanchez was born and raised in San Elizario, and although he migrated to Los Angeles, the roots of that small community some twenty miles east of El Paso, Texas, were deep within him. Eventually Ben had to return to his home place, so strongly was he rooted there; and his presence has made a difference to San Elizario, a settlement that can trace its own roots back to at least the late seventeenth century. The Spanish had explored and left their mark in the region a hundred and fifty years before that and around

1680 established a military base and small mission that became the town of San Elizario. When a corps of Spanish soldiers organized to reconquer neighboring New Mexico, other residents chose to stay in this land of fertile fields and settled into an agricultural community. Many of the people who today live in San Elizario and the nearby area are those farmers' descendants.

Last year Ben invited me to address the San Elizario Genealogy & Historical Society on preserving heritage and historic landmarks. I was honored to do so, for here was another opportunity to encourage interested people in their efforts to conserve, restore, and build upon the history and the stories of their community in a startlingly beautiful land. Although I knew little about San Elizario, I was acquainted with El Paso, and I knew that this part of Texas bore strong resemblance to the geography and culture of New Mexico.

In 1972 I set out from Ishpeming for the University of New Mexico in a frog green Toyota with a U-Haul trailer that I later discovered had wrecked the car's transmission. We first crossed Minnesota, then South Dakota, and then into Wyoming. I was disoriented by the high plains. My Michigan homeland had unmistakable reference points: trees, hills, creeks, lakes, mineshafts, but this land of the plains just curved to the horizon in every direction. I had never thought that the terrain could be so flat and the view so unimpeded.

In southern Colorado near Trinidad it all changed again. The land seemed dryer and then almost colorless. I was accustomed to the riotous greens of the northwoods. This land was a soft palette of earth tones, subtle and nearly invisible to eyes accustomed to sharp contrasts of landscape color: the white and green of birch against the azure blue of Lake Superior. From Trinidad south, many interstate exits had Spanish names: Raton, Ocate, Glorieta, Galisteo, Bernalillo, then Albuquerque, my new home, and on down river through Ysleta, Socorro, Las Cruces, and finally to that stretch of El Camino Real and El Paso Del Norte I would visit in San Elizario. Evidences of human presence changed. Instead of frame and brick dwellings, adobes. In my experience buildings were intrusive, symbols of human domination. Here the adobes blended into the landscape linking humans and land. Even the climate was foreign. The sky was a quality of pure blue I had never seen and the absence of humidity was almost unlike anything I had ever experienced. This was a world I knew only from written descriptions and photographs. It seemed imaginary, a fantasy world that I entered in near disbelief in its reality. The southwest would be my home for five years, and I immersed myself in the people, their history and culture, and the enchanted land.

CHAPTER 9

This is a land of adobe, a sensuous, almost erotic material. These mud bricks are covered with mud plaster and shaped by human hands, acquiring an unpredictable curvature. This spectacular aggregation of curves that form the approximate shape of a house, but a rounded house that has a sensuality that frame and brick houses can never have. Adobe construction is specific to places like this. People built with adobe out of necessity; lumber was scare but they needed shelter, and the arid climate made adobe practical. Adobe seemed a metaphor for life and simultaneously the ultimate environmentally sensitive building material. Adobe doesn't dominate the land but instead grows out of it and, when old and abandoned, it dissolves back into the earth from which it was made. The smooth curved lines of the material are an expression of this land, the aesthetics of humans who settled here. Where adobes were in various stages of dissolution, they reminded me of a melting ice cube as it begins to lose its shape into a spreading puddle of water.

If I had any expertise to offer the community of San Elizario, it was my advocacy of history as the only process for sorting out our future. History, people, and place are inseparable. Everything that has ever been done by humans happened some place. Place shapes us. This place called San Elizario has profoundly shaped the people who live here. Their history could not have happened anywhere else. The great dilemma that these people were confronting is the specter of placelessness. Ben Sanchez sent me a book coauthored by Rick Hendricks, *San Elizario: Spanish Presidio to Texas County Seat*. He writes that

Today San Elizario and the ancient communities of Ysleta and Socorro are heroically struggling to preserve their histories, as embodied in missions Corpus Christi de Ysleta and Purisima Concepcion de Soccoro and the church in San Elizario, standing on the original site of the military chapel of the long vanished presidio. Without doubt, we have a deeper understanding of that history than at any time in the recent past. Sadly the "picturesque little village" is also gone. In its place is a rapidly growing community that faces a serious challenge if it is successfully to impart to new arrivals a sense of the history of the place.[12]

San Elizarians had begun to face this problem long before I arrived with my counsel and experience. As I spoke at the luncheon and visited with the leaders and citizens of the town, I became more and more aware that my advice was, if not superfluous, at least a buttress of what they already understood and were

conscientiously attempting. They were involved in preserving a sense of history in their place, not as antiquarian novelties or tourist attractions or bygone traditions but as the vibrant, persisting connections with the past that will enhance their present and insure their community's future. Changes will continue in San Elizario; that is the human condition. But I am confident that the changes will not be wrenching for this little Texas town, the place or its people, for they are learning the value of their heritage and the means of best sustaining it.

The story of Reston, Virginia, is very different but substantially related. In the post–World War II boom period, developer Robert E. Simon had a vision of a residential development as something more than new houses; rather Simon imagined a town in which a person could begin life in an apartment or townhouse and then move into a detached home, all in the same neighborhood, a neighborhood with convenient access to friends, schools, and shopping. He visualized not a town or a suburb or a real estate development, but a place for a community, packed with opportunities for diversity in every aspect from the age, race, and economics of the residents to the size of houses and the shape of lots, from a purposeful mixed usage in the buildings to the ease of walking where you needed to go and meeting your neighbors along the way. Reston—the first three letters match Robert Simon's initials—was not only a success but a paradigm for other attempts at "New Town" development throughout the country.

Further, Reston seemed to be always a place where the residents were involved and articulate about preserving their place. Although a complex set of conditions allows Reston no local government, a group of citizens explored ways of creating consensus in a community that had grown enormously and changed significantly. Reston was attracting a different mix of residents and perceiving the real danger of becoming no more than a transients' suburb, and too many instances of the Oldtimers vs. the Newcomers were shaping the discussion of issues of concern. Along the highway from Reston to Washington, a high-tech industry corridor had developed, and Dulles Airport's expanding proximity made Reston property very attractive to modern real estate developers with ideas quite different from Simon's enduring vision.

In the summer of 2000 the Reston Historic Trust for Community Revitalization invited me to help the organization launch a county-funded revitalization study. The representatives promised me an interesting and worthwhile visit. What I learned about Reston and its people was even more: it was an experience in community that adheres to Robert Simon's

original dream, still invigorates a grassroots democracy in building, pre-
serving, and planning community, and has looked at their past as a means
of making choices that protect the future. As their consultant I was able to
help them articulate the link between understanding the past and planning
for the future, but the groundwork had already been done. The spirit of
community was already strong and vibrant in every turn of the streets of
Reston, where neighbors will continue to know the people next door and
down the block, where a customized transit service has lured people out of
their automobiles, where you can safely send children to buy a popsicle for
themselves. Reston isn't perfect—it is after all filled with humans who have
frailties and shortcomings—but it is a signal that there is hope for the future,
that the new town square is under construction and already in use.

Notes

1. Pennsylvania Writers Project of the Work Project Administration,
 Pennsylvania Cavalcade (Philadelphia: University of Pennsylvania
 Press, 1942), pp. 408–9, 421.
2. Simon Bronner, *Popularizing Pennsylvania: Henry W. Shoemaker and
 the Progressive Uses of Folklore and History* (University Park:
 Pennsylvania State University Press, 1996), pp. xiii, 49.
3. Dick Perry, *Vas You Ever in Zinzinnati?* (Garden City, N.Y.:
 Doubleday, 1966), p. 2.
4. Frances Trollope, *Domestic Manners of the Americans*, 5th ed.
 (London: Oxford University Press, 1984), pp. 72–73.
5. Dorothy Weil, *The River Home, A Memoir* (Athens: Ohio University
 Press, 2002), pp. 148–49.
6. Helen Traubel with Richard G. Hubler, *St. Louis Woman* (Columbia:
 University of Missouri Press, 1999), p. 14.
7. Traubel, *St. Louis Woman*, p. 15.
8. Traubel, *St. Louis Woman*, pp. 17–18.
9. Traubel, *St. Louis Woman*, p. 30.
10. Traubel, *St. Louis Woman*, p. 24.
11. Interview with the Ross family, Missouri Historical Society Archives.
12. Rick Hendricks and W. H. Timmons, *San Elizario: Spanish Presidio to
 Texas County Seat* (El Paso: Texas Western Press, 1998), p. 96.

CHAPTER 10

Under Construction

D URING THE WEEK THAT I WROTE THIS FINAL CHAPTER ON
the new town square, the Missouri Historical Society
was host to a women's forum composed of local busi-
nesswomen who were also civic leaders concerned with the issues in our re-
gion. The director of the Greater St. Louis Regional Empowerment Zone
phoned me to reserve space in the museum for a citizens' dialogue on city
concerns. I met with the head of the University of Missouri-St. Louis's Public
Policy Research Center to discuss the potential of a joint publishing pro-
gram, and senior staff were putting together the agenda for a student re-
search project with Washington University. Having just been elected to the
St. Louis School Board, I was making room on my calendar for the meet-
ings that holding this office requires. What has all this to do with a history
museum? Everything.

So, what are museums for? Although I have worked in museums for
what has become a long time, I still ponder the question. For me it is a per-
sonal as well as a professional issue.

With a spicy stew of late adolescent optimism and hubris, fortified with
the headiness of boomers who came of age in the 1960s, I thought that with
a little help from my friends I really could save the world and alter the
course of humanity. Thus I eschewed such practical things as law, science,

business, and medical school and decided to choose between history and the seminary. At the time both options seemed like alternate routes converging in the same point, strategies to prepare me to improve the well-being of others and contribute to the betterment of my place. For me this was a period of personal mentors and heroes, first the Roman Catholic parish priests of my childhood and then the academic intellectuals I encountered as I worked through a doctorate in history.

But I was to be neither priest nor professor. My first work after graduate school was in a museum, and although I had a few museum-related courses on my vita, I genuinely regarded this obsession with old stuff as second-rate employment. Objects, after all, did not speak explicitly the way documents and manuscripts do (I had not yet learned how to listen), and in the museum I was consistently required to explain and justify myself to the uninitiated, to both my friends and those visitors who made queries inside the doorway. How foolish, I think now. I overlooked what was apparent, that these conversations with my colleagues and community members were not distractive sideshows but rather the core of an exchange that could matter. In those conversations were the germs of what I now embrace as the essential function of museums: broad-based and inclusive conversations about how we know the world and each other; what we have done well, where we have fallen short, and how we can do better; what is beautiful, what is ugly, what is right, what is wrong, how can we know the difference, and how can we agree on what to do next.

Of course my attitude about objects has changed too. I laboriously learned a novel language, the idiom of artifacts. I aged in years and experience for awhile and scraped the edges off of my graduate school axiom of "dedication to objective scholarship" in which we were repeatedly admonished to emotionally distance ourselves from both our subject and subject matter. Now I think that emotional distance from either objects or audiences is a misguided tragedy that simultaneously diminishes the potential value of our work and undermines its efficacy. In order to matter, we must be involved. If we don't care, what's the point? My thinking about objects still evolves as I read, converse with people, and get exposed to new things.

But I needed to overcome other prejudices. Although I have come a long way, I was a historian by training with an unfortunate tendency to disparage other disciplines from the top of my own mountain. But museums are disparate and do not favor disciplinary chauvinism. Some of our colleagues

dig deep to find dinosaur bones, stone flakes, and remnants of peoples whose stories are forgotten. Others focus on aesthetics, creativity, artistic perception; some collect animals, insects, reptiles, and fish, or plants, flowers, trees, and seeds; still others examine the world through science or specialize in specific cultures or plan for special audiences or age groups. My mountain has leveled out. Now history includes everything.

History has implications. As a historian, I must be a community activist because I believe that history has implications that require action. It is my work outside the Missouri Historical Society, my professional involvement with the community, that enables me to think predictively about people and their communities. Our institutions have, or ought to have, concerns and objectives identical with those of the people we serve. Hence, those of us who work in cultural institutions must be involved in communities so that we can translate issues and concerns into our internal agendas. But in addition, we must be involved beyond our walls in meaningful ways if we are to bring anything important to the civic table. We must accept our responsibilities as citizens with special expertise if our institutions are to be relevant to our communities, however we define those communities. In one sense we must become a part of our own audience, more community-minded in defining our ends, much more capable of evaluating the efficacy of our efforts.

In the spring of 2002 I addressed the annual meeting of the St. Louis Association of Community Organizations (SLACO). Everyone in the audience had a stake in history, in what we do here, but only a few were members of the history profession. It was an honor to be SLACO's guest speaker, but also a humbling experience, for these are people who work with supreme dedication to make our city and its neighborhoods good places. I, too, am concerned about our city and our metropolitan region. We are all concerned or we would not have been there together. In our own ways each of us has fallen in love with this place. Some of us were born here. Others are here by adoption. The extent of relationships between people and places is ineluctable and complex, but I do know that places are not interchangeable. If I were in a different place, I would be a different person. I was raised on the cold, pristine shores of Lake Superior. I have lived in the desert southwest and in the mountains of Montana. I lived for nine years in a St. Louis suburb and now in the City of St. Louis. Each place has framed my life and my concerns differently. Yet despite my deep attachments to other places, it

is here in the City of St. Louis that I finally feel truly at home. People have invested so much here. There is such beauty here. There is so much of the past discernible here. There are no bygones here.

The depth of foundation rocks go down so many generations. We build upon the work of those many generations, and we see it in the buildings that trace a timeline from the earliest remaining structures near the core of the old city, reflecting the decade-by-decade expansions as we move further out in the fanlike grid that is our city. We see it in the trolley tracks that still heave through the asphalt on many streets. It is in the grandeur of parks, the resurrected magnificence of buildings like the Fox Theater, a fantasy movie palace of the late 1920s, and the emerging promise of the Homer G. Phillips Senior Living Community, formerly the abandoned hulk of the renowned African American hospital. It is in the network of alleyways, the reminders on nearly every block of the neighborhood corner store, in the forlorn wreck of the abandoned City Hospital. We hear it in the memories of people, in the music of Scott Joplin and Miles Davis, the poetry of T. S. Eliot and Maya Angelou. We can smell it along the levee, down by the brewery, at Shaw's Garden. Every building, every place is in part a museum, a library, a school. Each building enshrines the values, the hopes, and the memories of every person who has lived or worked here. Our city is a marvelous monument to the past, a past that is both burden and legacy. It is up to us, the living generation, to make it a monument to the future as well.

I, like many others, espouse these values, but in truth I have succeeded in acting upon them only intermittently. I wish that I could be more consistent in acting in accord with those values of civic-minded tolerance, respect for the rights and beliefs of others, and the sacredness of life. But I do believe that we can mutually succeed in elevating human consciousness of those values that promote good and combat evil.

Consciousness imposes wisdom and obligation upon humanity. As I grow older, the story of the fall of Adam and Eve in the Garden assumes nuances and additional meanings. When I was a child, it seemed a distant fable or ancient history; now Adam and Eve's story seems luminous with the accumulated wisdom of the ages. It was the "Tree of the Knowledge of Good and Evil" from which these two first humans plucked and then ate the forbidden fruit. My beautiful tabby cat has never tasted of the fruit in the garden. He is not capable of evil because he cannot know evil. That is not to say that, given an opportunity, he would not leap at a mouse and

claw it, maim it, and paw it as it died. But he is a cat. He is doing what cats do. It is programmed in his genes. He is a predator—by nature, a carnivore. The story of Adam and Eve strikes me as that seminal moment when we became different from other creatures, really human, separated by a vast impassable canyon of difference from all other creatures, endowed with free will and obliged to choose between good and evil. Never again could we claim the innocence of animals or plead natural instinct as a defense for our behavior. We became capable of intent, including the intent to do good and to do evil.

Barry Lopez wrote a wonderful book entitled *Crossing Open Ground* in which he considered the capacity for evil embedded in humanity. He tells a story of a terrible day in the sixteenth century, when Hernan Cortes and his small army arrived in Tenochitlan, the capital of the Aztecs in the Valley of Mexico where Mexico City now stands. Then it was a gleaming city of gardens and water built on artificial islands in Lake Texcoco, with stunning collections of birds whose songs filled the clear, bright sky. On that awful day in the Valley of Mexico, the soldiers in Cortes's army burned the aviaries and incinerated the birds. "It stands," Lopez observes, "for a fundamental lapse of wisdom . . . an underlying trouble in which political conquest, personal greed, revenge and national pride outweigh what is beautiful, serene and defenseless." And he concludes, "Cortes's soldiers, on their walks through the gleaming gardens of Tenochitlan, would have been as struck by the flight paths of songbirds as we are today. . . . In such a moment, pausing to take in the flight of a flock of birds passing through sunshine and banking gracefully into a grove of trees, it is possible to move beyond a moment in the Valley of Mexico when we behaved as if we were insane."[1]

Lopez does not say, "when *Cortes and his men* behaved as if they were insane." He says when *we*, every human in every age, behaved as if we were insane. These words remind us of the shallow burial of our lurking, unacknowledged capacity for evil. As children many of us needlessly caused pain, senselessly destroyed life, and sometimes even took pleasure in the acts. In crushing flowers, pulling off spider legs, teasing—sometimes to death—frogs and snakes and other living things, many of us have "incinerated the birds." Such acts, especially as adults, cross forbidden boundaries and the chasms of decency and conjure the demons within us. Those boundaries are transgressed far too often and the consequences are unspeakable evil and horror.

Although the Nazi Holocaust is a pinnacle of the evil within, it is unfortunately not singular. Thousands of years of human history are full of the ugly proofs that we will never banish evil, for the very capability for good and evil defines our character. The innocents and the powerless have been enslaved, tortured, maimed, killed, demeaned, and dismissed from the foggy dawn of history until even now when the World Trade Center towers collapsed, and a Bosnian was laid in a mass grave, and a terrorist murdered another person in Israel, and another drive-by shooting took a young life on a street in south St. Louis. But then I saw a tawny orange-breasted robin flying in front of my window, a ridiculously large bit of foliage in his beak. He is on a nest-building mission.

Beauty, self-sacrifice, sensitivity, kindness, and peacemaking have also endured, compelling, even irrefutable evidence of the extraordinary goodness of which humanity is capable. And although evil lurks in the dark recesses of all of us, so also does good inhabit the better sides of our natures. Each of us embodies both good and evil, and the world around us and the relationships between humans of every time in all corners of this planet reflect this ambiguity of human potential. Good and Evil exist in the world. The challenge to us is to unrelentingly and unceasingly struggle to subdue the evil within us and to express our opposition by combating the evil beyond ourselves, so rampant in the world around us.

When I was a boy, we had a beautifully illustrated book of Greek fables in our house. I would sit for hours, reading the stories and letting my imagination loose over the pictures. The story of Pandora always struck a chord of awe and fright in me. Pandora, of course, opened the box just as Adam and Eve ate the apple. And when she opened the box, all manner of evil, pestilence, war, pain, and disease flew out. What I had nearly forgotten about the fable was the whole point of the story. For when evil escaped from the box, one thing remained at the bottom. What remained was hope.

Lopez concludes his piece in *Crossing Open Ground* with admirable optimism that we can redefine our relationships with our planet, acknowledge and trust the best of our emotions, and treasure our relationships with each other. Beautifully and poetically Barry Lopez exposes what is the real heart of the matter. It is the issue of sustainability in its most holistic sense. Can we acknowledge that we have an obligation to leave this world in better condition than we found it, a world more capable of sustaining life, less wasteful of resources? Do we realize that places that are good for people are

also good for the planet—places that nurture relationships, places that inculcate a sense of identity, places that are conducive to elements that cannot be commodifed in the marketplace: civility, empathy, inspiration, integrity, memory, mutual obligation, and respect. Through such good places, places that are crucibles of democracy and planetary responsibility, people accept their mutual accountability as the living trustees of this intergenerational project called life on earth and, equally important, learn to care for each other.

On the cusp of a new century we can see that fundamental change characterizes the past one hundred years. Our national culture has become democratized; we have become a multicultural society that increasingly takes pride in its "coat of many colors." Voices previously silenced are raised in a rich and complex chorus; now we both hear and hearken to the voices of racial and cultural minorities, women, gays and lesbians, people with disabilities, the elderly, and a plethora of other groups representing a full spectrum of interests and concerns. Our nation is democratic in ways that our predecessors could not have predicted nor imagined. Our society has moved from one in which exclusive homogeneous groups wield the power to a society in which power and decision making are more broadly shared than ever before, a milieu that places expanded obligations upon its citizens and also offers them unparalleled opportunities. The democratizing forces in society have also affected museums. Once considered closed circles of authority, our institutions now seek to interact with our communities in more meaningful ways, to apply innovative technologies and educate our constituencies by methods that more clearly reflect the increasingly dispersed authority and power within our communities and nation.

My youthful suspicion that museums were not places for meaningful work was a consequence of the dichotomy between my personal urge to work on big issues and my immature conviction that what museums did was passive reflection at best and entertaining reinforcement of the status quo at worst. I took no solace from museum mission statements that proudly announced that museums exist to collect, preserve, and interpret. Did we collect whatever we fancied? For whom did we collect and preserve? How and what were we to interpret? Was one interpretation as good as another? Why do we bother, and why should anyone care? I belatedly recognized that history is not fact, that objects do not speak for themselves, that science is value laden, that art is perspective, that technology is not neutral,

that memory is not static, that there are no fixed canons, and hence museums' claims of objectivity, authority, and truth were disingenuous. In fact and in practice, we make daily judgments about what is important, what is good, beautiful, ugly, right, wrong, significant, and insignificant. The notion that individuals, museums, or any institutions are wholly separate from their own time and place is pompous self-deception. Museums can make critical contributions but only if we abandon the pedestals of authority that distance us from those we serve and enter into the discourse about important things in our communities.

In the future our society and our communities will function only through a process of inclusion in which those people affected by a decision will insist upon participating in the decision-making process. How will museums incorporate this principle of inclusion into our internal workings? How will we—or should we—become advocates for inclusion in the larger community?

In 1998 the American Association of Museums (AAM) introduced its Museums and Community Initiative. The centerpiece of this effort was a series of six dialogues in cities across the United States. Each dialogue included approximately one hundred people. More than half of the people in each dialogue work outside of the museum field in politics, philanthropy, corporations, social service agencies, and community action organizations. Our goal was to gather perspectives and opinions on the possibilities of new relationships between museums and the communities they serve. From my experience as chair of the Steering Committee of the Museums and Community Initiative, I can unequivocally state that there is no community resistance to museums' greater involvement with community concerns. But the community representatives were not talking about "outreach."

I was struck by a conversation I had with the director of a metropolitan Los Angeles social service agency. The exchange took place over a break during one of our dialogue sessions, as such conversations often do. "What," the young Latino man asked, "can museums do for my clients who are mostly people of color and very poor?" I almost described existing museum outreach programs for him. Then I realized this response would be too haphazard since I know nothing about his clients and he knows only a little more about museums. So I explained museums' resources: collections of clothing, art, music, books, historical objects, animals, plants, and more; exhibits and programs but also facilities for meeting space and diverse profes-

sional expertise in fund-raising, oral history, education, ecology, archaeology, physics, exhibit development and design, research, theater, publishing, public relations, and other disciplines. "If a museum described its assets for you," I said, "and made them available to you, is there anything that you and a museum could do together that would be of value to your clients?" "Of course," he replied, "if that's what a museum does, there are infinite possibilities for a museum to serve my clients." And therefore infinite possibilities for community involvement by both his clients and the museums of his region.

Rick West, director of the National Museum of the American Indian and a member of the AAM initiative, calls it "inreach." Outreach simply is the system for delivering services, not a means of building relationships with the community. Real community building is not about how museums reach *out*; it is about how we allow the public to reach *into* our institutions. Some nonmuseum participants even voiced their suspicion that in some museums, outreach is just a substitute for real change. But there is no substitute for "real change."

Inreach applies to all museum constituencies. My example is a Latino who worked with people of color in a poor section of Los Angeles. But we need to be careful not to equate "inreach" exclusively with words like diversity and inclusion, occasional code words for "minority people of color." If what we have to offer is of value, as I believe it can be, then it must belong to everyone. My origins are Irish, German, French, English, plus that extraordinary cultural blend of Michigan's Upper Peninsula, and consequently I cannot consider myself a person of color, nor can I claim to "understand" the African American or the Latino or the Asian experience of history. Nor can the descendant of enslaved people or a Vietnamese immigrant immediately grasp my perspective. Therefore we must talk to each other, share our stories, and discover how those stories have divided us and where our separate histories intersect. The standard outreach programs do not provide the means with which to carry out such a conversation; the standard outreach programs have been instructional monologues, educational and even entertaining but essentially a dead end on the road to community building.

Just as we cannot justify our museums' existence on the basis of our "outreach," or on any of our exhibitions or programs or collections, we cannot defend ourselves as essential to the community's economy. Museum and history organizations are not primarily economic engines. While our

employment and operational spending do influence local and regional economies, most museums do not have a major effect on their local economies. Yet we often participate in "economic impact" studies, using the usual optimistic multipliers to gauge magnitude of economic contribution. For most of us the total significance is less than that of most businesses in our communities. Some time ago the Missouri Historical Society participated in an economic impact study conducted by a broad consortium of St. Louis area cultural organizations including performing and visual arts, historic sites, the zoo, the botanical garden, a children's museum, and the science center. While the dollar sum of the organizations was impressive, it was not large enough to compare with any of the large corporate or entertainment venues in the area. So if we were to call upon the community leadership for more influence and more dollars, we could not use this measurement as the basis upon which to justify our pleas.

When I was director of the Montana Historical Society, a state agency, I had to approach the state legislature for funding of my institution. I remember very well waiting my turn in the appropriations committee hearings, listening to the pleas of social service agencies for funds to help single mothers, people who were deaf, lame, ill, imprisoned, unable to work, abused, abandoned. I had walked in thinking that my work and the work of the Montana Historical Society were important, but as I listened I thought that maybe the moral course would be to offer up the institution's whole budget to ameliorate some of the suffering and desperation of others. I was in my thirties then, and I wondered whether I had made a life choice that consumed resources better spent in meeting the often desperate needs of others for food, shelter, safety, health, and justice. Every one of us should be required to sit through such a hearing and then make the argument for money for cultural organizations. Years ago I had similar experiences with donors who rejected my solicitation by pointing to stacks of appeals. Why should they support my work when they received hundreds of requests from individuals and organizations facing the most immediate crises of humanity? It was humbling and healthy, although initially depressing, but a necessary challenge to any grandiose assumptions about the value of our work. I knew there were good reasons for supporting my particular institution and those of my colleagues. Formulating and articulating the justification for our existence and for public and private support has resulted in a deepening awareness of the true importance of museums and culture in a community

and a total commitment to the work we do in the community we exist to serve. It is *not* the economy.

Our business is about what it means to be human, to ask and address the ultimate questions that persist through every generation, despite the many nuances that characterize every age. No matter the type of institution, we are places of varying perspectives that reflect diverse humanity; we are places of dialogue about important issues; we are places for building of relationships, and we are places that espouse values. We are incubators of community because through us people discover not only how they differ but even more importantly what they share—a common past, common concerns, shared space, and mutual aspirations. It doesn't matter much if we are an art museum whose business it is to facilitate dialogue about perspectives of beauty, emotion, and thought, or a science center that examines scientific explanation and definitions of progress, or a zoo that focuses on species, habitats, and human repercussions, or a children's museum that encourages learning, interaction, and relationships, or a history museum that creates dialogue about the burdens and legacies of the past. All of us should be places that acknowledge difference, seek common ground, facilitate dialogue, and assist in the delineation of a shared future, places to both maintain tradition and heritage and chart the changes that help to shape our present story.

History belongs not to us, the professionals, but to the community. It is a discussion of the burdens and the legacies that we bear, an active process engaged in by living people in order to discern the errors of the past and the means to remedy them, to develop a common agenda that will build upon benefits left to us. It is a process by which we weave our narratives, stories that must include all of us. We do all weave our own individual narratives, as I wove my own story of Anna Karinkevich, one of the millions of Europeans dislocated by World War II. Anna came to live with my family in the year I was born. She never left. Of course I knew her well, but my story of Anna was incomplete. When she died, I sorted her belongings, knowing that I could not keep everything. What I searched for were symbols. Some of the symbols reinforced my existing memory of her: crochet work, knitting, refugee documents and later citizenship papers. Other objects that she left behind were symbols that puzzled or surprised me. I had not realized, for instance, how deeply Catholic she was: Latvian prayer books, votives, miraculous medals, a statue of the Virgin. Through this discovery I came to

understand what sustained her through loss of family, place, and roots. So she is different to me now after her death. In this excruciating picking and choosing I was constructing a narrative, my narrative of Anna. If she were still here, she might have said, "You did not pick the most important things. Why didn't you pick the pink blanket? I was knitting it when the letter came saying that my brother died." But I was not constructing Anna's memory of herself; I was constructing my own memory of her, a memory to sustain me. History is about making useful narratives for the living, based upon an infinity of choices between what to remember and what to forget.

We in the museum business are collectors, but none of us can collect everything, even everything in a specialized field. Therefore we must make daily choices about what we keep, what we seek, what we don't need, decisions about what to keep and what we can discard. Thus whether we acknowledge it or not, there are values underpinning our work, values that must be broadly shared if we are to truly represent the communities we exist to serve. So history is a broad-based discussion in which an institution shares authority with the citizens it serves, for we cannot dictate the meanings of their pasts and the significance of their lives. History is a conversation about what is important, about who we are, what stories we will tell. It is a search for common ground between people with diverse interpretations and experiences, a search for mutual understanding and a unified narrative for both our present and our future. It is the process of discovering the differences between us and the examination of what we share. History is both burden and legacy, a discussion of what we have done well and what we can do better, and we are the place to discuss the difference. We must become the facilitators in the new town square.

In *The Presence of the Past: Popular Uses of History in American Life,* authors Roy Rosenzweig and David Thelen found that people experienced museums as one of their closest connections to the past, second only to family gatherings. Furthermore, the respondents put more credibility in museums than in any other source of information, while extensive surveys undertaken by the American Association of Museums verified the trust that Americans feel in museums of all kinds. While these results are gratifying, they also issue a challenge to us, a challenge to justify the public's trust and strengthen the links that the public has forged with its museums.

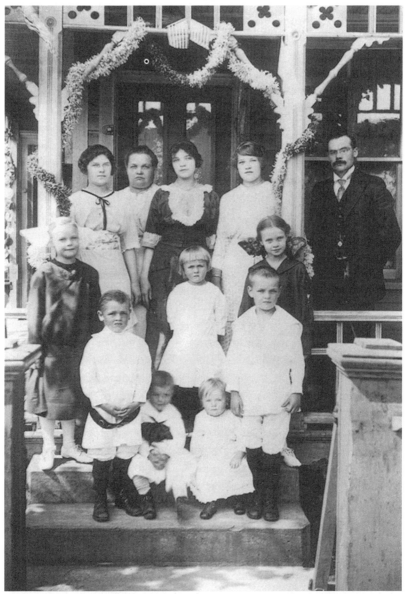

Museums, like family gatherings, are close connections to the past. The Alexander Pantti family of Ishpeming, Michigan, ca. 1914. Photo courtesy of Robert Marsh.

To become effective facilitators we must accept the responsibility of articulating the core values axiomatic in our community. *Values* may be an alarming term, suggesting the imposition of another narrative like those exclusive narratives of the past. But the alarm is fortunately a false one. In practice the use of core values is an effort to describe some conclusions about the character of human life and relationships based on our study of the past. Many museums are experimenting with new processes for public dialogue and engagement, but I know best the experimentation of the board and staff of the Missouri Historical Society where I have been president since 1988. In 2001 the Board of Trustees, staff, and stakeholders of the organization completed a planning process that codified much of what we had learned during the preceding years. Our journey as an institution is not over and probably never will be, for like history itself our work is an ongoing process, a work in progress in which the Board of Trustees, the staff, and the community at large are all engaged. Some days I feel that we have only nibbled at the possibilities. Yet, when I look back I know that we are different than we were, different and, I believe, more responsible and respected, more a part of our community than ever before.

Having asked what values are at the core of our work and our community, we have discovered certain desirable qualities on which we can agree. We all seek a civil society, a healthy community where we recognize and accept our rights as individuals and obligations to one another. To achieve such a society we need empathy, to consider wholeheartedly the perspectives of other people. We need inspiration, places that nurture spirituality and appreciation for what is beyond us. We must have integrity, adherence to the highest standards in all we do. We need to remember, for memory is the indispensable foundation for a better future. We must practice good stewardship, of the collections in our keeping but also to reflect the obligation to leave this community and this planet in better condition than we found it.

These core values represent the foundation on which we as a community can build the new town square. But this list does not explain the process by which we do the work. Consequently we have evolved a set of commitments, endorsed by the board and embraced by the staff and volunteers, again not necessarily complete and not a departure from our general practices, but rather a codification of the way we do the business of history. These terms are familiar yet the implications may be unexpected.

Here is what we have pledged to our community: to pursue our work, fulfill our mission, adhere to core values, and conduct our business in a manner that is:

Collaborative, a practice that will augment our efforts with the skills, resources, and expertise of others, expanding the effect of our work, and that requires shared vision, resources, and implementation, in essence a relinquishing of claims of ultimate authority;

Engaged, an attribute that means we are involved as citizens and focused on the community, which is crucial to an institutional understanding of community concerns and to awareness of both the burdens and the legacies of the past;

Flexible, so that we may accept those important opportunities that arise unexpectedly but at the same time concerned with the safeguarding of our institution and its resources, even when experimenting with innovative ideas and initiatives;

Inclusive, because common stories and shared meanings cannot evolve from exclusive activities, a resolution that obliges us to seek diverse public representation in planning and implementation and to apply this principle consistently in all business practices;

Open, an atmosphere that removes barriers between our institution and the community it exists to serve and commits us to equity, fair practice, diversity, and honoring our word;

Responsible, being good stewards of our collections, those raw materials from which we construct our stories, examine the past, and frame the future, and caring for them in a professional manner; and furthermore exploring ways to expand our collections consistent with our mission.

Perhaps these are radical ideas. It presupposes that a museum is willing to share authority with its community. It means that trustees, directors, curators, and all the staff and volunteers must formally embrace the notion that the public makes its own meanings in museums and that the museum's task is to facilitate the making of meanings in a collaborative manner. In this way the public gets to fully participate in the creation and implementation of the museum's agenda. This concept presents obstacles, but obstacles to change in any profession are rarely external. They are predominantly internal because real change threatens the best practices that have evolved over many years in every profession. We need to ask ourselves questions such as: do museums have to exert absolute ownership of collections? Can we enter into partnerships, develop collaborative agendas, and raise dollars that do not necessarily flow into our institutional budgets? Can we really work for the common good of our communities, not just for the benefit of our own institutions? Can we really understand that institutional survival is not sufficient motivation nor justification for our work?

Traditional performance measurements of finance and museum practice, while important, would not suffice for us given our emphasis upon values and commitments. So we developed multidimensional performance standards to evaluate our effectiveness including standards of financial performance, museum practice, and social responsibility.

Through its standing committees our board will continue to annually evaluate financial and museum practice performance, according to standards, policies, and procedures previously established. In addition, every two years board and senior staff will convene a diverse group of people involved in public decision making, community issues, regional collaborations, and mission-related activities to assess the institution's effectiveness in areas of social responsibility. In our first such evaluation we included open-ended questions in each of the three performance areas to guide discussion and evaluation. The section related to social responsibility was new and original, anecdotal instead of quantitative. We will have to learn to recognize the legitimacy of anecdotal, informal evaluation, or we will be stuck with quantitative measurement and forced to emphasize only those activities that are liable to such measurement. Alan Artibise, then director of the Public Policy Research Center at the University of Missouri-St. Louis offered this statement in response to our survey. "The role of the Missouri Historical Society is profound; no other historical society plays such a role. The institution in its many forms—exhibitor, educator, convenor—encourages citizens to acknowledge the past, participate in current events, and, most importantly, shape our future. And it does so with affection, conscience, and aplomb." Such a statement is hardly quantitative, but Professor Artibise's assessment is at least as meaningful as a head count.

The questions we will address to the community outside of the institution as an informal measurement of performance are open-ended, an impetus to further discussion of community and institutional goals. In every instance the concluding topic for dialogue is What more can we do? Where are more opportunities for us to fulfill our role as the new town square?

These are sample questions for this ongoing dialogue with the community:

Has the Missouri Historical Society succeeded in undertaking an expanded role as a "town square" where issues facing our region and state are discussed in constructive public forums?

Have we helped bring people together to strengthen the infrastructure of civic and community life? Have we brought historical perspective to conversations about significant issues? Have we worked to facilitate coordination and cooperation for community betterment? Have we implemented

collaborative programs and initiatives with other organizations? Have we achieved inclusive practices in terms of staffing, governance, operations, and programming? Have we reached new and diverse audiences?

Have we taken appropriate advantage of the burgeoning new technology available? In this past century technology has revolutionized every aspect of our lives, not just information technology but automobiles, airplanes, air conditioners, television, medical technology. This revolution presents both peril and opportunity. Technology has diminished certain values. Shared space like the old town square once defined community, common life, civic obligation, a sense of place undergirded our ongoing experiment with democracy. Technology has allowed us, sometimes forced us to replace communities of place with virtual communities. But we can also recite the blessings: relief from drudgery, ease of travel, instantaneous communication, expanded commerce, longer and healthier lives. In the museum business we are achieving more efficient service to our public, better management of our collections, expanded opportunities for collaboration, more comprehensive and engaging exhibits. Technology is actually neutral, an impartial tool for the vagaries of human activity. Thus we accept responsibility for using this tool to build the new town square, rather than to fracture and disband the community of place so essential to the existence of humanity and its planet.

In more than fifty years of living, over twenty-five of those years as a historian and museum professional, I have learned that few questions are answered simply and absolutely, that many issues require radical re-thinking and unconventional processes. I have discovered—am still discovering—that this is an adventure too vital to undertake alone. The essays collected here represent some of my own contemplations of recent years, but more importantly they embody an invitation to participate in the adventure, one that is open to every one of us. Accept this invitation because your participation is essential in building the new town square. Accept it for the sake of those who come after us in the field of museum work, in the life of the community, and in the future of the planet.

Note

1. Barry Lopez, *Crossing Open Ground* (New York: Scribner, 1988), pp. 207–8.

Index

abandonment, 51, 104, 143–44, 151, 175, 180, 193
Acoma Pueblo, 111
African Americans, 62–75, 98, 186–89
Alaska, 112–15
American Association of Museums (AAM), 208–12
Andriacchi, Theresa, 8, 25, 27, 112
Artibise, Alan, 216
artifacts, 77–99, 201; definition of, 98

Benga, Ota, 64
Beyond Housing, 196

Cahokia Mounds, 102–3
camp, 5–6, 117–21. *See also* deer camp
Campbell, Robert, 93–95
Cape Girardeau, Missouri, 23
cemeteries, 22

change, 8–10, 42, 45, 49–50, 103–6, 109–114, 133, 182–83, 193, 207; resistance to, 11
Cincinnati, Ohio, 182–83
City Hall, St. Louis, 34–35
community, 2, 9, 57–58, 61, 103, 113, 128, 154, 185, 195–96, 199, 203, 208–17
community planning, 28, 147–51
Compton Hill Water Tower, 52
continuity, 42, 46, 52, 111–14, 119
cultural tourism, 163, 174, 177
culture, 2–3, 17, 157–64, 170–71, 176–78
Cupples Station, 95–97

daguerreotypes, 82–84
Davis, Miles, 66–67
deer camp, 3
Douglass, Frederick, 67–69, 92
downtown, 7–9, 27–28, 44, 50–51, 175, 182–83, 193–95

Drey, Leo, 137
Dunham, Katherine, 78

Eads Bridge, 46–47

Fields, Wayne, 166–67
Fishers, Indiana, 27–30
folklore, 180
Forest Park, 16, 105–8, 149–50

G & W Sausage, 179–80
Gateway Arch, 46, 157
ghost towns, 104–5
Gilded Age, 101–2
grandparents (the author's), 11, 23, 192–93

historical imagination, 102
history, 10–11, 19, 26–27, 43, 47, 106–8, 113, 146–47, 177, 198, 203, 211–12. *See also* public history
home, 39–40
Homer G. Phillips Hospital, 62–63
Hopi storyteller, 17–19
Hotchner, A. E., 172

identity, sense of, 44, 69
"inreach," 209
Ishpeming, Michigan, 1, 6–8, 15–16, 38, 77, 112

Jefferson, Thomas, 61, 131
Joplin, Scott, 64

Karinkevich, Anna, 211–12
Keokuk, 82–85

Lewis and Clark expedition, 130–33
Lincoln, Abraham, 20–21

Lindbergh, Anne Morrow, 87–89
Lindbergh, Charles, 61–62, 87–89
Lindbergh, Reeve, 87–89
Lomawaina, Hartman, 17, 27, 110
Louisiana Purchase Exposition, 22, 64, 106, 140

MacKay, Bill, 125, 173
Mackinac Island, 173–74
Madison, Elijah, 90–92
Maquoketa, Iowa, 193–94
McKittrick, Thomas, 22
memory, 10, 12–13, 17, 20–22, 41, 50, 191–92
memory place, 22, 41, 46–47, 52
Mill Creek Valley, 186–89
Millstone, I. E., 107–8
Minnesota, 126–30, 158–64
Mississippi River, 46, 139–40
Missouri Historical Society, 61–64, 73–75, 78, 97–99, 102, 131, 201, 214–17
Missouri History Museum. *See* Missouri Historical Society
Montana, 2–3, 19, 104–5, 117, 120, 125, 132
museums, 11–12, 19, 108, 201–2, 207–15

narratives, 17, 33–35. *See also* stories
New Mexico, 48

open space, 142–45

the past, 10–11, 13, 24–25, 27, 30, 42, 49–50, 111–13
pasties, 4, 168–69
Penitente Tenieblas, 20, 48–49
Pennsylvania, 52–57, 180–81. *See also* Schwenkfelders

place: crisis of, 1; loss of, 43, 141–42 (*see also* abandonment); meaning of, 37–41, 45, 126; relationship of people to, 38–49, 203–4; sense of, 6, 9, 21

preservation, 49–51, 199. *See also* stewardship

Presque Isle, Michigan, 109

progress, 25, 49, 103, 134, 181

public history, 13. *See also* history

Quinn, Michael, 23

Race Riots, East St. Louis, 1917, 64–66

racism, 70–71, 75

Raven, Peter, 134

Reston, Virginia, 199–200

Ross family, 186–89

sacredness, 20, 24, 56, 182

Sam Wah Laundry, 89–90

San Elizario, Texas, 196–99

Schwenkfelders, 52–57

Shoemaker, Henry, 180–81

Soulard Market, 30–32

St. John's (in Ishpeming), 15–16, 189–91

St. Louis, 9, 16–17, 40, 46, 50, 137, 146–47, 153, 184–89, 203–4

St. Louis Hills, 153–54

stewardship, 57–59, 152. *See also* preservation

Stine, Emily, 79–81

storied place, 23–25, 34

stories, 17–20, 27, 64–69, 78–79, 81–82; shared, 13, 61, 72–75, 99. *See also* narratives

suburbs, 44, 143–45

Superior, Lake, 5–6, 78, 109–10, 137, 168

sustainability, 137–41, 152, 156, 206

Tandy, Charleton, 72

technology, 47, 58, 109, 217

Texas, 44–45. *See also* San Elizario, Texas

Thoreau, Henry, 115, 130

town square, 9, 14, 35, 178, 179, 196, 200, 212, 214–16

Traubel, Helen, 184–85

University of New Mexico, 13

Upper Peninsula of Michigan (U.P.), 1–6, 20, 117, 145, 155–85, 165–68, 192–93

values, 55–57, 145–46, 214–17

Voelker, John, 115, 165–66, 171

water, 139–41

Weber, Nettie, 85–87

West, Rick, 209

World's Fair (1904). *See* Louisiana Purchase Exposition

Yellowstone National Park, 127–28

Yoopers, 5–6

Zoo, St. Louis, 71–72

About the Author

The author at the site of his grandparents' house in Negaunee, Michigan.
Photograph by Sue Archibald, 2003.

Since 1988 Robert R. Archibald has been president and CEO of the Missouri Historical Society in St. Louis, Missouri, the public history institution that received the first National Award for Museum Service in 1994. He has been the director of the Montana Historical Society and of the Western Heritage Center in Billings, Montana, and curator of the Albuquerque Museum in New Mexico. An active member of many professional and community organizations and author of *A Place to Remember: Using History to Build Community*, published by AltaMira in 1999, he writes and speaks on numerous topics from history and historical practice to community building and environmental responsibility.

Archibald spent his first twenty years of life in Michigan's Upper Peninsula, born in Ishpeming and educated at Northern Michigan University in Marquette, where he achieved undergraduate and graduate degrees. He earned his doctorate at the University of New Mexico, an experience he deeply values. He has received honorary doctorates of letters from the University of Missouri–St. Louis (1998) and from Maryville University (2003) and the 1998 Distinguished Alumni Award from NMU, honors he thoroughly appreciates.